Snow Country

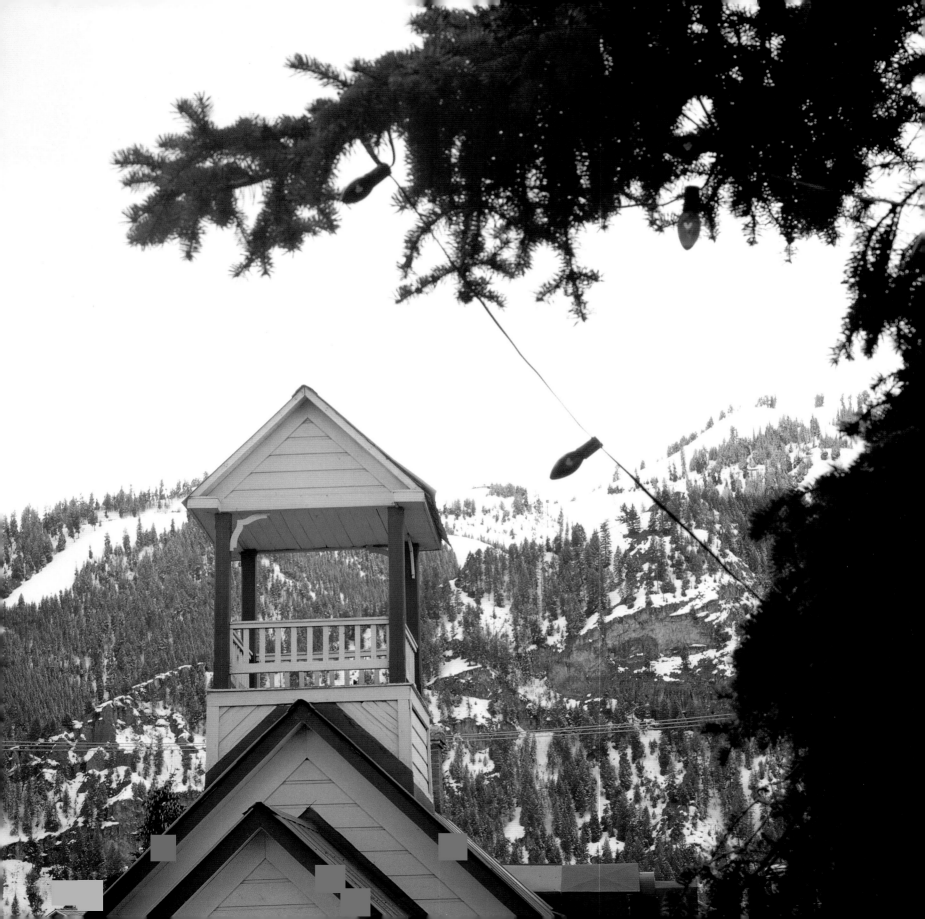

Snow Country

MOUNTAIN HOMES AND RUSTIC RETREATS

Text by Elizabeth Clair Flood
Photographs by Peter Woloszynski

CHRONICLE BOOKS
SAN FRANCISCO

Text Copyright © 2000 Elizabeth Clair Flood
Photographs © 2000 Peter Woloszynski

All rights reserved. No part of this book may be reproduced in any form without written permission from the publisher.

Library of Congress Cataloging-in-Publication Data:
Flood, Elizabeth Clair, 1967–
Snow Country: mountain homes and rustic retreats / text, Elizabeth Clair Flood; photographs, Peter Woloszynski.
p. cm.
Includes index.
ISBN 0-8118-2451-9
1. Interior decoration—West (U.S.) 2. Architecture, Domestic—West (U.S.) 3. Architecture, Modern—20th century—West (U.S.) 4. Ski resorts—West (U.S.) 5. Interior decoration—West (U.S.)—Pictorial works. 6. Architecture, Domestic—West (U.S.)—Pictorial works. 7. Architecture, Modern—20th century—West (U.S.)—Pictorial works. 8. Ski resorts—West (U.S.)—Pictorial works. I. Woloszynski, Peter. II. Title.

NK2008.F57 1999
747.218'0914'3—dc21 99-059190

Book and cover design: Rowan Moore/doublemranch
Cover photographs: Peter Woloszynski

Printed in Hong Kong

Distributed in Canada by Raincoast Books
9050 Shaughnessy Street
Vancouver, BC V6P 6E5

10 9 8 7 6 5 4 3 2 1

Chronicle Books LLC
85 Second Street
San Francisco, CA 94105

www.chroniclebooks.com

Dedication:
For Emily and Harry, and for my parents,
who introduced me to snow country.

Thank you to all the homeowners who graciously invited us
into their homes and shared with us their stories.

We also appreciate the help and inspiration we received from the
numerous individuals who were our faithful guides: Terry Baird,
Joan Benson, Rachael Bertinelli, Corinne Brown, Mark Brown,
Rebecca Callender, Steve Chin, Andy Corwin, Diana Cunningham,
Prue Hemmings, Nathalie Kent, Stephen Kent, John Lawlor,
Deavours Hall, Shannon May, Bruce Olson, Polly Peak,
Quentin N. Scott, Robin Stater, Elizabeth Stevensen, and Sandra
Wolcott Willingham.

Warmest thanks to Jack and Angela Hemingway for
allowing us to photograph Ernest Hemingway's home in Sun Valley.

We also appreciate the Hotel Jerome for their
kind and generous hospitality.

Special thanks to our editor, Christina Wilson, and to the
in-house designer, Julia Flagg, and to designer Rowan Moore
for putting the book together beautifully.

Finally, thanks to Phelps Dewey for his support and to
Nion McEvoy, who assigned us this project, which sent us wandering
through some of the most beautiful mountains.

PAGE 2 A church bell tower, originally the tower on Ketchum, the first Congregational Church of Idaho, built in 1883, rises high in front of Sun Valley's Baldy Mountain. In 1954, the building ceased to be a church. Instead the structure housed a gourmet coffeehouse, then Louie's, a popular spaghetti restaurant.

TABLE OF CONTENTS

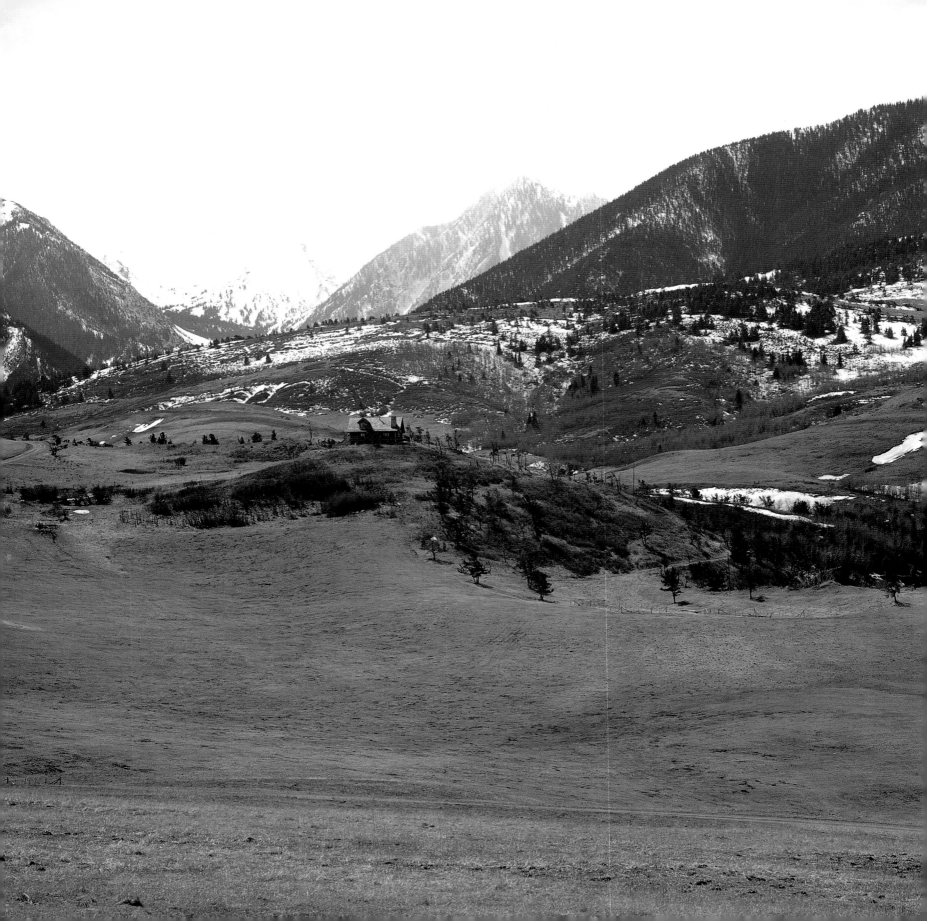

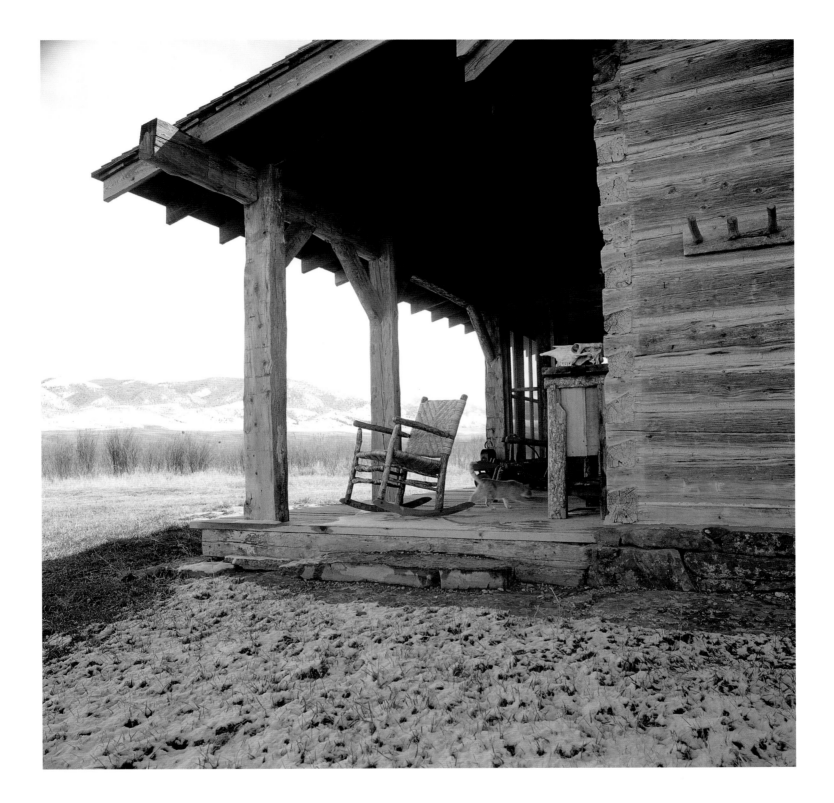

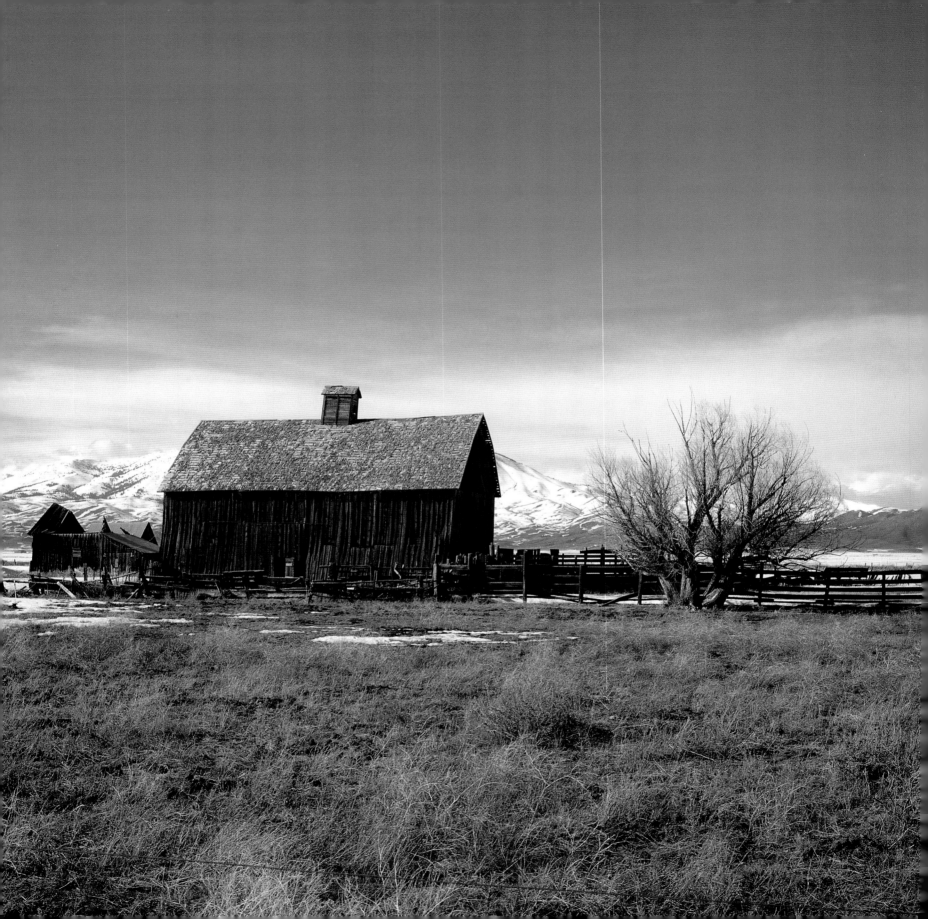

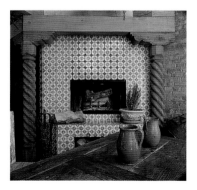

ABOVE A Southwestern-style fireplace, featuring tiles and wooden pillars, provides warmth in a restaurant in Park City, Utah.

LEFT Before Sun Valley, Idaho, became a popular ski resort, the area was predominately inhabited by ranchers. Today ranching is still a viable way to make a living in the mountains, but the work is tough in this country, where winter can last up to nine months.

RIGHT Many Californians enjoy their second homes in the Lake Tahoe area. Surrounded by the Sierra Nevada and situated on the bank of the lake, properties are extremely valuable. Locals say people are tearing down million-dollar homes to build five- and ten-million-dollar homes. Once mostly a summer resort, the Lake Tahoe area has become a year-round recreational area.

PAGE 6 Many people move to the Western mountains to enjoy the open space. Jagged snow-capped mountains surround this Livingston, Montana, home and open land stretches for miles.

PAGE 7 An old hickory rocker on a cabin porch provides a quiet place to sit and look at the mountains in the distance.

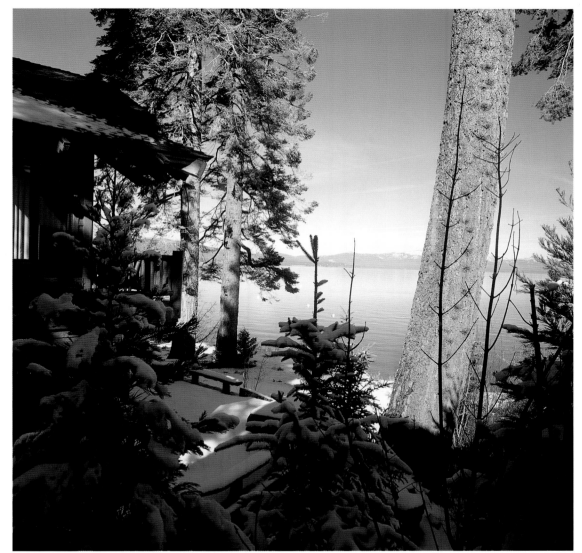

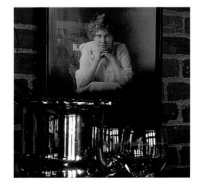

Introduction

As we drove into Aspen, Colorado, on a chilly December day, Peter told me that "this is the kind of place where people you meet over cocktails offer you a lift in their private planes."

"Yeah, right," I said, rolling my eyes. Peter Woloszynski, a photographer from Bath, England, and I were headed to Aspen's historic Hotel Jerome, where we would be staying a week while we photographed mountain home interiors for this book. We had just arrived from Mammoth, California, where some skiers still live in A-frames carpeted with orange shag rugs and own avocado-green refrigerators. Neither one of us had ever stayed in Aspen before. We looked forward to a change.

After checking into our rooms, we dressed for dinner and met antler artisans Stephen Kent and Joan Benson of Crystal Farm and their friend Andy Corwin at Jimmy's, a local restaurant and bar. The evening clicked along at a brilliant pace, with martinis arriving faster than chairs on a high-speed quad. Then Peter mentioned that we were thinking about continuing on to Santa Fe and Taos to photograph more snow homes.

"Oh, take our plane," Stephen said. "We're not using it."

I looked at Peter, dumbfounded.

"No, really, we insist, and Andy will fly you," Stephen added.

In disbelief, Peter and I looked over at Andy who was well into his fifth cocktail.

Tipsy, he laughed. "Don't worry, I never drink and fly."

That comment was *so* Aspen — like the professional Christmas tree decorator we met, who'd flown in from Los Angeles to create chic trees for the socialites, and the fur-lined Gucci dog beds costing over $2,500, and a bar owner who tells you he entertains "only the *crème de la crème*" of society.

Aspen was just one of many ski resorts on our tour. From Whistler, Canada, to Santa Fe, New Mexico, Peter and I

ABOVE A historic black-and-white portrait of an early Jerome visitor and a silver bucket on the piano create a nostalgic atmosphere for the good old days at the Hotel Jerome.

RIGHT The staff at the Jerome gathers on the front porch of this historic hotel. From carrying weighty fur coats to providing room service, the Jerome staff makes sure a guest's stay in Aspen is memorable.

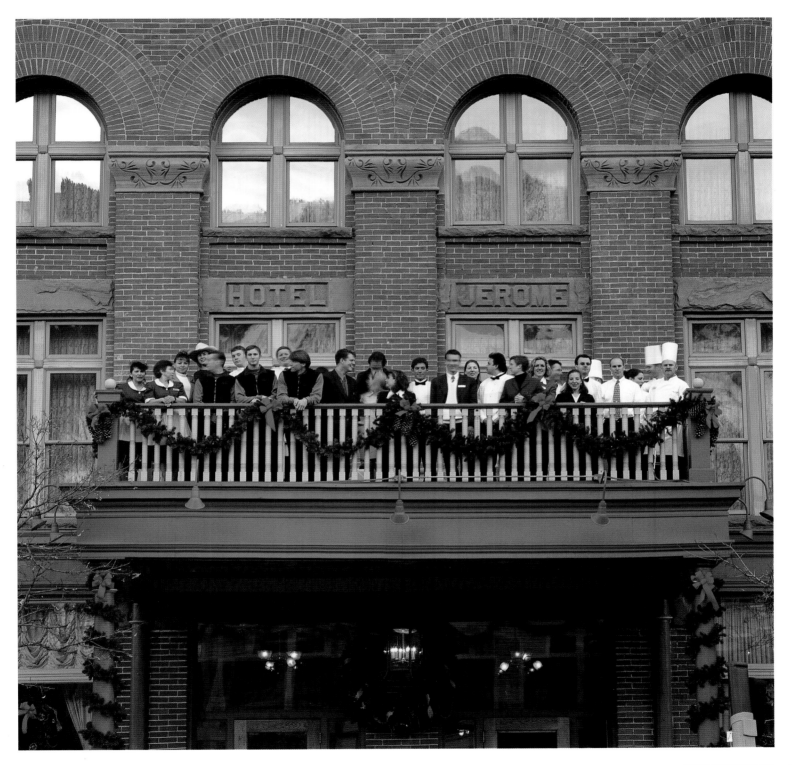

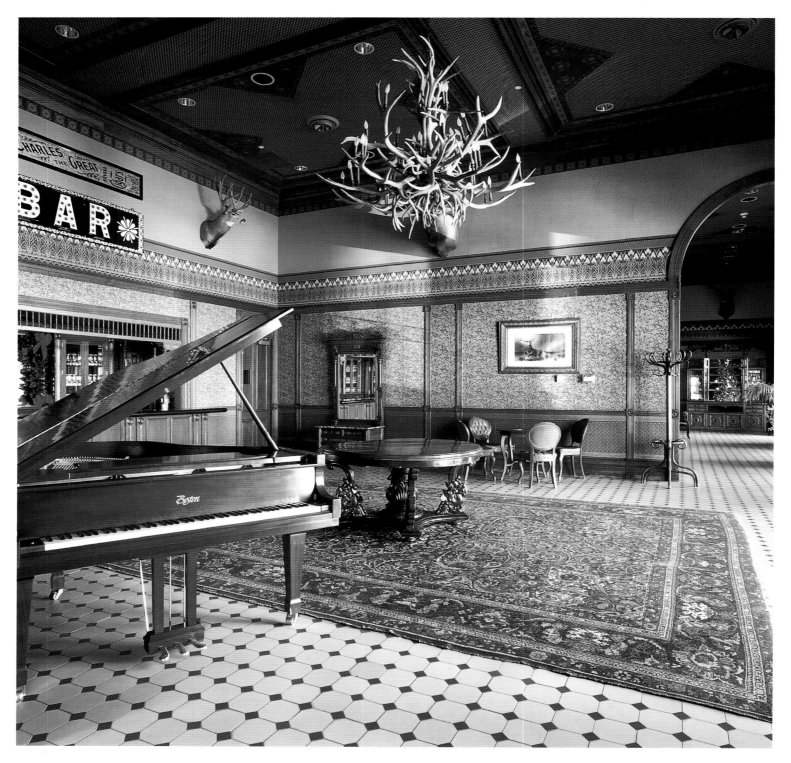

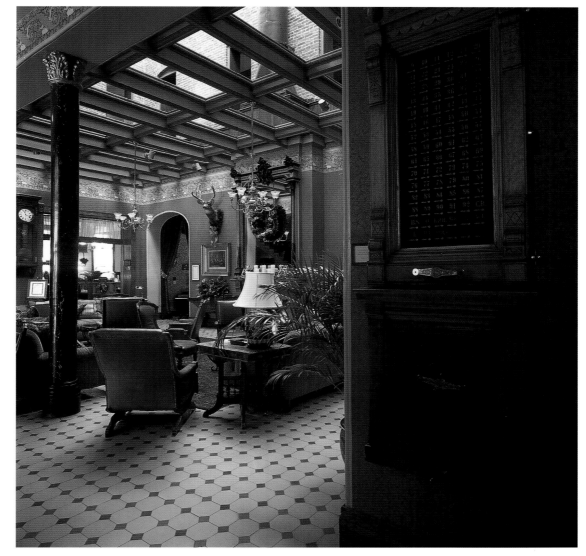

RIGHT In the 1980s, interior designer Zoe Murphy Compton of Emma, Colorado, restored the Victorian mining-camp style to the Hotel Jerome. The custom-made wallpapers, the furnishings, and the palms are reminiscent of the Eastlake Gothic style popular in the 1880s.

LEFT The piano room at the Hotel Jerome features an antler chandelier made by Crystal Farm of Redstone, Colorado.

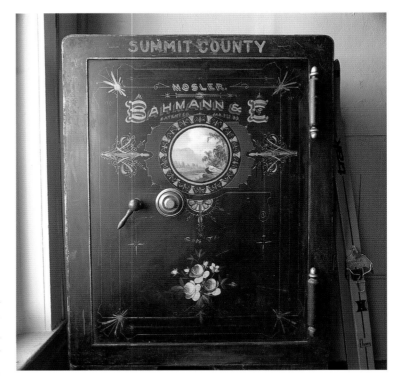

traveled throughout the fastest-growing ski region in the world, an area that includes the Rocky Mountains, California's Sierra Nevada, and the Coastal Mountains. Our assignment was to photograph an "authentic and accessible mountain style" in some of the most popular Western ski areas. Driving over lofty mountain passes, through formidable snowstorms, Peter and I discovered, rather unexpectedly, a refreshing diversity of interior style in booming Western ski towns. From Aspen's glitzy houses to good old Wyoming cowboy cabins, we uncovered a gold mine of interiors. Happily, not everyone lived in gigantic log castles, furnished with predictable leather and plaids.

Shelters including quaint chalets, rustic cabins, and over-the-top fantasy retreats reflected a joyful appreciation for the natural surroundings. We met individuals passionate about skiing and the outdoors, who embraced a casual lifestyle. While some people modeled their homes after indigenous rustic pioneer cabins or early national park lodges, others preferred a more European alpine style. Since most everyone is from somewhere else, many homes showed off family heirlooms and antiques that were not native to the area. Surprisingly, we also turned up contemporary buildings featuring glass, concrete, and metal and a number of quirky abodes, like a Southern mansion in Montana and a pink trailer painted to look like a log cabin in Wyoming. As Mammoth, California, interior designer Corinne Brown said, "Everyone wants a mountain style, but everyone's idea about what is mountain style is different."

ABOVE An old safe sits in an abandoned Park City building. The owner plans to remodel the building and use the safe in the interior. Because Western history is little more than 100 years old, people cherish the few relics they have from our recent past.

RIGHT Not everyone lived in rustic cabins in the Old West. This bathroom in the John W. Mackay mansion was the first to have running water in Virginia City, Nevada, in 1860. The home was originally built by George Hearst, the father of William Randolph Hearst. The porcelain fixtures from England would have been shipped around the horn to San Francisco, then sent to Virginia City via wagon.

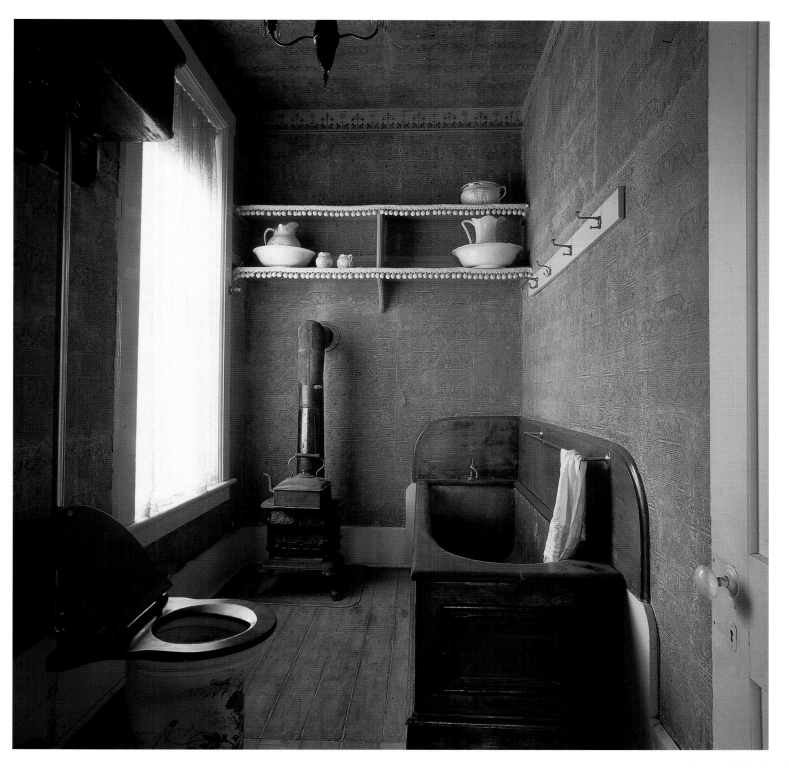

ABOVE Park City, Utah, once a bustling Victorian mining town, now attracts skiers from all over the world. This Victorian, like many others, is now being restored.

LEFT A typical log building from the turn of the century in Virginia City, Montana, an old mining town that now attracts a thriving tourist crowd.

Although people have lived in the Rocky Mountains, the Sierra Nevada, and the Coastal Mountains for more than a hundred years, the majority of early travelers to these regions stayed a short time. Explorers came, then left. Starting in the 1880s, people vacationed at dude ranches or traveled through our national parks. Doctors sent their patients west for the elixir of fresh air, and a few artists headed for the mountains at the turn of the century in search of inspiration. After World War II, the ski industry boomed, and skiers built modest ski chalets, where they spent part of the year.

Many people felt that the few who stayed in these early years and tried to make a life for themselves ranching or mining or working in a small town were rebels. Sometimes, an Eastern family sent a young relative who "didn't fit in" west to spare the family name. These individuals, called remittance men, enjoyed a classless society where cowboys mixed with millionaires. The society had few rules, and the locals respected newcomers for what they did, not for who they were back East on some social register.

There was good reason most people refused to settle in the Western mountains. Primitive living conditions and a winter that could last up to nine months frightened many. Wyoming homesteaders used to say, "If summer falls on a weekend, let's have a picnic," writes John McPhee in his book *Rising from the Plains*. Homesteaders suffered from cabin fever. After being cooped up in her cabin all winter, Miss Waxum, a Wyoming schoolteacher, wrote in her journal, "My spirit has a chair sore." A forlorn cowboy wrote home to his parents: "The cards are all worn out and the winter ain't over yet."

But people have learned to survive over the years. Intoxicating beauty and open space, outdoor recreation, and modern heating lured others. Many people told us they came west to ski, then never left.

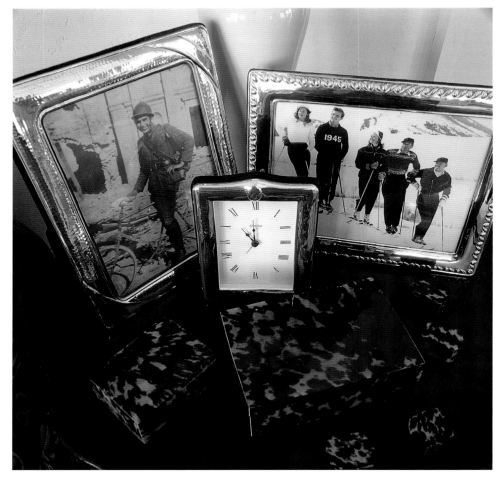

A photograph of Jack Hemingway skiing with Rocky Cooper, Ingrid Bergman, Gary Cooper, and Clark Gable on Rudd Mountain in Sun Valley just after the war sits next to a picture of Ernest Hemingway as a young man.

Skiing was a novelty in the twenties, so Western ski towns and ski homes are relatively new. During the gold rush in the mid-1800s miners traveled the Sierra Nevada, the Rockies, and the Coastal range on long, wooden skis or crudely made snowshoes. By the late 1920s, skiers shuffled about for recreation on barrel staves and ash skis with no metal edges, using hazelnut sticks for poles and old bear-trap-style leather bindings. While some areas offered Poma lifts, most die-hard skiers climbed mountains on skins attached to their skis, then descended.

Impressed with the Swiss ski resorts of St. Moritz and Gstaad, Averell Harriman, president of Union Pacific and an avid skier, opened the first destination ski resort in America in 1936 in Sun Valley, Idaho. Formerly the winter stomping grounds of the Shoshone and Bannock Indians, and later the home of miners and sheepherders, Sun Valley resembles a European ski village. To promote his new resort, Harriman encouraged movie stars like Gary Cooper, Judy Garland, Clark Gable, and Marilyn Monroe to come ski. He also invited author Ernest Hemingway, who stayed gratis in the grand four-story Sun Valley Lodge, where he wrote part of *For Whom the Bell Tolls.* Determined to create a state-of-the-art resort, Harriman hired renowned skiers Friedl Pfeifer of Austria and Alf Engen of Norway to build the ski runs at his snowy Shangri-la.

Hemingway in Sun Valley

Writer Ernest Hemingway frequented Sun Valley soon after the resort opened in 1936. He enjoyed the outdoors, fly-fishing, and bird hunting on Silver Creek. Because Averell Harriman wanted to attract movie stars and famous people to his resort, he offered Hemingway a free room at the lodge for many years.

In 1958, Hemingway moved into a home on twenty-two acres near the Sun Valley ski resort with his fourth wife, Mary. Its architectural style resembled that of the rustic Sun Valley Lodge. Open space surrounded the home, and mountain views dominated all the windows, from which no other houses were visible. In an upstairs bedroom, Hemingway stood at a desk to type while looking out on the Sawtooth Mountains. Although many of the furnishings have been removed, a few Hemingway treasures remain, such as old photographs, magazines, traveling trunks, and a few hunting trophies. Sadly, Hemingway lived in this home only briefly before he shot himself in the projection room.

Mary Hemingway continued to live in the home for another twenty years. She left in the 1980s intending to return, but never did. She died in New York City in 1986 and left the Sun Valley home to The Nature Conservancy.

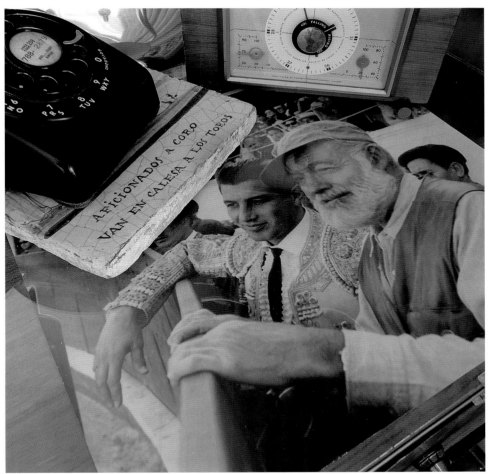

A photograph of Ernest Hemingway with his friend and bullfighter Ordoñez in Spain in the latter years of Hemingway's life enhances the writer's telephone table in Sun Valley, Idaho.

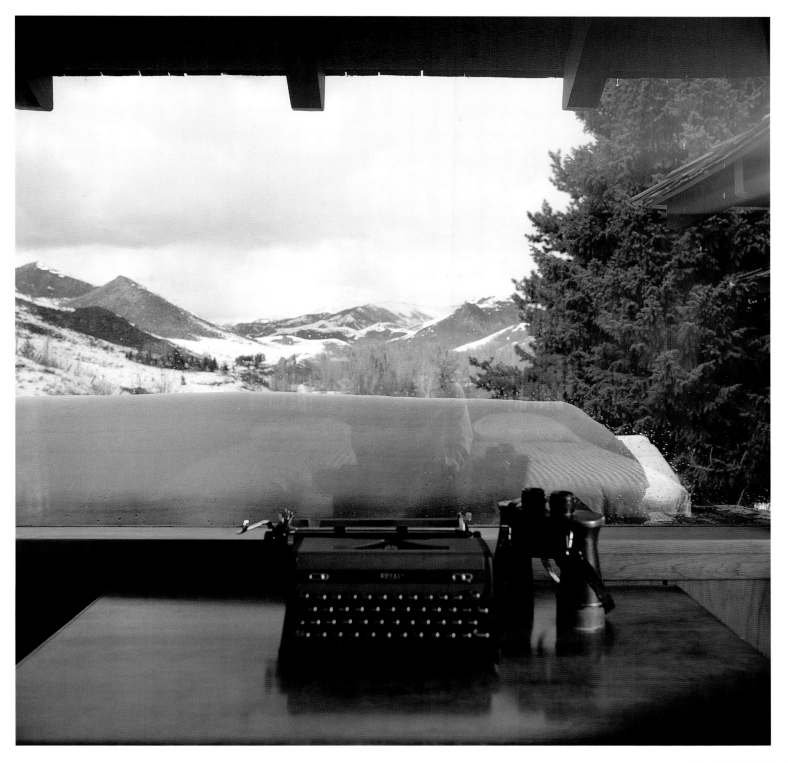

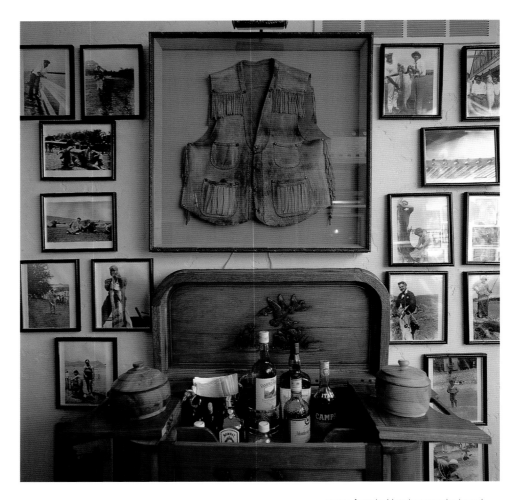

ABOVE Angela Hemingway designed this casual den for her husband, Jack Hemingway, Ernest Hemingway's son. The room honors his father's life with a collage of hunting photographs and his hunting vest. The antique bar, with carved hunting motifs, came from a shop nearby.

PAGE 20 Ernest Hemingway's house was modeled after the Sun Valley Lodge. Although Hemingway was a frequent visitor to Sun Valley, he didn't spend much time in this house. What time he did spend was painful. It is now owned by The Nature Conservancy.

PAGE 21 Hemingway liked to write early in the morning, standing up. At this typewriter, he wrote parts of *A Moveable Feast* shortly before ending his life in the downstairs projection room.

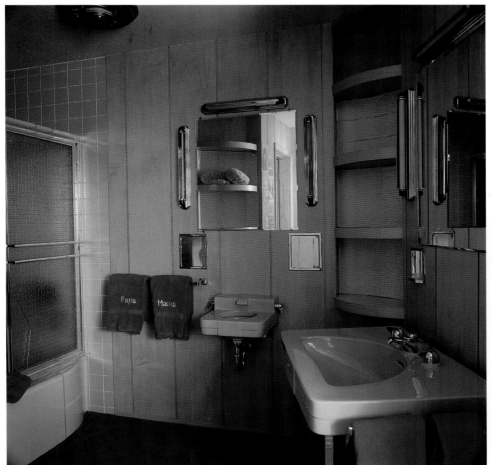

BELOW Ernest Hemingway's son Jack's den, a monument to his father. The room features Hemingway's fly rod and a French daybed.

BELOW, RIGHT Much of the furnishings in Hemingway's house were sent to the Kennedy Library in Boston. What used to be in the house has inspired a recent furniture line of comfortable, masculine Western furniture.

ABOVE Ernest Hemingway's son Jack started calling his father Papa. Then Hemingway referred to himself as Mr. Papa, and his friends called him Papa. These "mama and papa" towels, which hang in the Sun Valley home, were added after Hemingway's death.

RIGHT A few animal trophies and a traveling trunk decorate the Hemingway's living room in Sun Valley.

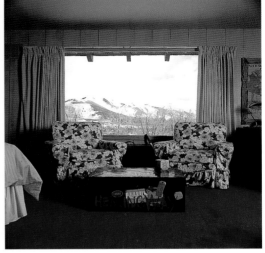

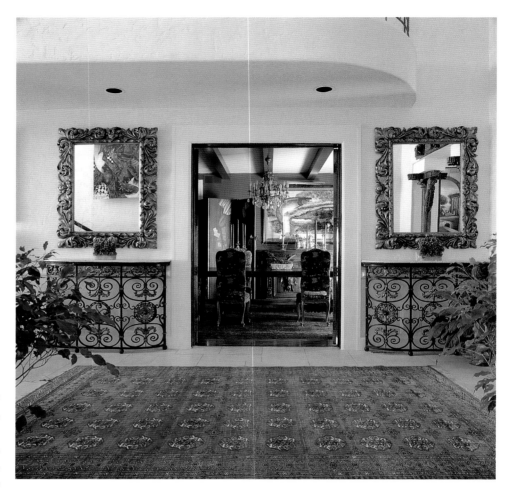

Because of his father, Jack Hemingway visited Sun Valley. Also an avid outdoorsman, Jack immediately fell in love with the area. Throughout his school years he returned to the Sawtooths to hunt, fish, and ski. Now he lives with his wife, Angela, in a house near the ski mountain. After the two were married in 1989, they took a six-month honeymoon to Europe. They were thinking of living in France, but after six months they decided that Sun Valley would be their full-time residence. "I will create our own little Europe," Angela Hemingway said of their mountain home. "I want our place to be comfortable. I did not want our place to look like everybody else's." Mixing European antiques with Turkman rugs and a chandelier from France, she created a sophisticated mountain sanctuary. In memory of Ernest Hemingway she designed a den, decorated with the writer's hunting equipment and old photographs, for her husband.

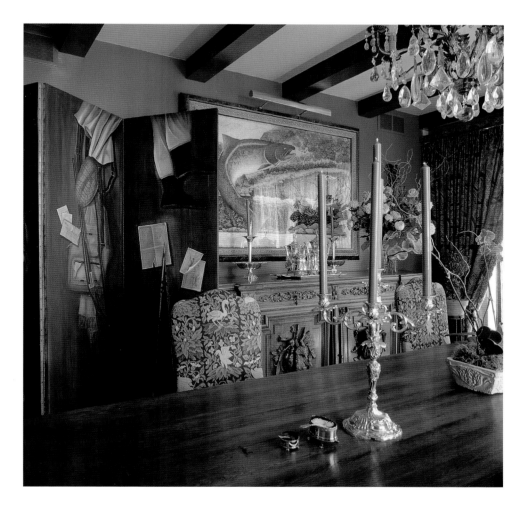

LEFT The Hemingway dining room features a walnut table and a Venetian chandelier, picked out by Jack Hemingway on one of his trips to Europe. Angela Hemingway commissioned an artist to do the fish painting in honor of one of her husband's grandest catches.

FAR LEFT Some people who live in the mountains full-time prefer formal interiors. Two gold mirrors from Nogales, New Mexico, hanging above two iron consuls frame the entrance to Jack and Angela Hemingway's dining room in Sun Valley. A Turkman rug covers the hallway.

Russian Art

In the 1800s, Taos was an enclave for mountain men such as the famous Kit Carson. An Indian pueblo, which is still in existence, was established in 1765. In 1898, painters Bert Phillips and Ernest Blumenschein, impressed with the brilliant New Mexican light, stayed. Socialite Mabel Dodge Luhan arrived in 1917 and immediately encouraged artists and writers to gather. "Until her coming Taos was a beautiful little-known sleepy crumbling adobe small town. Now it is the world famed 'Art Colony of the South-West,'" wrote English painter John Young-Hunter. Because of Luhan's efforts to promote the arts, creative types such as Ansel Adams, Willa Cather, Aldous Huxley, Carl Jung, D. H. Lawrence, Georgia O'Keeffe, Thornton Wilder, and Thomas Wolfe were drawn to Taos.

A Russian painter, sculptor, and woodcarver named Nicolai Fechin was part of Taos's creative legacy. Having grown up in Russia, Fechin was encouraged to visit the small, dusty town by artist friends. He fell in love with the mountain landscape and enjoyed the artistic milieu.

RIGHT In Nicolai Fechin's dining room a portrait of his father, Ivan Fechin, painted by the artist, hangs above a carved sideboard he also created. The wooden gate and columns, made of clear white sugar pine, were carved by the artist as well. The vigas—the ceiling beams—are local ponderosa. The tongue-and-groove flooring came from Santa Fe.

FAR RIGHT Although Nicolai Fechin lived in Taos for only six years, he called it his American home. His home is now listed on the National Register of Historic Places.

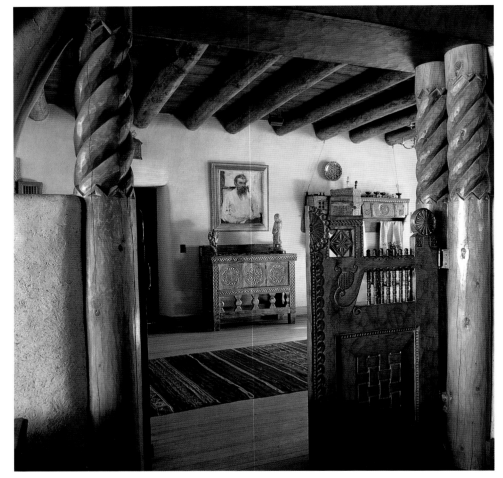

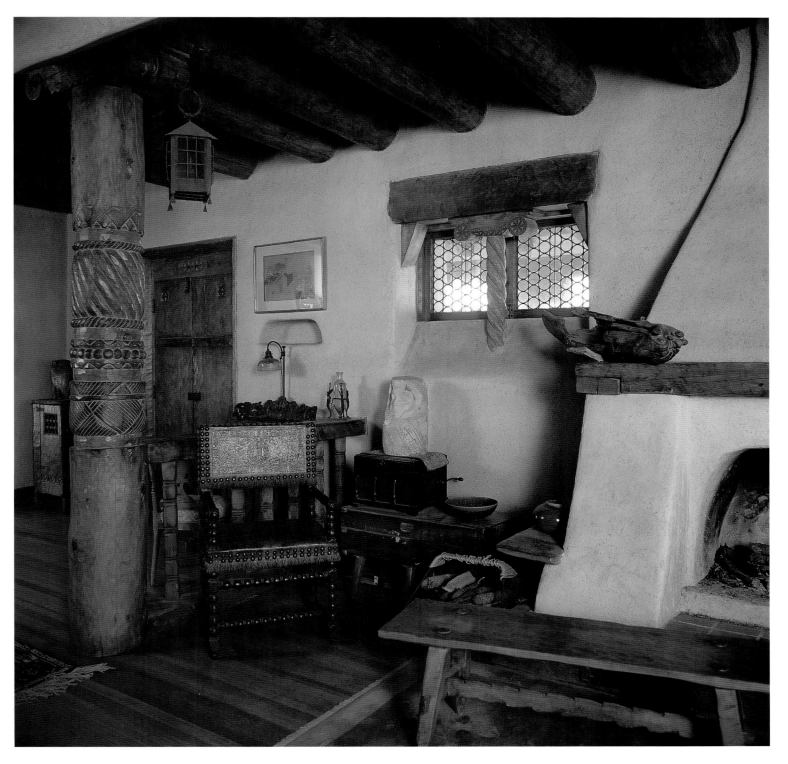

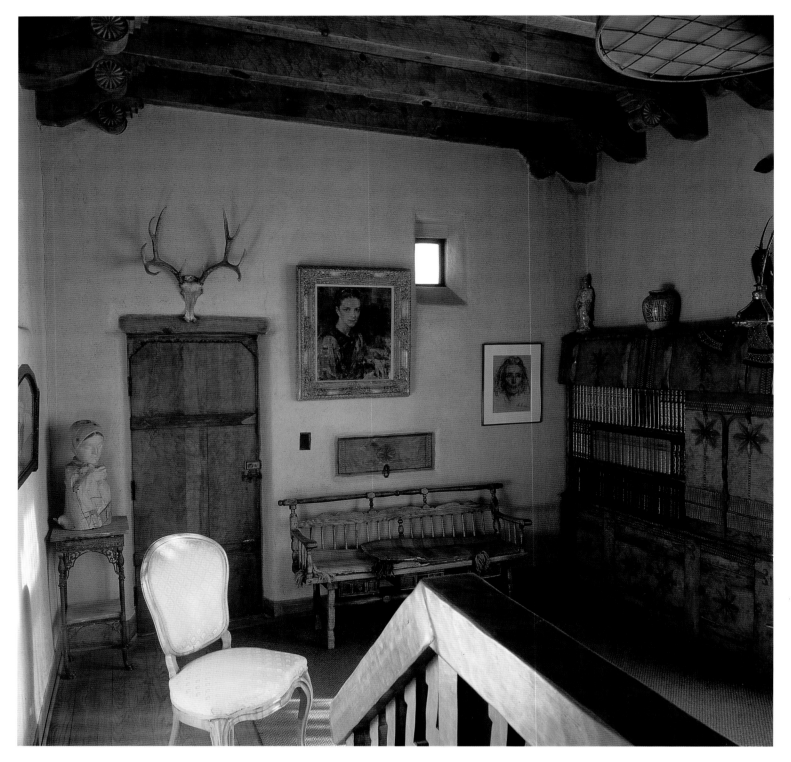

Fechin, called the "Michelangelo of our time" by his daughter, Eya Fechin, liked the area and the mountains, which reminded him of his country's Caucasus range, enough to build himself a home. Between 1927 and 1933, he created a Russian house out of New Mexican mud. He designed the home and built most of the furnishings. His daughter remembered how difficult it was to get materials such as flooring. "There was nothing available in town," she said. Much of the materials came from Santa Fe. Their house was one of the few in Taos with plumbing and electricity.

While Fechin was proud of his home, he spent more time in his studio just beyond the house. His daughter was a willing model. ("How on earth could I sit still that long?" she now wonders.) In the winter, Fechin, who had grown up skiing because it was a primary mode of transportation, joined a small group of skiers for Sunday cross-country outings to a small forest service cabin. Eya remembers the gourmet luncheons and shuffling through the snow on wooden skis and poles, ordered, like everything else from beds to kitchen utensils, from a mail-order catalog. Although Fechin lived in Taos for only six years, he always called it his American home.

"We were very good friends. We discussed things endlessly and I would take notes," Eya recalled. Her father taught her to paint and carve, and she even sold some of her carvings in a local curio shop. When Fechin traveled, he often took Eya with him. As she likes to say, she was brought up by genius. When she wasn't with her father in his studio or traveling, she enjoyed riding horses with the Indians from the Taos pueblo or escaping to her own library, a present from her father. Like her father, she had an insatiable appetite for knowledge. "Since the Russians called everything an art I was curious to know something about everything," she said. Out West, Eya found time to explore her varied interests.

Out of tremendous loyalty, Eya Fechin remains in Taos preserving her father's legacy. She has turned his home into a museum, and when she has time she works on a book about her father. She is one of his greatest fans. "Even today I'm not bored with the house because I'll see something different or I'll feel different. Sometimes I'll sit in the house without lights because I like it when it is dark and mysterious," she said.

ABOVE This Westinghouse electric stove in Nicolai Fechin's home was one of the first in Taos in the late 1920s.

LEFT Down a short stairway, Fechin built this small library for his daughter, Eya, for one of her birthdays. The room features her father's work such as the portrait of Eya as well as an etching of an Irish poet named Ella Young, who used to frequent Taos. Fechin also carved the wooden bust in the corner.

The first ski areas continued to have a European aura. After the war, Friedl Pfeifer and Alf Engen moved to Aspen, Colorado, once a booming silver-mining town, to help set up the new resort, which well-known skier André Roch of Switzerland had discovered in 1937. Pfeifer, along with many other men, had trained with the 10th Mountain Division in Camp Hale, near Aspen. After their tour of duty, Pfeifer and others returned to Colorado to help develop the ski industry.

In the Sierra Nevada, a mountain range called the "Range of Light" by renowned naturalist John Muir, a group of skiers convinced Walt Disney to invest in Sugar Bowl. A cozy chalet-style resort near the old mining town of Truckee, California, Sugar Bowl opened in 1940. Farther south, near the rural town of Bishop, California, Dave McCoy operated a roving Poma in 1941, then developed Mammoth Mountain, installing his first chairlift in 1955. In this same year, the Swiss-German Ernie Blake, a legendary skier, founded the Taos Ski Valley in New Mexico, one of the most challenging Western ski resorts. A few years later, Earl Eaton and Pete Seibert discovered Vail Mountain in Colorado. With the invaluable help of business manager George Caulkins and a small team of directors, Seibert sold enough shares in 1962 to open a small pedestrian-style ski village, where skiers could walk throughout a quaint town without the interference of cars.

These early ski pioneers created ski villages that ranged from the posh to the down-home. Despite competition between the areas, camaraderie prevailed among the founders. They shared a love of the mountains and skiing, and imparted their passion to visitors. At this time, Howard Head's black metal ski revolutionized the sport, making skiing easier. People flocked to Western ski resorts to enjoy the glamour of a new sport and the legendary powder snow. They wore everything from old-fashioned knickers to stylish Bogner suits and hobnobbed with the Hollywood stars who frequented the slopes, often by invitation.

ABOVE People who move west treasure their roots. Taos painter Anee Ward stashes her paintbrushes in her grandmother's silver. Silver family heirlooms are a meaningful reminder of Ward's life "back East."

RIGHT The original Bellevue, Idaho, city hall houses the local museum. The wooden building was constructed in 1885 and is described as having a typical Western-expansion design.

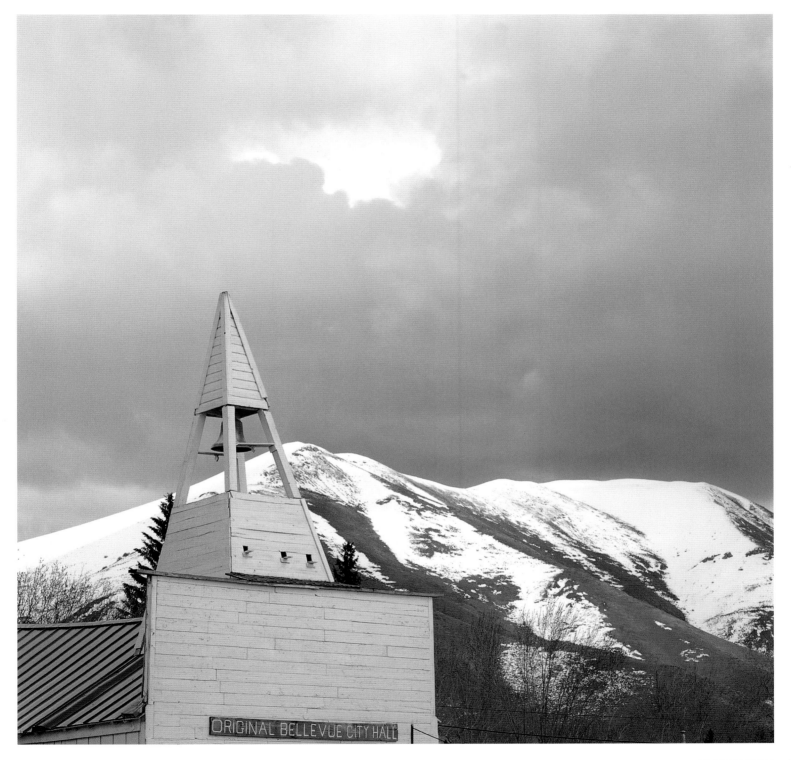

"Skiing was a way of life, money was not important, and we never really cared as long as we could get along and we were eating," said George Engle, an early Colorado ski patrolman.

"It was fun because it was a culture," said Olympic racer Linda Meyers. "I bet every single one of these old-timers has said that skiing was a way of life. It isn't today; it's a recreation, and it's a business."

Ski areas in the Rocky Mountains and the Sierra Nevada have continued to boom as the West grows faster than any other American region. Now these resorts attract year-round mountain dwellers, who for the most part came for the skiing but discovered the added perk of an enchanting and casual outdoor lifestyle year round. While mountain communities have developed considerably since Lewis and Clark laid their eyes on this pristine environment in 1804, the alpine areas' snow-capped peaks still beckon with their mysterious beauties. When English traveler Isabella Bird crossed the Sierra Nevada and Rockies in the late 1800s, she was impressed with the imposing mountains, the luscious forests, and the peaceful open space. Of the Rocky Mountains she wrote: "The scenery up here is glorious, combining sublimity with beauty, and in the elastic air fatigue has dropped off from me. This is no region for tourists and women, only for a few elk and bear hunters at times, and its unprofaned freshness gives me new life." Today, in the last stages of the settlement of the West, the majestic Western mountain ranges still inspire.

On our last evening at the Hotel Jerome, Peter and I met Sheriff Bob Braudis, a big guy with a silver belt buckle and tall cowboy boots, at the hotel's famous J-Bar. Braudis told us about the freewheeling good old days of the sixties and seventies in Aspen and at the Jerome. "The Jerome was the home away from home for so many people," said Braudis, who came for the Western atmosphere and the hope of being a sheriff one day. "You were always guaranteed you would see someone you

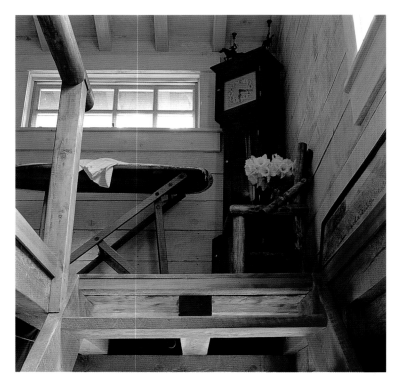

ABOVE Log cabin builder Terry Baird, who lives in a modest country home along the Boulder River in Montana, built this clock as a challenge. Now the piece sits at the top of the stairs, leading to his daughter's bedroom.

RIGHT A Montana ranch porch, furnished with Old Hickory furniture, is a comfortable place to relax in the day during one of Montana's famous chinooks.

knew and respected and assured of a decent conversation." Skiers crowded the hotel bar and lobby, drinking and talking and carrying on. Illicit activities went on in the downstairs phone booth and in the elevator, which could be stopped between floors. "I am grateful for having sipped from that cup—and it didn't kill me," Braudis added.

During my week in Aspen, I had been eager to interview gonzo journalist Hunter S. Thompson, a legendary Aspen local, a frequent visitor at the Jerome, and the author of *Fear and Loathing in Las Vegas*. I asked Braudis if he could arrange an interview. "Oh sure," he said. "Let's see if we can reach him on the phone."

So I chatted with Thompson from the bar on a cell phone. He told me the Jerome used to be "the capitol of the world," and that it had been a wild place. He had contributed to some of the mayhem. He said he believed many of the wild people had been chased out of Aspen, and that it wasn't as easy to get into trouble there anymore. Although the Jerome had been remodeled and scrubbed of its lawless charm, the hotel was still "the best hideout in town," according to Thompson, who used the J-Bar as his office when he ran for mayor some years ago.

As Peter and I wandered the Western mountains, we continued to meet characters like Thompson, with a hardy sense of self and a flair for unconventional living. The styles of their homes revealed to what degree they were committed to a mountain lifestyle. We photographed second homes, but also a surprising number of primary residences. More people are settling in the mountains year round. Their unusual stories, their intense love of the alpine environment, and their solutions for living in snow country kept us marching along snowy paths and knocking on their doors.

This Whistler, British Columbia, Canada, home, affectionately called "the mushroom house" by locals, features an unusual curvy roof line and octagonal shape. Many mountain dwellers feel free to express their individuality. Local communities are typically tolerant.

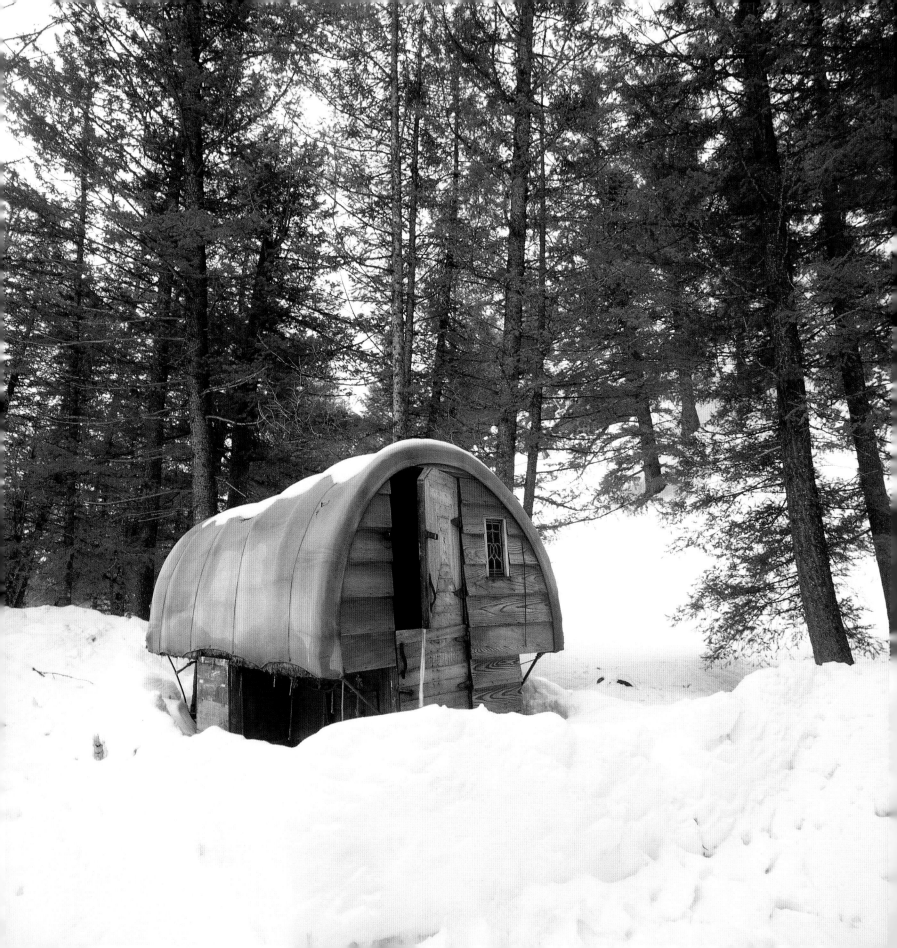

In the Western mountains, pioneers, cowboys, and gold miners built log cabins because they discovered wood plentiful and cabin construction simple. Furnished with a stove, a few crude pieces of furniture, a straw-filled bed tick, and possibly a rag rug, the primitive structure provided an adequate shelter from the elements.

Modern-day romantics like to believe these one-room cabins offered a glorious escape, but many of these homes made uncomfortable living spaces. At the turn of the century, Nan Budge of Jackson Hole, Wyoming, stashed her children under the kitchen table to keep them from being showered by the mud that dripped from the sod ceiling during a rainstorm. Mrs. Lucile Moulton, holding her baby Clark, cried when she crossed the threshold of her fourteen-by-eighteen-foot Wyoming homestead in 1910. The one-room cabin, built by her husband, comprised a dirt floor and roof, a few pieces of handmade furniture, and a family of mice.

For the most part, early mountain cabins provided temporary shelter for settlers, until the owners could afford a larger home. Inventive occupants scrambled to furnish their cabins with whatever they could find or make. Writer John L. Sinclair of Santa Fe, New Mexico, nailed a wooden box to the wall for a bookshelf and turned a tomato can into a bookend. Homesteader Elinore Pruitt Stewart braided a rug out of old blue and white sheets. In the mountains, the rustic style emerged as a style of necessity. Despite the hardship of living in a cabin and settling a frontier, the rustic cabin emerged as a symbol of hope for a better life.

Modern-day cabin dwellers, who chose the rustic style, appreciate the simplicity of a compact primitive shelter but allow themselves a few modern appliances. Weather-beaten shanties exude a warmth and a connection to the past. They have soul. Hidden in a forest, or set on a lonely prairie, these modest structures seem to belong to the country. As architect Jonathan

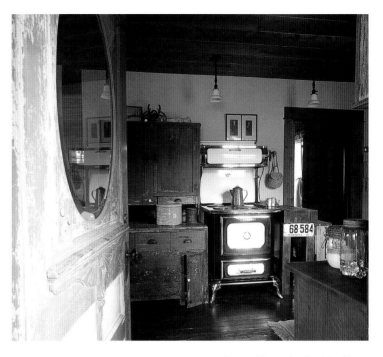

ABOVE In a cabin on the Boulder River in Montana, Terry Baird installed a modern Heartland stove from Canada because it combines all the charm of an old pioneer stove with modern efficiency.

RIGHT Three weathered wooden structures are reminders of Sun Valley's more rustic past.

PAGE 36 A sheepherder's cabin, once a practical housing solution, is now a romantic hideout, even in winter. A bed, a wood stove, and a few benches furnish the interior. This cabin, huddled in the snow in Sun Valley, had been temporarily abandoned. Floral cushions decorated the bed; lace curtains hung over the window. Occupants of historic pioneer cabins and these unusual compact spaces find the juxtaposition of a small space in a vast, and for the most part cold and snowy, landscape extraordinary.

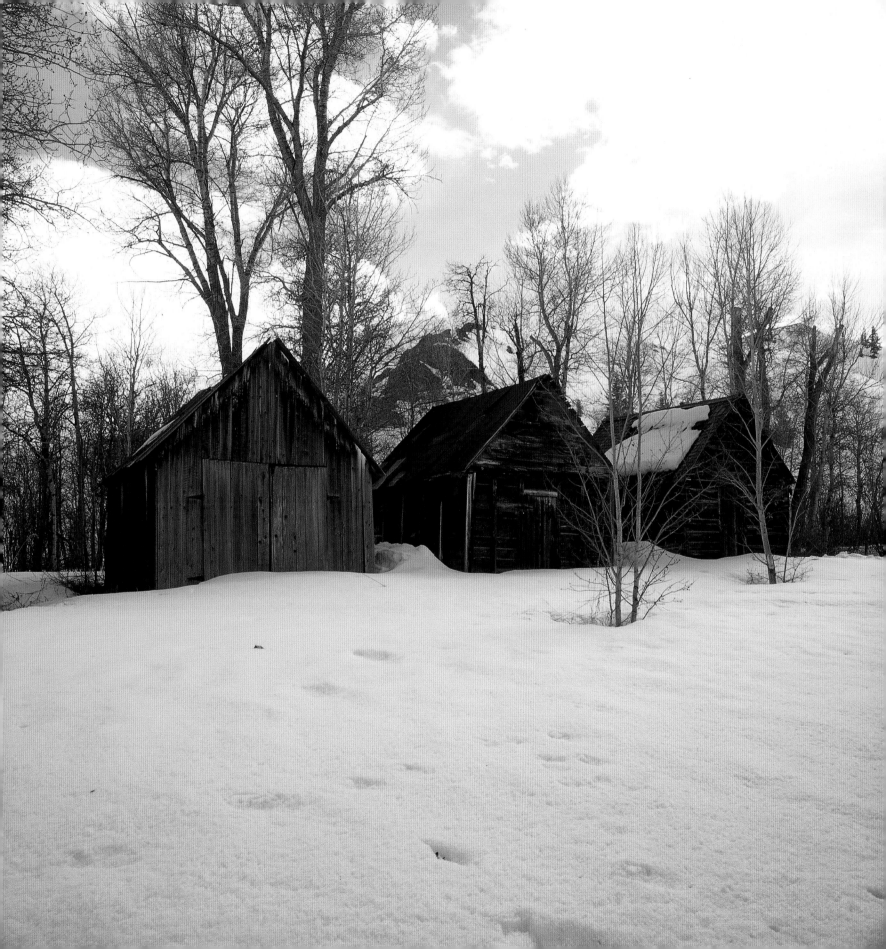

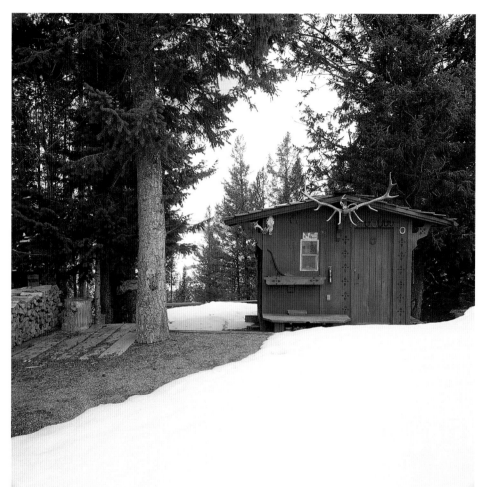

Foote of Livingston, Montana, says, a rustic cabin is a "usin' place."

In 1927, famed naturalists Margaret and Olaus Murie, who lived in Washington State, moved into a rustic mountain cabin at the base of the Grand Teton Mountain Range. They read by dim lamps powered by a gasoline-engine generator, ate sourdough pancakes by an old-fashioned wood range, and in winter skied a mile to the post office. On frosty days, they enjoyed skiing through quiet forests. Tucked away in their warm cabin, they relished the solitude. Sometimes, however, Margaret experienced pangs of guilt when there was a problem with the lights or some other inconvenience. "Oh dear, maybe we shouldn't have—," she would say to her husband about moving into their cabin. She was always answered with, "Oh Mardy, of course we should have."

Today the rustic log cabin provides a meaningful retreat, for those who don't mind a few inconveniences such as wind whistling through the chinking or a few spider webs in the corners.

Snow covers a storage shed decorated with deer antlers in Smiley Creek, a small community in the Sawtooth Mountains near Sun Valley, Idaho.

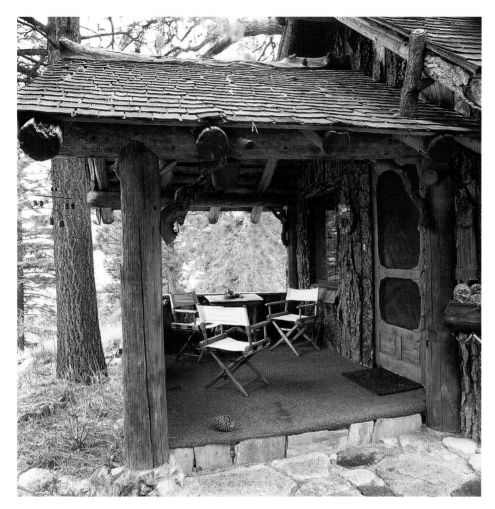

BELOW An early rustic Wyoming cabin with traditional green roofing makes a romantic retreat in winter.

ABOVE Laura Brun enjoys her rustic fishing cabin on June Lake, near Mammoth, California, even in winter. Brun walks on her snowshoes to town to buy supplies. On warm winter days she can sit on her deck and enjoy the scent of pine trees and the sound of the wind.

RIGHT AND FAR RIGHT This home, covered in redwood bark, disappears gently into its surroundings. As builder-contractor Bruce Olson said, "This is old Tahoe." The home has the feeling of a simple Adirondack camp.

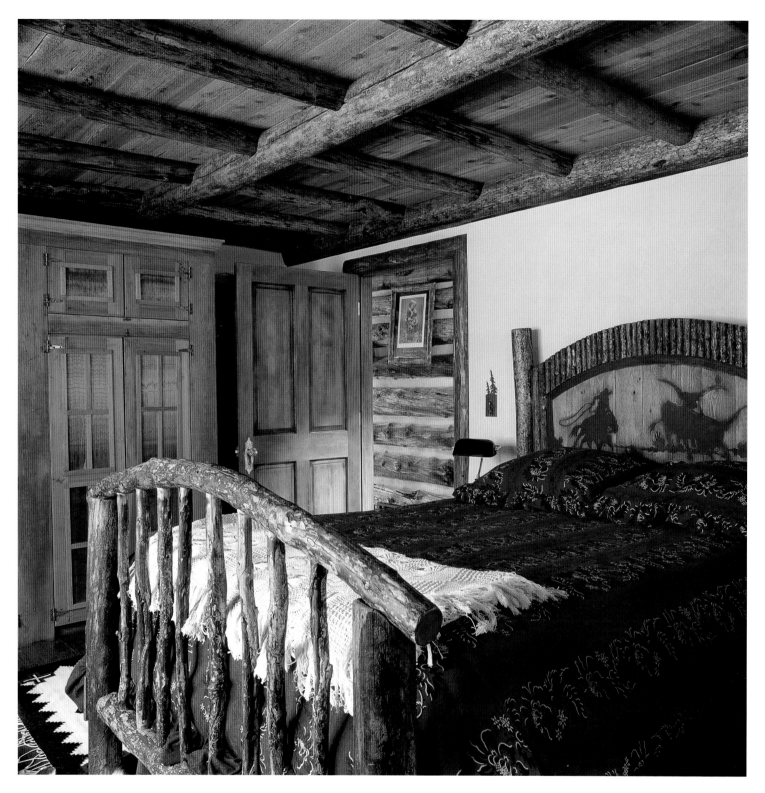

Rustic Lair

South of the small ranching town of McLeod, Montana, and at the foot of the Absaroka Mountains, sits a small, solitary cabin. As a light snow falls and wind skirts across the Boulder River, the cabin's occupants slide under their homemade quilt and curl up with their pet—a two-year-old lynx named Larry. Stretched lengthwise between the couple, the big cat with pointy, tufted ears, purrs. "We wouldn't dream of kicking Larry out of our bed," said Jeane Aller, who gave the wild kitten to her husband, Steve, for his fiftieth birthday. "Larry is very endearing. He is so special you don't even have to like cats to like him."

While not every cabin dweller is comfortable living with a lynx, those drawn to a rustic style are drawn to an element of wildness. They fancy rough-sawn walls, imperfect furniture, and a primitive coffee table for resting tired feet. Passionate about an unconventional lifestyle, rustic aficionados don't mind snow trudged in from outdoors, an unfinished project in the middle of the room, or an hour's ski to the nearest store. Wind may blow through the chinking, or moose may block the front door, but these minor inconveniences only enhance the romance of the retreat.

When it came time for the Allers to build their dream home, the couple dismantled a dilapidated livery stable (once part of a mining town) that had been sitting on the ranch since the late 1800s. They hired a friend and well-known contractor and expert cabin builder, Terry Baird of Big Timber, to help them transform the old cabin into a desirable shelter.

"We wanted our place to look like the old cabins used to look with small windows and tiny dividers. Everything we could recycle and reuse we did," Jeane Aller said. The Allers didn't want their home to look "too new or too shiny or too sparkly."

Throughout the project, the couple worked alongside Baird. They helped stack the logs, plaster the walls over chicken wire,

ABOVE Larry the lynx crouches on the cabin roof, playfully stalking visitors down below.

LEFT Inspired by early rustic traditions, Jeane Aller built this lodgepole master bed where she and her husband and their lynx, Larry, curl up at night. Like the pioneers, Aller finds long winter days the perfect time to make furniture.

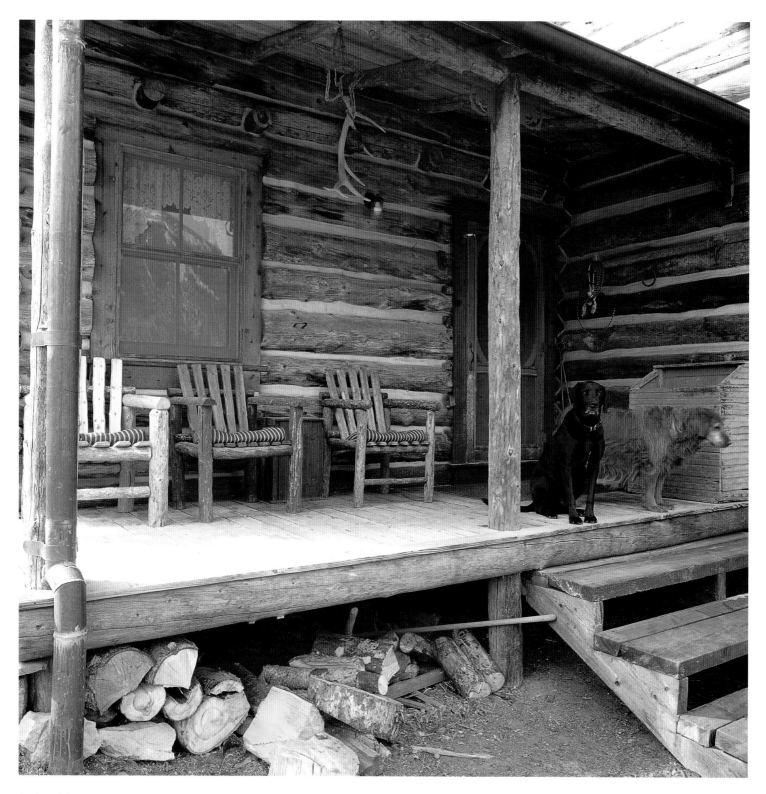

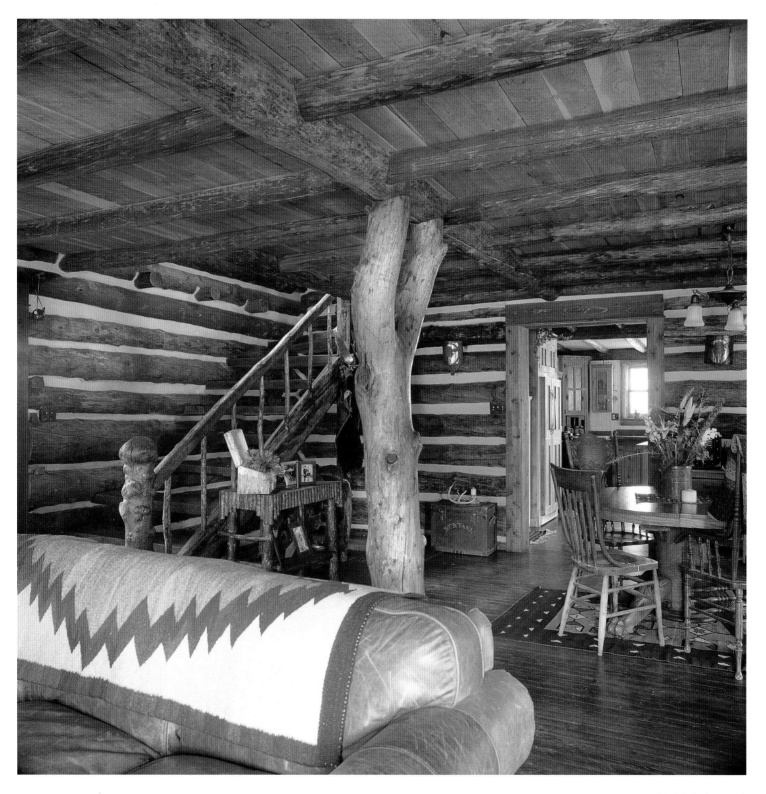

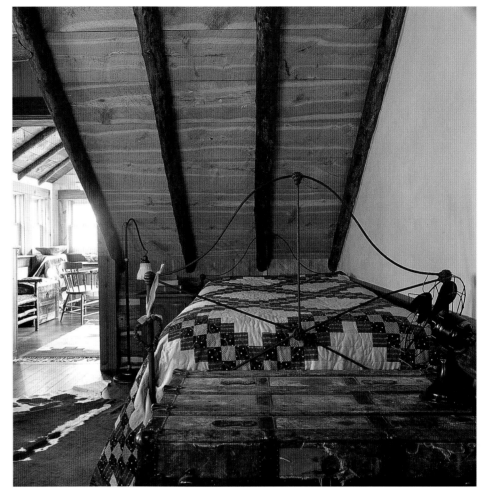

PAGE 44 Amos and Buffy pose for the photographer outside this refurbished Montana cabin, restored by cabin builder Terry Baird of Big Timber, Montana.

PAGE 45 A cozy, humble retreat with comfortable furniture and rustic accents invites inhabitants to stay in on a snowy day. The Allers look forward to quiet winter days spent together or catching up on different projects.

then slather milk paint on the rough surface: "We left the walls as rough as we could." Jeane made their lodgepole bed and a number of other furnishings and sewed a few quilts; her husband forged all the ironwork. Together they collected antiques and rag rugs, and they uncovered an iron bed that had been buried outside a ranch cabin for years.

This combination of old things, family heirlooms, and handmade furnishings makes their cabin enchanting, especially in winter. "Because we entertain so many people all summer, winter is a time for us to have our own life," Jeane noted. So when the snow falls, the Allers and Larry enjoy quiet hours in their rustic lair circled around a crackling fire.

"Sometimes I wish I had been born a cowgirl, some one hundred years ago," Jeane said. "If I could, I would choose to go back and live when there were log cabins and people rode horses all the time. I've always had an interest in that era."

ABOVE An old iron bed, discovered buried on the side of a dude cabin, fixed up nicely. Jeane Aller made the quilt to keep her guests warm.

RIGHT Handmade chaps by the Allers' daughter, Jordan, hang over an early piece of Western porch furniture from the ranch.

FAR RIGHT A poster of three 1920s rodeo cowgirls, Kitty Canutt, Prairie Rose, and Ruth Roach, reminds the owner of the era she would like to visit, when women rode bucking broncs and roamed the countryside on their horses.

Sierra Gold Mine

The rustic style attracts the person nostalgic for a simple way of life. Some know, however, that they couldn't have survived back when there was no electricity or running water and elk meat and potatoes were the staple. "Actually, I'd like to go back for a vacation, but I wouldn't want to be there a long time," said Ron Bommarito of Genoa, Nevada, once a busy supply town incorporated in 1851 at the foot of the Sierra Nevada. As a child, Bommarito took an interest in meeting the old-timers in California and Nevada. "I loved to talk to old guys who stashed gold nuggets under the beds," he said. "They used to sell me great things for five dollars."

But, for Bommarito, the stories were always more important than the money. Once he thrilled to meet a guy who had a gun that had been given to him by Buffalo Bill; he has also studied so many early diaries, journals, and photographs of people that sometimes he can recognize a stranger's face better than the stranger's relative can.

Bommarito moved to Genoa some twenty years ago because the historic town was close to the Sierra ski areas and rich hunting grounds for Old West antiques. "I bought some old buildings like one would buy an old gun," he said. "I like to buy houses that are completely unrestored," including his 1880s cabin.

Slowly, Bommarito fixed his place up, filling the small rooms with treasures from the past: an old stove from Virginia City, Indian baskets, a burly buffalo head, early pioneer portraits, cowboy spurs, gold and silver molds, and vintage miner's skis nine feet long. "I decorate with what I can, then I put some things in boxes if it gets too overwhelming," he said. An upstairs office turned into storage space for his first-rate collection of early photographs. Looking around at his jumble of things burying every inch of his home, Bommarito shrugs his shoulders and laughs, "All the history and no house."

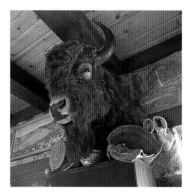

ABOVE A jumble of Indian baskets, a pair of beaded gauntlets, and beaded moccasins have settled below a buffalo head in Ron Bommarito's historic cabin in Genoa, Nevada.

ABOVE, RIGHT This early stove once warmed a mansion in the famous silver town of Virginia City, Nevada. Because his family is in the wine business, Ron Bommarito purchased the old-fashioned cooker embellished with grape designs.

ABOVE, FAR RIGHT These stairs lead up to a room overcrowded with collections of cowboy gear and a first-rate collection of vintage photographs. "It was sort of an office, but it just sort of got buried," Bommarito said. An exquisite black-and-white photograph of Virginia City by Carlton Watkins once hung on the wall of the Bank of California in Virginia City.

BELOW, FAR RIGHT A collection of antique silver and gold molds pile up at Ron Bommarito's doorstep.

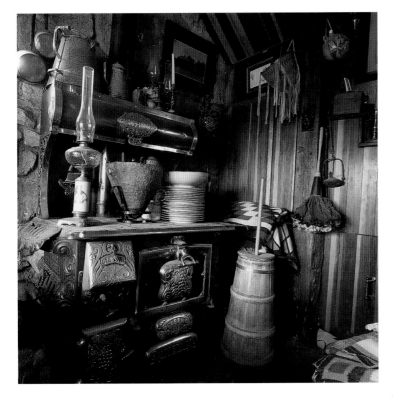

Mobile Mountain Homes

The historic value of an early log cabin attracted Kaidi and Bob Dunstan of Wilson, Wyoming. With help from Paul Kipp, they moved their home, a 1940s cabin from the Crystal Springs dude ranch, onto their property. "Moving wooden buildings is a common practice in this climate, particularly small cabins," Kaidi Dunstan said. "The corners are jacked up, a trailer slid underneath and off the cabin goes down the highway. Unfortunately poor luck and bad weather found the cabin on Paul's trailer stuck in a muddy hollow in the middle of the adjoining hay field. This meant abandoning the project until the following spring."

After the installation of the Dunstans' house, the place evolved in "spits and starts," Kaidi said. First a cozy home for a couple, the house became a shelter for a family of four. Pressed for space, the Dunstans chose to add outside buildings rather than disturb the integrity of the cabin structure. They built a bunkhouse for their children, and Kaidi moved a compact 1950s frame house onto the property and turned the building into her painting studio. Before the studio, Kaidi worked in her bedroom, where she stacked her canvases under the bed and propped them up around the bed, along all the walls, and in the closet. The seat of a small chair provided the only space for her husband's clothes.

The Dunstans' cabin style evolved over the years. For many years, a couple of sawhorses with two-by-tens laid across them served as a deck. Exterior plywood formed a workable kitchen countertop, which improved over the years with increasingly better materials and is now clean Formica. The interior style developed, as the old-timers used to say, "like topsy." The couple spent the 1980s building furniture for many Jackson Hole residents and, as a result, have accumulated a number of odd experiments and prototypes that mix with lodgepole furnishings and eighteenth-century English pieces.

Moving wooden buildings in the Rockies is a common practice. Some forty years ago, this cabin was moved from a dude ranch to the Dunstans' property. Since then, the cabin has been the home of the Dunstan family, whose eclectic style spans eighteenth-century English formal to lodgepole rustic.

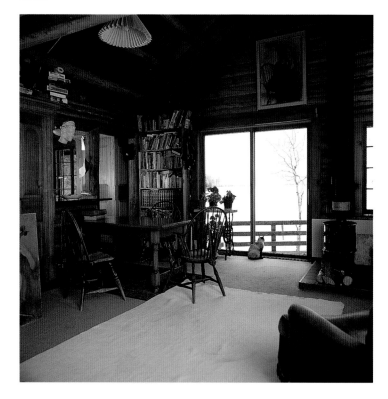

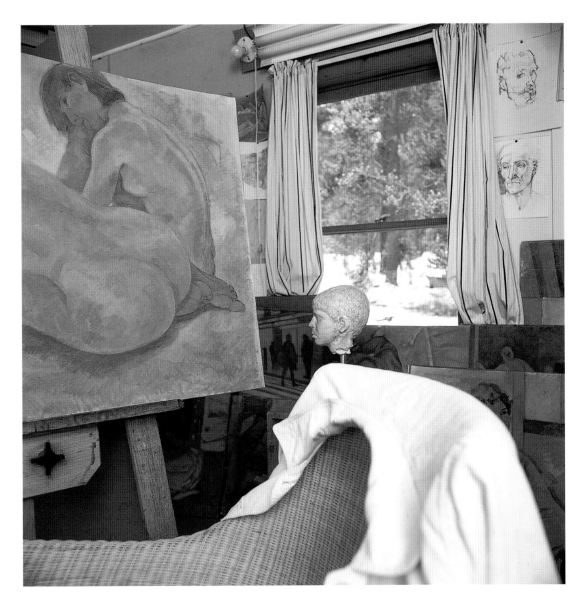

Painter Kaidi Dunstan of Wilson, Wyoming, acquired this 1950s building from a rancher down the road. The compact frame house that had served forty years of duty made the perfect studio.

"I don't think we intentionally strove for a simple rustic theme, but to attempt an overtly contemporary aesthetic in this old cabin would be perverse and frustrating," Kaidi said. "We are naturally somewhat cluttered in our habits and perhaps a rustic cabin wears clutter better than most."

Architect Jonathan Foote, well known in the Rocky Mountains for his rustic shelters built from recycled barns, stagecoach stops, and pioneer cabins, lives in a cabin built in 1911 on the Yellowstone River just outside Livingston, Montana. Like the Dunstans,

A Usin' Place

he appreciates the informal spirit of a cabin. Foote enjoys designing newer buildings for clients, but he prefers to live in this old house, probably once a ranch foreman's, because the building has soul. "I just love old things. They make me feel better. I think the cabin recharges some of my primal batteries," he said.

Foote, born and raised on the East Coast, moved to Montana because he felt more comfortable in the West than he did entrenched in his formal family life of finger bowls and "hot and cold running servants." As a boy, he visited the Rocky Mountains and worked on ranches. "I always felt better about myself out West," he said. "I was someone I liked being. It was who I really was."

In the early seventies, Foote packed his bags, sold his architectural firm, and trailered his cutting horses to Livingston. He left his three tuxedos and fifteen suits on the East Coast, packing only Levis and a few old shirts. Foote looked forward to living in "a usin' place," a place where he could kick off his boots and not worry about scratching the furniture. He also needed a barn, some horse pens, river access, and a property in close proximity to Montana State University, where he would be teaching architecture.

On a slushy Easter Sunday, Foote's cat pleads to come inside.

The cabin he discovered was perfect and needed little work. Foote remodeled the kitchen slightly and filled the home with a few family pieces and gifts. By no means was he swayed by fashion. "I don't decorate. I just put in things that I love," he said. "Everything from my son Nathaniel's paintings to my trophy belt buckles to the bobcat skin, and the old trunk from my other son—they all have meaning to me."

Although most of the original furnishings were removed from the home, two pieces remained: an old rocker and a pair of Angora chaps with a 1920s letter in the pocket from a cowboy to a friend "back East" that mentions "the new pretty school marm in town."

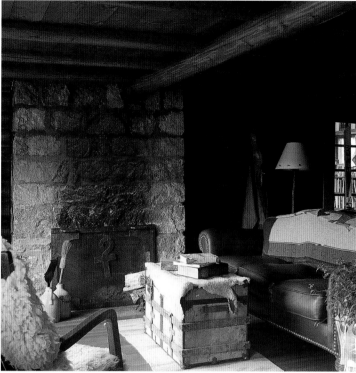

ABOVE Jonathan Foote feels more comfortable in a western cabin than he did in his luxurious family homes with "hot and cold running servants." A fifteenth-century English oak chest and an eighteenth-century English cabinet, full of gold-edged finger bowls (which Foote has never used in Montana), are equally comfortable in their rustic surroundings.

ABOVE, RIGHT A comfortable couch, a trunk, and an old rocker create a charming and simple interior. The old fireplace along with a small gas heater keeps the cabin warm in winter.

RIGHT A clutter of silver belt buckles awarded to Jonathan Foote for excellence in cutting horse competitions has become part of his cabin decor.

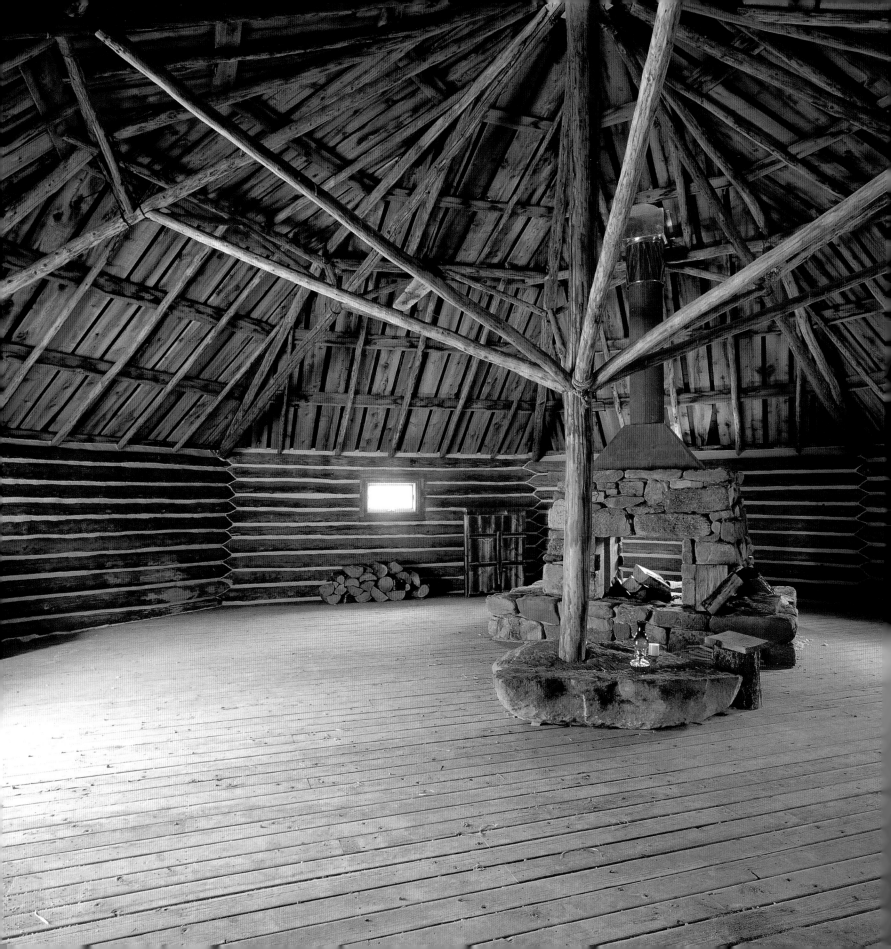

For Foote and many others, the primitive cabin is a romantic space because it is a relic from our pioneer past, which wasn't that long ago. As people like to say around the mountains, "Our history was yesterday."

Back at the Barn

Joy Smith of Livingston, Montana, built a comfortable ranch house, but she enjoys spending a night or two in what used to be a calving shed. Built in the 1920s by a cowboy, the octagonal structure stands without the support of nails. The cowboy builder fastened beams together with bailing wire and used tongue-and-groove slats for the walls. Originally he intended to remove the center pole, but he apparently changed his mind for fear the place would collapse. Smith discovered the rustic space provides a peaceful escape. She likes to light the fire, burn a few candles, sleep in a sleeping bag, and listen to the night sounds.

LEFT This building was originally designed to be self-supporting, with no nails, just tongue and groove. But the builder left the center pole in because he was afraid the building would fall.

RIGHT Originally a calving shed, this 1920s rustic structure now makes a simple weekend escape just outside Livingston, Montana.

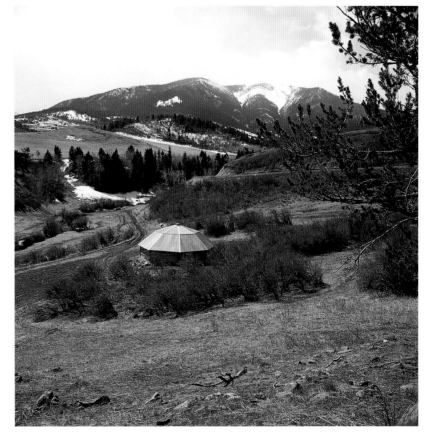

Bless This Lousy Trailer

When artist Greta Gretzinger moved to Wyoming she couldn't afford the traditional log cabin, so she moved into a trailer and painted it to look like a cabin, albeit pink with a painted image of Elvis waving out a small window at the front. Inside, a glorious clutter of objects crowds every available space. Barbie dolls, plastic dinosaurs, pink flamingos, and velvet paintings create a jumble of color. Her papier-mâché fish hang from the ceiling.

Living in a small place is "tight, tight," Gretzinger said. "I don't flail around much and I've learned to pivot on the balls of my feet." But, she is not complaining. She moved to Jackson Hole because she wanted to live on her own in a small place somewhere remote, but near a small town. "I wanted to live in a place where I felt involved with the place and the people," she said.

In the West, Gretzinger feels comfortable exploring her personal style. Even her traditional mountain car, a Subaru, doesn't escape her paintbrush. The hood features a painting of the Mona Lisa with the painted words, "Fish Where the Fish Are."

ABOVE A tin thrift-store treasure hangs above the front door and serves as a "welcome mat" of sorts.

ABOVE, RIGHT With a little paint, artist Greta Gretzinger transforms the conventional into something fun. Her Jackson Hole home and Subaru car attract photographers every day.

ABOVE, FAR RIGHT On chilly winter days, Greta Gretzinger holes up in her eccentric-style trailer. Warmed by a stove, she creates works of art like the papier-mâché fish hanging from the ceiling.

BELOW, FAR RIGHT Gretzinger likes incorporating an element of surprise and wonder into her haphazard design. A plastic iguana and a plastic Komodo dragon in her tub look real to an unsuspecting visitor.

BELOW, RIGHT An interesting collage shows off Gretzinger's flair and her joy in mundane objects and Elvis memorabilia.

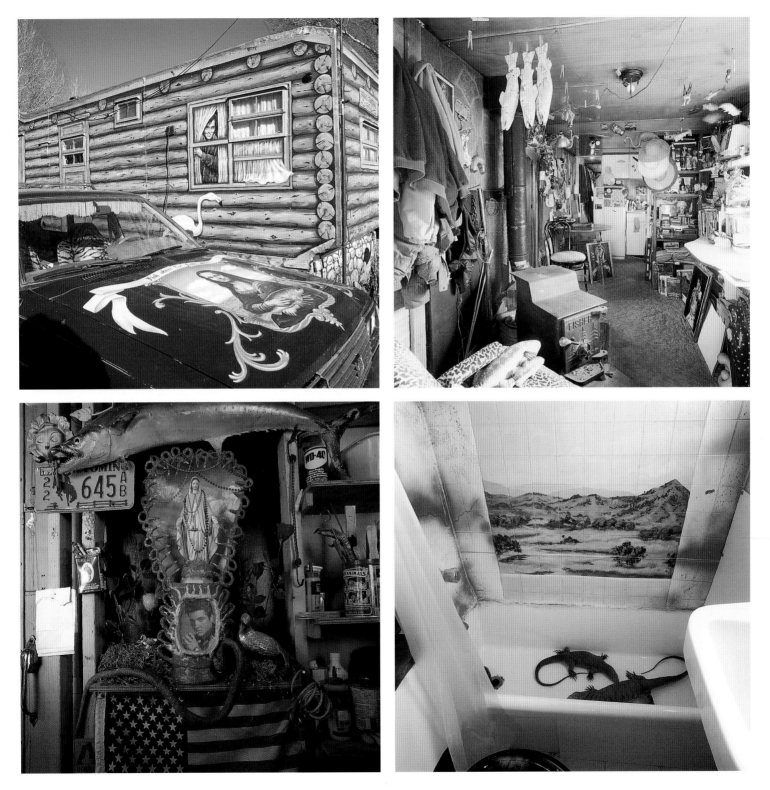

Some people chose the pioneer log cabin because the rustic space defies suburban conventions. "I've never wanted to live in a tract home and have a station wagon," said Corinne Brown, who moved to Mammoth, California, some twenty years ago to be a ski bum and live in a safe place. After she

Spare Parts and Odds and Ends

met her husband, Allen, they moved into a cabin surrounded by Jeffrey pine trees at the base of the mountain. It was an old log kit house, built out of "spare parts and odds and ends," Brown said. "It was the only house we could afford besides an A-frame."

After so many years in this modest place, the family still enjoys the rustic lifestyle. They cook on a 1950s cooker, split wood in the fall, and warm by a fire in a stone fireplace. At the heart of the ski season, they ski off their roof and through racing gates set up in their driveway.

An interior designer, Brown feels comfortable in her informal home, where she juxtaposes family antiques with more sophisticated treasures such as Chinese urns and silver candlesticks. In a rustic decor, there are few rules. Anything goes, and as one discovers there is little pretension in a casual pairing of a Chinese urn and a hand-stitched red-and-white quilt, a French couch in front of a river rock fireplace, and polished silver on a rough-hewn table.

FAR RIGHT When the Browns moved to Mammoth, California, the style was still A-frames, shaggy orange carpets, and avocado-green refrigerators. They opted for a cabin in a Jeffrey pine forest. Over the years, the interior evolved with antique finds and family heirlooms.

RIGHT The Browns discovered an unclaimed 1950s Okeefe and Merrit stove in a storage unit. The stove works beautifully in their Mammoth, California, cabin.

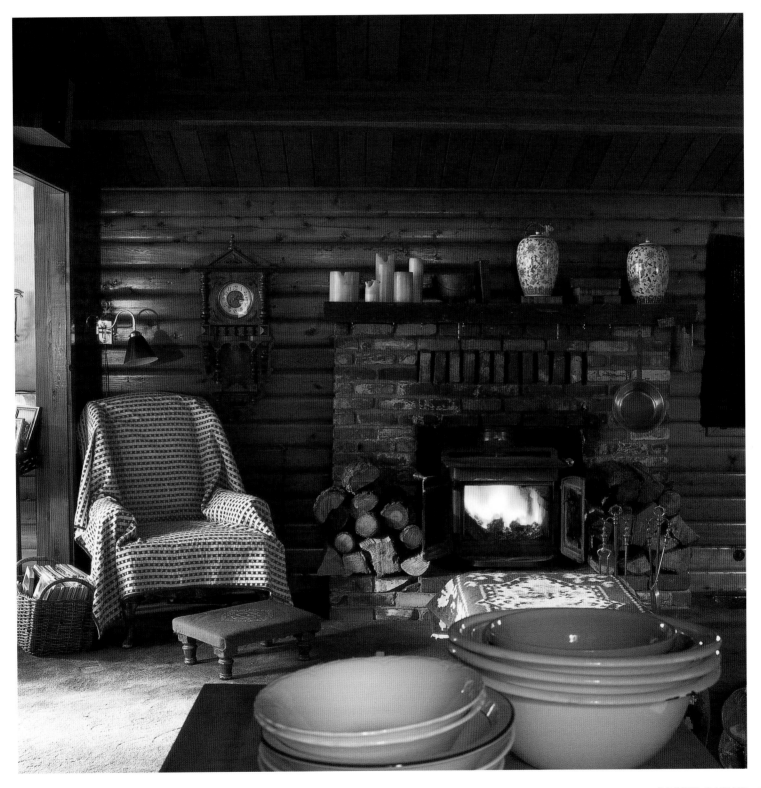

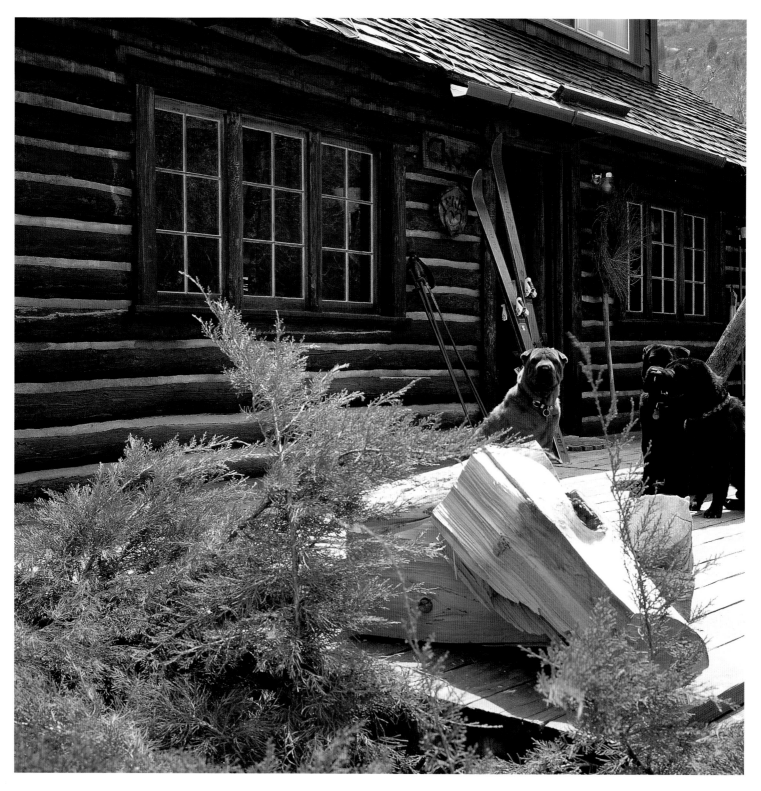

A Skier's Outpost

Longtime skier Lynn Christensen-Biddulph moved into a cabin near her favorite ski resorts, Alta and Snowbird, in the seventies. When she moved into an old miner's cabin that had been moved to its present site, sagebrush stretched from her doorstep for miles. Christensen-Biddulph loved the intimacy of the cabin, the fact that her dogs could chase rabbits across the prairie, and knowing that she could be at the ski resort in fifteen minutes. Unfortunately, in the last few years, expensive homes, which are regulated by neighborhood policies, have infringed on her space. Despite this change, Christensen-Biddulph holds on to her cabin for sentimental reasons.

LEFT Lynn Christensen-Biddulph enjoys the simplicity of her miner's cabin, fifteen minutes away from popular Utah ski resorts Snowbird and Alta. Christensen-Biddulph and friends were some of the first skiers to try Millers, the first "fat skis" for powder.

RIGHT Cottage industries are popular in the mountains because people find they can work on their own time. For a while, Christensen-Biddulph designed fashionable dog collars like the ones hanging in her cabin.

Patty and Doug Campbell of Wilson, Wyoming, loved the romance of a Western home, but they chose not to copy an old home exactly. After staying in a rustic log cabin in historic Atlantic City, Wyoming, the couple was determined to build their own pioneer-style log cabin.

Cottage Dwellers

"The cabin in Atlantic City touched my soul," Patty told me as we sipped wine along the grassy banks of Fish Creek in her backyard. "My husband and I are also cottage dwellers. We like small spaces." By keeping their cabin only three rooms and a bath, the Campbells re-created the intimacy of that Atlantic City cabin, but modern touches made their home more livable. Windows in all the walls, a vaulted ceiling with trusses, and bead-board walls, an old-fashioned style of paneling, give this cabin some light and space that its traditional predecessors lacked.

Patty admits decorating a small space can be a tortuous process, noting, "The pieces have to look nice and be functional. And they have to be able to store things." So she chose carefully, accumulating a few significant pieces: comfortable couches, a Gustav Stickley sideboard, a hand-me-down coffee table, and a collection of vintage photographs by Jackson Hole photographer Harrison R. Crandall. "I don't like too much clutter," she said. "I think more clearly in a more simple environment."

The Campbells opted for only a few Western accents, such as a vintage creel, baskets, and a dry-stacked stone fireplace. "I like the Western style," Patty said, "but I don't know if I want to live around it. It's pretty clunky."

The Campbells relish winter in their cabin. Most mornings they awake to moose munching on willows in their backyard. Some days, the Campbells don't bother to leave their place. "It is a fantasy that has come true and I like to be wrapped around it," Patty said.

ABOVE, RIGHT From this window seat the owners can enjoy watching moose in their backyard. After a snowy, frosty night, the Campbells like to sit and enjoy the sun rise over moose munching frosty willows.

BELOW, RIGHT Bead-board walls and a vaulted ceiling give this traditional-style log cabin, designed by architect Stephen Dynia, a comfortable modern touch. The two couches are covered in a fabric from the English company Bennison. The floors are ash. "I already had too much pine in the house to do the floors in pine too," Patty Campbell said. A Japanese tansu chest provides a bit of storage.

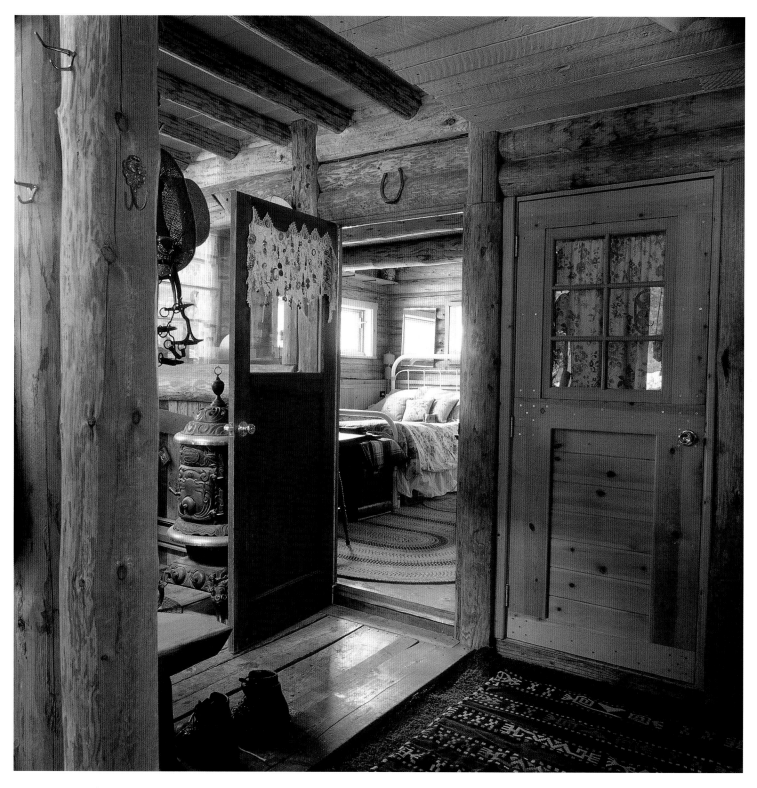

Work in Progress

While people in remote areas can have as modern a home as they want these days, there are still those like Foote and the Campbells who prefer a simpler interior. In high school, David Shideler dreamed of building a log cabin in Idaho. When he purchased a piece of property at Smiley Creek in 1981, forty-five minutes from the popular Sun Valley ski resort, his mother thought he was crazy. Especially when he told her he wanted to build the place all by himself.

For the first winter, Shideler lived in the basement of his building, enclosed with plastic, eating cold beans for dinner. On particularly frosty and lonely days, he drove to a nearby lodge and drank coffee and wrote postcards. Eighteen years later, David and his wife, Karen, are still working on their place.

"We never seem to have time and money at the same time to finish a project," said David. But, after spending time with this couple, one realizes the unfinished project is part of the house's charm.

"Won't it be nice when this place is done?" Karen said.

Cocking his head slightly, David grinned. "Done? I never really thought of our home in those terms before."

Much of the Shidelers' home is recycled. Looking around the place, David points out Buster Back Ranch's ceiling, neighbor Lois Glen's deck, and Karen's grandfather's windows. Even the wood for the twisted banister came straight out of the nearby forest. "I like to putter away at my project," said David, leaning against a pile of floorboards for the kitchen.

Living in a work zone doesn't interfere with the Shidelers' mountain lifestyle. "It's almost like a celebration when we first get snowed on," David said. One winter when their snowmobile broke down, they let the snow bury the machine. For the rest of the winter they walked, pulling groceries on a sled.

An iron bed, a rag rug, and lodgepole walls create a pioneer fantasy. The Shidelers lived in this room for years before they got around to building an upstairs.

When the couple isn't busy working, they spend days telemarking in the back country. As an antidote for loneliness, they often get together with their twenty-five neighbors. With so few neighbors, no one feels they can leave anyone out. One year, Smiley Creek residents gathered for a potluck. Unfortunately, they had all been snowed in for days, so every entrée was some kind of potato dish.

Despite difficult living conditions, Smiley Creek residents thrive on camaraderie. Around the holiday season, residents gather to sing carols. Because the town is so small, some people carol while others have to stay home and listen. One winter when the temperature dropped to forty below, the caroling group gathered around one resident's telephone, and they called the at-home neighbors and sang songs into the receiver.

For many like the Shidelers, a rustic lifestyle in the mountains is rich with a quirky, down-home atmosphere that makes living in a rural cabin a dream.

Curvy sticks from the local woods make up this distinctive stairway. "We like to wander in the woods," David Shideler said. "It's fun to go out and find pieces." The exposed worm tracks on the wood remind the owners of Egyptian hieroglyphics.

BELOW Inspired by these two stained-glass windows from the Gold Mine, an antique store in Ketchum, Idaho, Shideler built a door around them. This small entry leads to a loft that was once an office and is now a cozy music room.

ABOVE An unfinished kitchen, in need of flooring and some cabinets, holds the promise of something to do on a snowbound day. Old colorful table-cloths hide the kitchen shelves beautifully.

RIGHT Big Guy, the cat, crosses the railing of an upstairs bedroom balcony that looks out over the Pole Creek and Boulder Mountains to the east. "You kind of move to the rhythm of the seasons. It's really beautiful to watch the snow blanket the area," said Karen Shideler, who looks forward to winter.

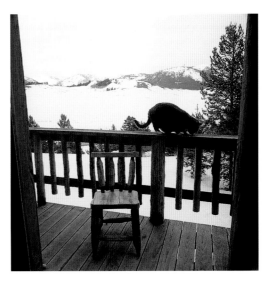

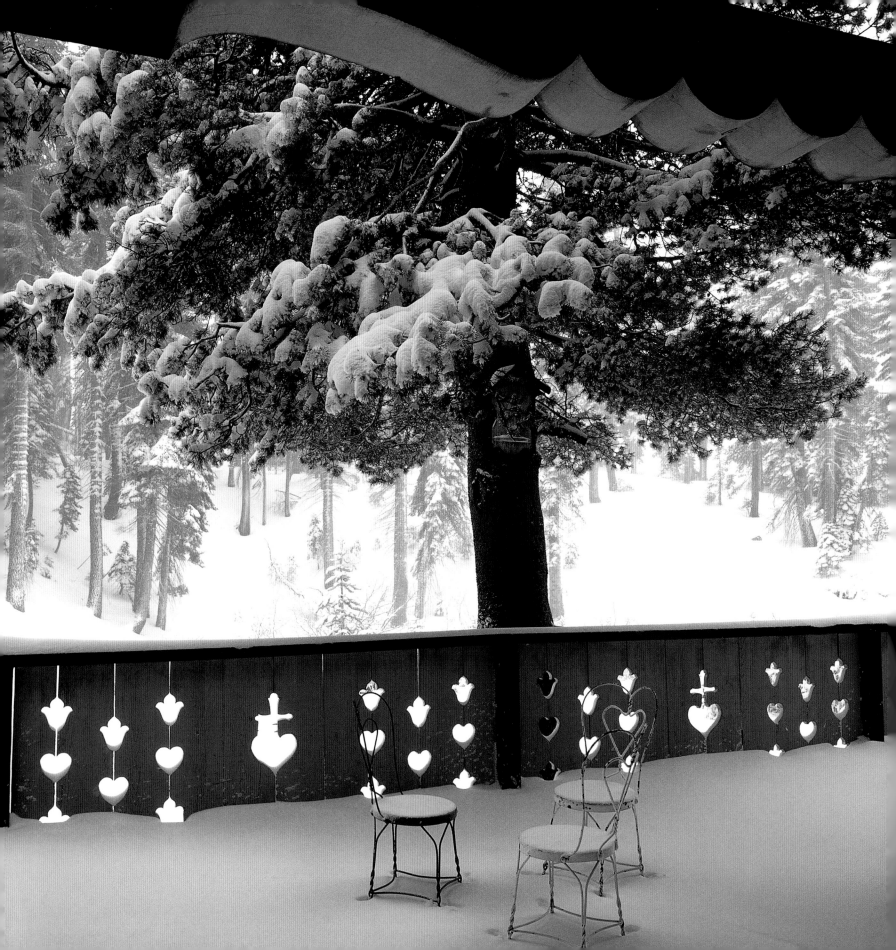

Walt Disney and a handful of investors created Sugar Bowl, a magical Tyrolean enclave near the famous Donner Summit in California's Sierra Nevada. In the 1940s and 1950s, the lodge, modeled after the classic Hotel Solaise in the French Alps, bustled with Hollywood stars including Claudette Colbert, Errol Flynn, and Greta Garbo. The deck provided a place to see and be seen. When Tyrolean music played from the lodge's front porch, skiers felt like they were in the middle of Kitzbühel.

To enter Sugar Bowl, skiers still arrive at the small town of Soda Springs, then travel to the resort on a red gondola called the "Magic Carpet." Inside the resort, skis and snow cats provide the only modes of transportation. The first homes, simple chalets with scalloped roofs and painted ski scenes on exterior walls, are hidden in the pine forests.

The first Western ski resorts resembled European villages because the ski pioneers of resorts such as Sugar Bowl, Sun Valley, Aspen, and Vail grew up skiing in Europe. Founders hired European architects to help design lodges and often pedestrian-style villages. In keeping with the alpine theme, the first homeowners built modest chalet-style houses, surrounding the resort.

For the most part, the first ski homes were vacation retreats. European antiques mixed with "leftover furniture," as Dorothea Walker called extra furnishings from her main residence. A simplicity of style pervaded. The houses required little upkeep. When the season ended, owners boarded up the windows and doors of their homes, leaving them unoccupied for the remainder of the year.

While there are still a number of these original chalets, today the typical ski house has become much more grand. Perhaps because people spend more time skiing and feel they need more

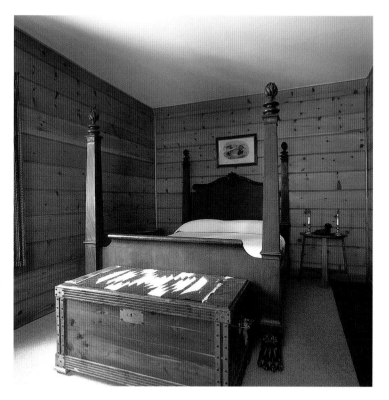

ABOVE A four-poster bed, a family treasure, has been in the Jones' house in Sugar Bowl, California, for more than fifty years. Simple furnishings distinguish the early Sugar Bowl chalets from the newer homes.

RIGHT The early ski resorts embraced a European style. Inspired by painted buildings in the Alps, this Sugar Bowl exterior features a whimsical snow scene.

PAGE 68 In Sugar Bowl, California, a fresh snow blankets the front porch and three old-fashioned ice-cream chairs. During the springtime, the porch makes a lovely place to eat lunch after a morning ski.

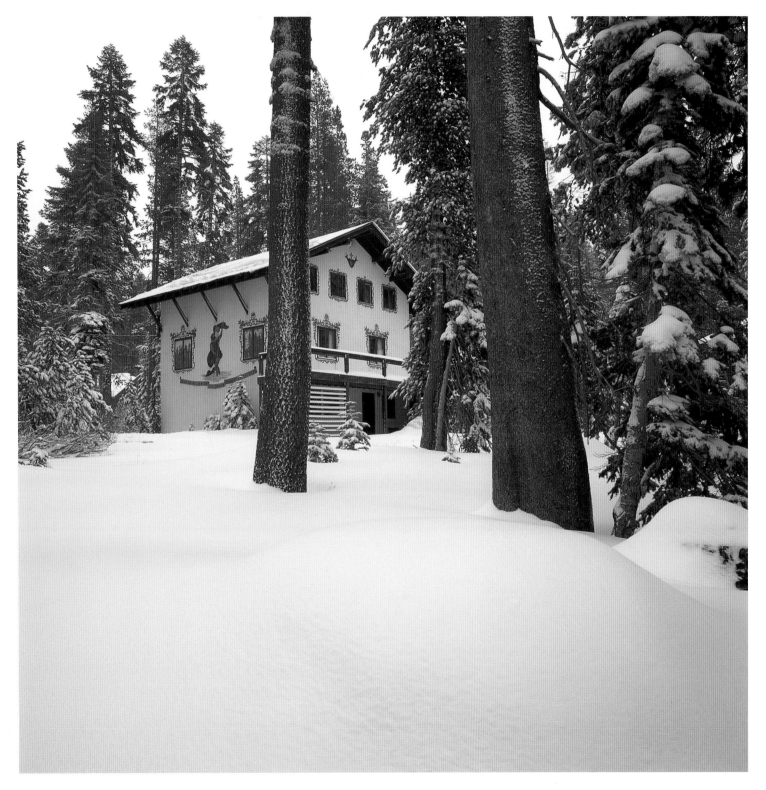

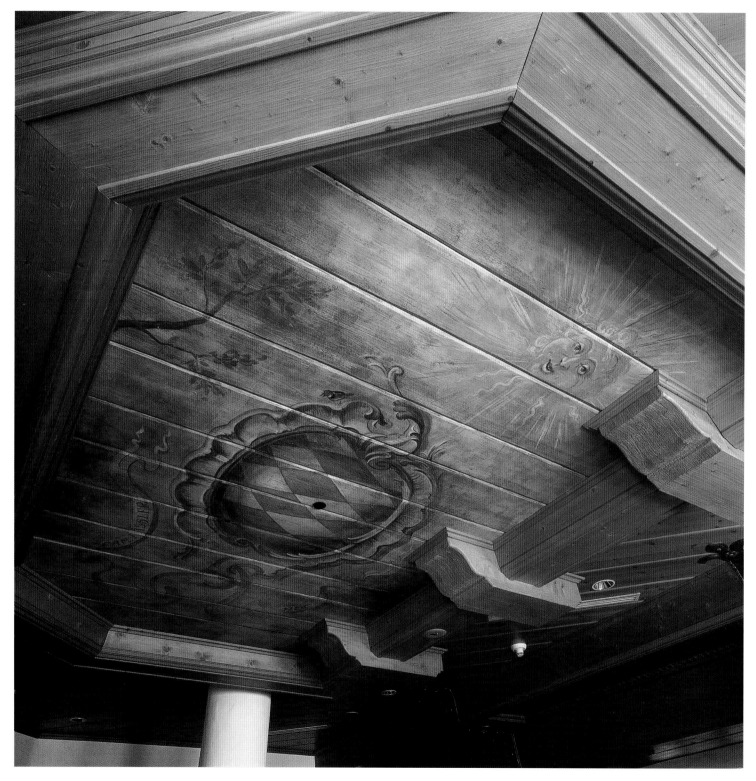

LEFT This painted wood ceiling in the dining room at the Sonnenalp, a popular hotel, was executed by an artist from the small Bavarian town of Garmisch. Several others like these decorate the hotel.

BELOW Chalet-style homes in Sugar Bowl create a magical ambience around the resort. Most of the early homes were small and functional. Homeowners easily boarded up their homes in summer, leaving few precious things behind.

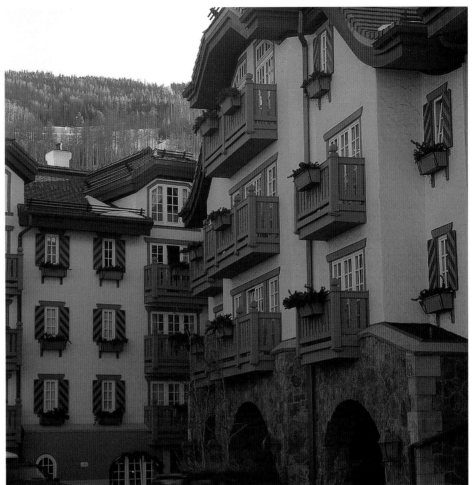

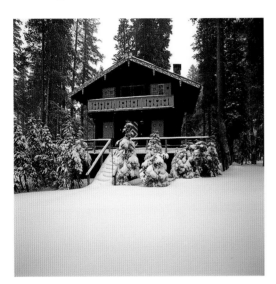

ABOVE In 1992, Yonis Fessler remodeled his prestigious Sonnenalp hotel to create a more alpine feel. Born and raised in the Bavarian Alps, he chose to imitate his hometown style.

LEFT A wooden sculpture of a skier stands on a porch of a Park City house. In this Utah ski area, a network of trails from houses connects skiers to the chairlifts.

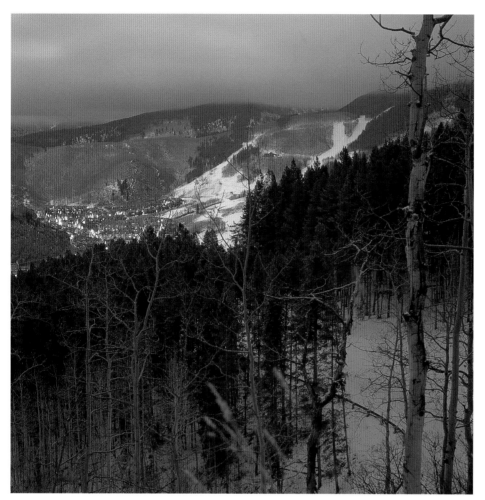

BELOW "I don't like to walk into a house and have it look like everything was acquired at once," said the owner of this Beaver Creek, Colorado, home. The residence is a work in progress, featuring antique German shutters, an eighteenth-century walnut linen cupboard, and an old telescope. The owner designed the clock, with antique iron hands from France set on a face painted by a local artist. The time is set permanently at five to seven to remind the owner's husband when she'd like to see him home.

ABOVE Beaver Creek, an exclusive resort that was built next to Vail, Colorado, in 1980, has a village atmosphere. After skiing, winter revelers like to congregate around a centrally located skating rink.

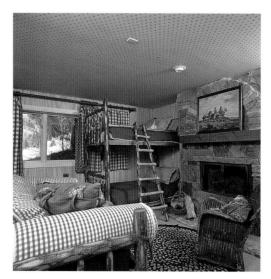

LEFT Lodgepole beds and bright fabrics create a comfortable and virtually indestructible children's room in Park City, Utah.

RIGHT This great room in Park City, Utah, can accommodate a number of tired skiers. Because the kitchen and living area are all in one room, the cook doesn't miss out on après-ski conversation.

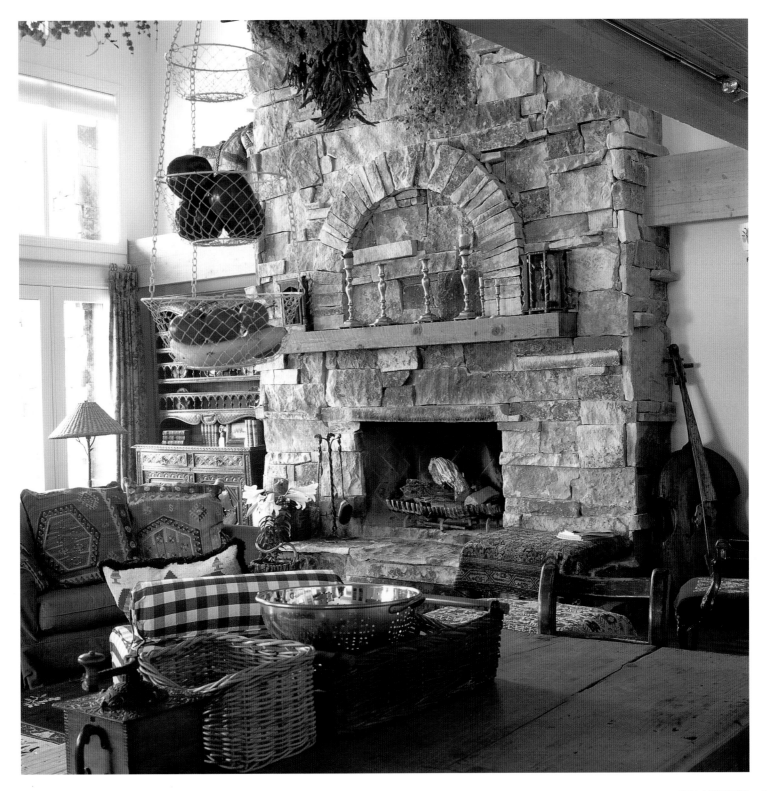

room for family and friends, the ski house has grown into a spacious first or second home. One homeowner admitted that her ski home is more formal than her main residence.

One of the trends is to have a great room, which usually encompasses the living and dining areas and often the kitchen. This room provides ample space for entertaining family and friends. New ski homes also allow for many guest rooms, as well as a large mud room for changing in and out of winter gear. Interior styles vary from European to country to contemporary.

Despite the varying styles, Western ski homes for the most part emphasize a casual, comfortable atmosphere. There are exceptions, of course, especially in Aspen, where discothèques and Louis XV furnishings can be found. One Sun Valley resident indulged himself with an elevator. Apparently, the gentleman of the house loves skiing, but he has brittle bones, and they keep breaking when he falls on the slopes. Rather than stop skiing, this die-hard skier installed an elevator to hoist himself into his house and onto the second floor after a ski accident.

ABOVE In winter, the views of California's Lake Tahoe are pristine.

LEFT Scott King grew up in Pasadena, California, where Craftsman-style homes are fashionable, so when he purchased a home in Mammoth, he chose this traditional American style. A historic image of Mammoth hangs above an Arts & Crafts bookshelf and vintage Arts & Crafts chair. The rug and stained-glass door are in the Craftsman style. The walls are a combination of mahogany and fir.

Ski In–Ski Out Chalet

Ellie Newman and George Caulkins met in St. Anton in 1962. Four days after one enjoyable dinner, Caulkins asked Newman to marry him. "We met on a Friday, and he asked me to marry him on a Wednesday," Ellie said. She and George were wed two weeks later in Zermatt, where the bride and bridesmaids wore dirndls and snow blanketed the town.

That same year, Vail, a European-style ski resort with a pedestrian village, opened in Colorado. George Caulkins, one of the original founders, with the help of Peter Seibert sought financial backing for the resort. "Ski resorts were risky then," George said. After much struggle, Vail opened. "We didn't have any snow until the last minute, which was good because the lifts weren't quite finished," he recalled. But when the Olympic ski team showed up at the end of December, "we had this wonderful deluge of snow. Someone must have been doing an Indian dance or something."

The Caulkinses, as well as many others who experienced skiing in Europe, chose to impart their passion for European style in the new Western ski resorts. With the help of the late architect Fitzhugh Scott, Ellie and George built an Austrian-style chalet at the base of Vail Mountain.

The Caulkinses' chalet, with its scalloped Swiss roof, epitomizes the spare but comfortable ski chalet and requires little upkeep. Durable wood floors withstand heavy foot traffic, and there are no curtains to collect dust. The Caulkinses' children sleep in an upstairs bunkroom. Downstairs, the family gathers around a large fireplace, and when dinner is served they balance their plates on their knees. The furnishings are simple. A few pieces came from Norway, old skis decorate the wall, Swedish shutters accent the building, a French armoire from the early 1900s sits in the living area, and a bumper pool table takes up the basement. "It's just a mixture. We put in a little bit of this and a little bit of that," Ellie said. On a recent house tour, the Caulkinses overheard one of their guests exclaim: "Wow, it looks like people actually live here, instead of looking like a furniture showroom."

Inspired by many ski trips to the Alps, Ellie and George Caulkins built an Austrian-style chalet at the base of Vail Mountain in Colorado. They built a simple home that would require little upkeep, because they prefer skiing to cleaning house.

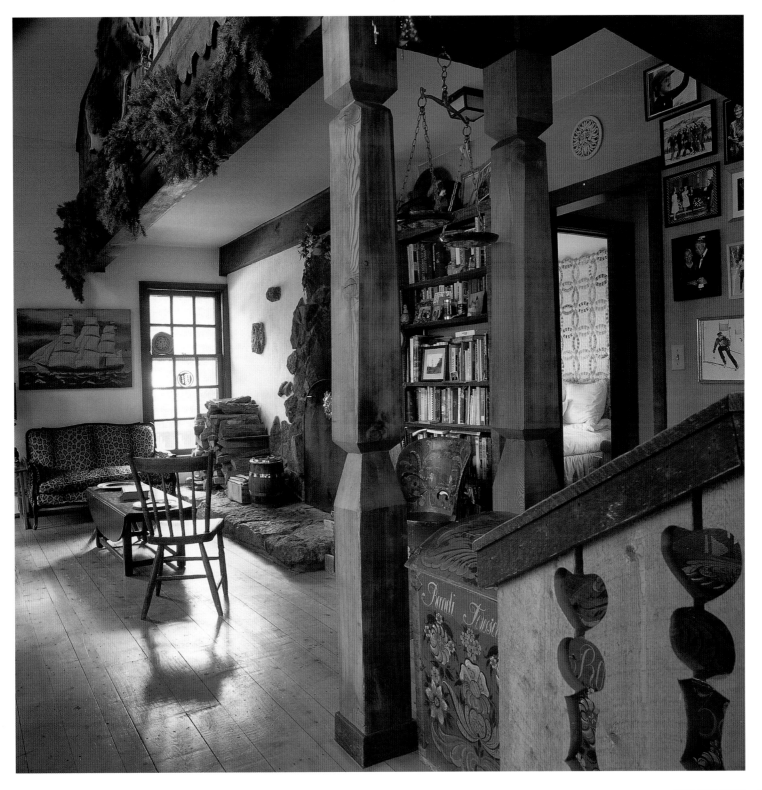

A Snowy Shangri-la

Celia Cummings, the daughter of Dr. Gerald Gray, owns one of the first chalets in Sugar Bowl. An avid skier, Gray explored Sugar Bowl Mountain before the area became a resort. Throughout the 1920s and 1930s, he often climbed to the top of what is now called Lincoln II on skins attached to his skis, then skied the backside of the mountain to Truckee, where he and his friends would take a train back to Soda Springs.

Shortly after Sugar Bowl opened in 1940, Gray built his house in the style of an Austrian chalet. The home includes several small bedrooms with bunks and a main room where skiers congregate around a warm fire on sunken benches, covered in brown and white cowhide. Gray hired an Austrian artist, who, inspired by a vintage fairy tale, painted whimsical murals of deer and a hunter in a magical forest. A wide-open deck, perfect for an afternoon lunch, stretches toward Sugar Bowl Mountain.

Cummings returns to her father's home every year. She grew up skiing at Sugar Bowl, as did her children and now her grandchildren. After a day of skiing, the Cummings family still hang their wet socks and ski pants by the fire, and in the evening, roast marshmallows between the wet clothes. And with any luck, someone plays the piano. One year the power went out and the Cummingses roasted Cornish game hens in the fireplace; another Christmas they were snowed in and made popcorn and cranberry decorations for the Christmas tree.

"It was a wonderful Christmas," Celia Cummings said.

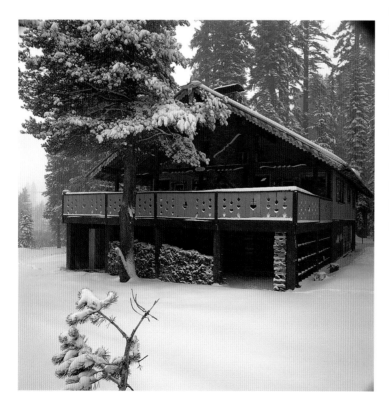

The Gray house faces Sugar Bowl Mountain in California. A thick lodge-pole pine tree forest creates a magical setting for the house.

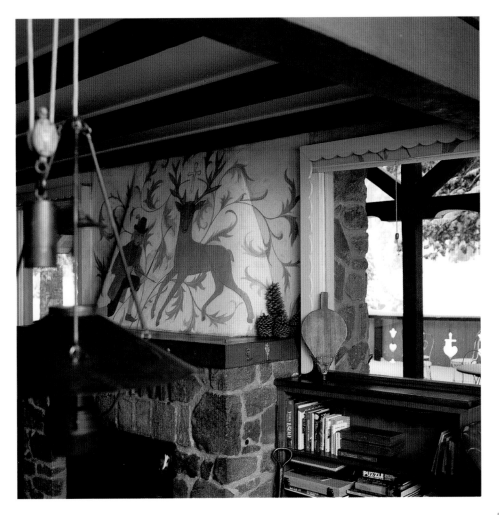

LEFT An Austrian artist, inspired by a fable, painted a hunter and deer on the hood of this old fireplace, which on many evenings is covered with dangling wet socks.

BELOW The Cummingses enjoy inviting guests to their chalet, especially if they play the piano. On occasion, if they invite too many people, a child will sleep under the instrument. The cowhide seats also provide a cozy resting place in front of the fire.

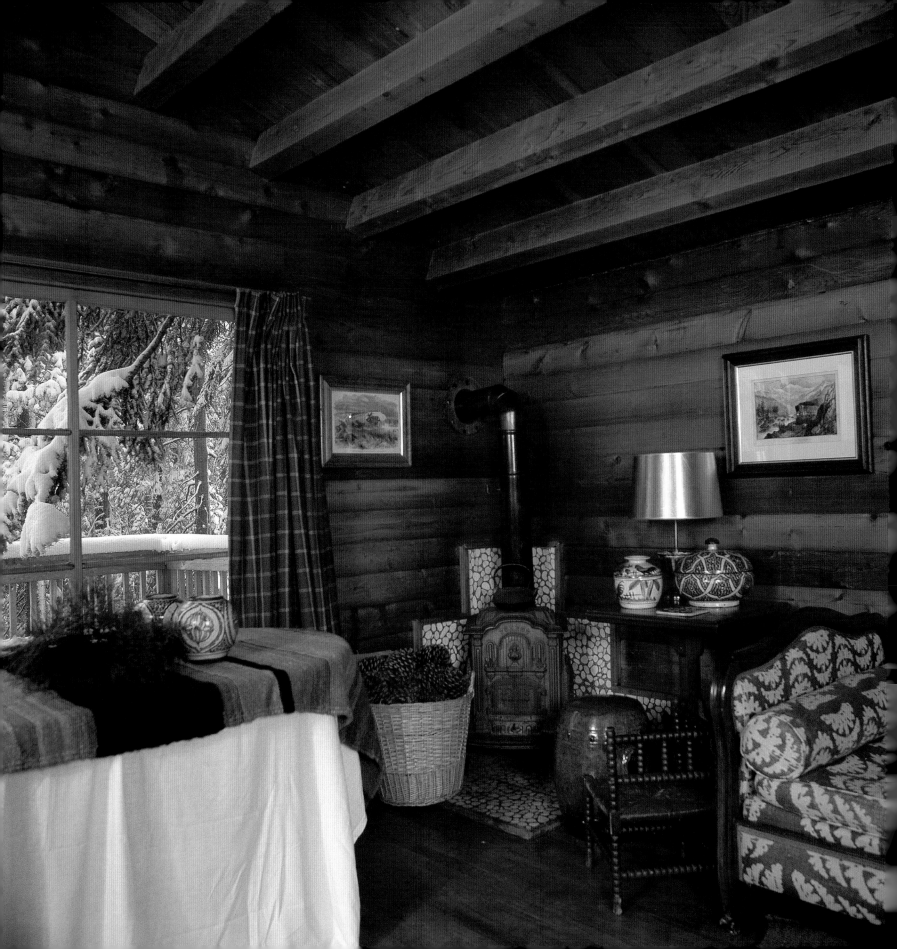

Inspired by the quaintness of Sugar Bowl, the Cummingses' neighbors, the Walkers, part of the original founding group, built a do-it-yourself, precut house in 1939. They wanted to build a simple and easy-to-maintain home without spending a fortune. The initial kit included numbered cedar logs and cost the Walkers $2,490. By the time they finished, they had spent less than $10,000 for a family ski house that still accommodates the same family of skiers.

A Cozy Igloo

Building an eight-foot-tall basement to ensure that their first floor was above the snow was the most challenging aspect of the project. The house itself had to be constructed board by board. Cedar boards fit together with a tongue-and-groove joint along their length and a locking corner joint. "In three hours, three men had half the walls up," Dorothea Walker wrote in *The American Home* magazine in 1956. Happily, installing the plumbing, heating, and hot-water heater, building an enclosed porch, insulating the roof, and doing the electrical wiring went smoothly. "The high point in our building program was the day the electricity and the furnace and the water were turned on," Walker said.

A Franklin stove in the corner and a terrazzo floor and walls are features of this 1939 precut house in Sugar Bowl, owned by the Walker family. The daybed is French Provincial.

Friends were skeptical about the quality of the Walkers' precut house and wondered whether the home would withstand a Sierra winter, which can see more than 500 inches of snow. "A Russian contractor who was in charge of construction on a large house down the slope walked over to inspect our progress," Walker recalled. "He pushed back his knitted skull-cap and put his hands on his hips. 'So stronk,' he said, 'like izbushka. In Siberia.' I shuddered, visibly. 'Izbushka,' he explained, 'was in my day, something like a cozy igloo.'"

Once the structure was up, Walker tried to keep the interior simple. She started with what she called "leftovers," furnishings that had gathered in her San Francisco basement, such as old blue leather office chairs for the dining room and hand-blocked linens for the guest room. "Because these leftovers kept pulling me back to a starting point, I feel that they were a godsend," she wrote. "They prevented my veering off toward those just-the-thing-for-a-mountain-cabin purchases."

The Walkers still enjoy their modest ski home. "Housekeeping is reduced to a minimum. There's not a wasted step in any direction. Our house is a delight, winter and summer," Dorothea said.

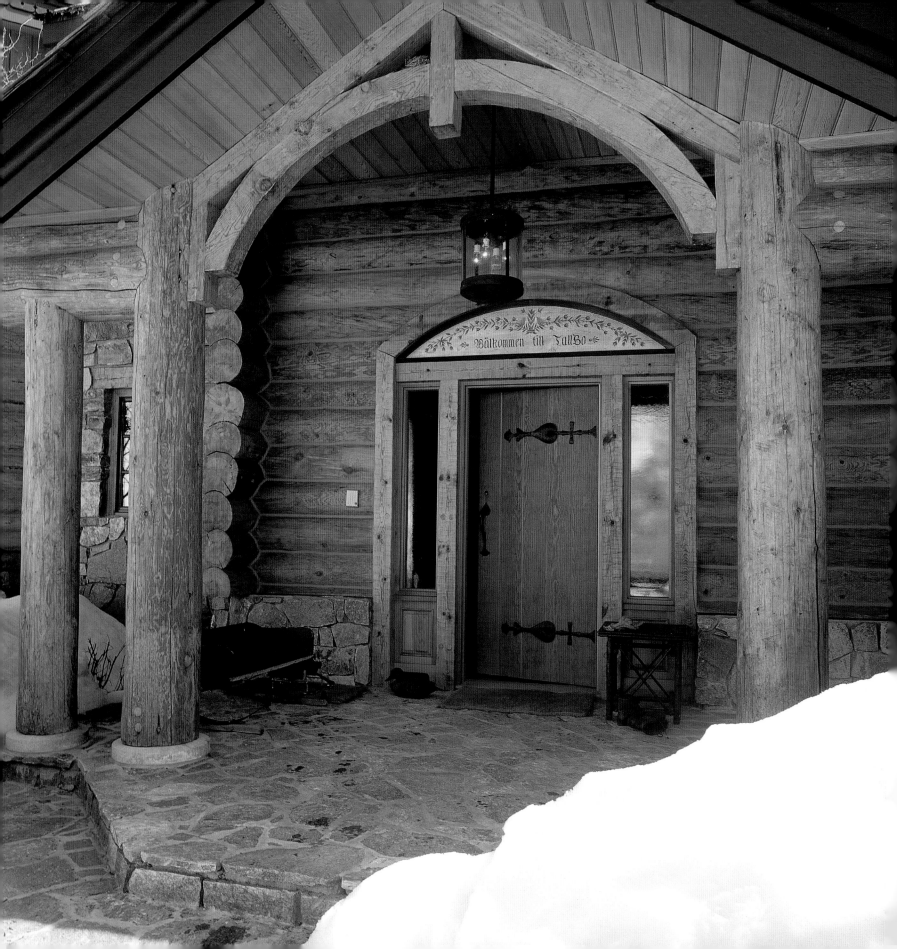

Völkommen till Tallbo

A family who moved from Chicago seeking a more relaxed life in the Rockies found it in this Swedish-inspired log home in the heart of a pine forest in Jackson Hole, Wyoming. From the start, this family wanted a mountain hideaway where they could enjoy a slower pace of life. Working in the hectic business world, they desired a quiet place to go where they could enjoy the outdoors.

While researching log cabin construction with their architect, Janet Jarvis, this couple, who had European roots, discovered that Swedish immigrants pioneered building cabins in the Rockies. They constructed them using a technique that allowed the logs to be fitted together so neatly that no space was left between them. Deciding what to do with the interior proved more of a challenge. The couple considered several styles, but in the end felt that a traditional Swedish house should have an interior to match. By using painted furniture, colorful gingham curtains, and Swedish bunk beds for their grandchildren, they found they could celebrate their own heritage as well as that of Wyoming.

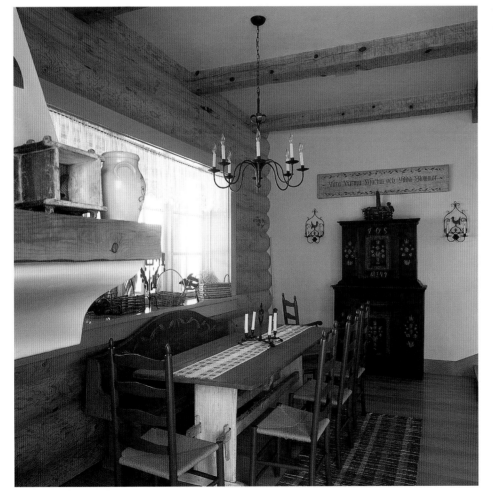

FAR LEFT The Swedish inscription above the front door means "Welcome to a nest in the pines." Nestled in a forest of pine trees, this home is just a few minutes from the Jackson Hole ski resort.

LEFT A traditional Scandinavian table and cupboard furnish this Jackson Hole, Wyoming, kitchen. A corner fireplace provides warmth in winter.

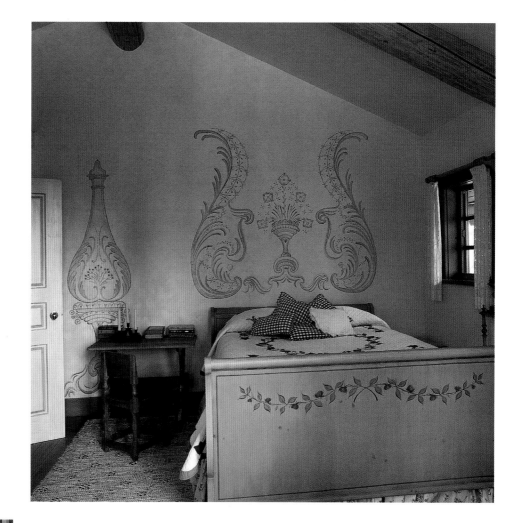

RIGHT Swedish architect and designer Lennart Stense, noted for his restoration projects, painted the bed and wall.

BELOW Bluebirds adorn the doors of the main bedroom at the Tallbo House in Jackson Hole, Wyoming.

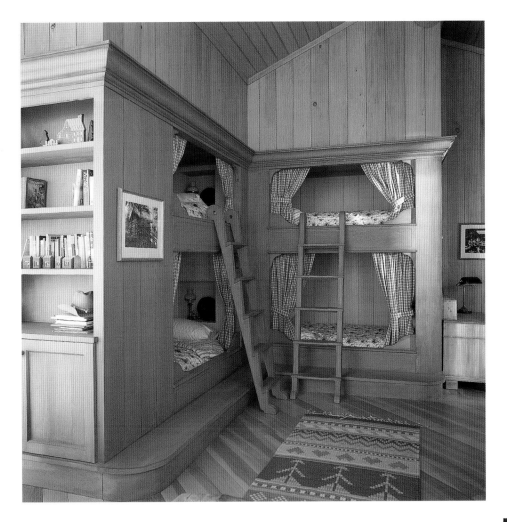

LEFT Traditional Swedish bunk beds are the focal point of the grandchildren's bedroom.

BELOW A grand dining room accommodates a large family and inevitable guests over a ski vacation. "I love this room when the candles are lit and the fire is going," the owner said. The table and chairs were inspired by a picture of Swedish artist Carl Larsson's desk and chair, while the custom-made rug features Swedish woodcuts and the chandelier incorporates traditional ironwork designs.

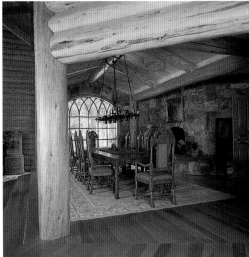

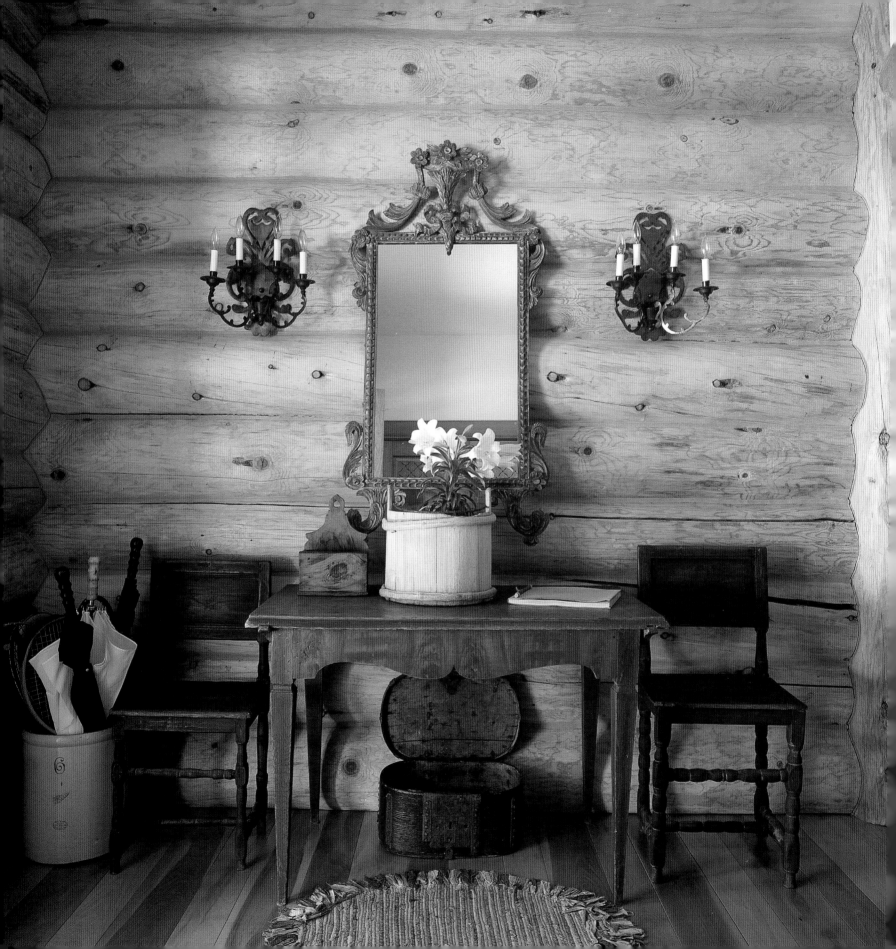

ABOVE A balcony decorated with a playful pig sculpture and the American flag faces a forest of Douglas fir and Rendezvous Mountain in Jackson Hole.

LEFT Opulent pieces are placed with more primitive items in true Swedish style in the entrance hallway.

With the help of designer Marcia Morine, the couple developed the elegant look of a nineteenth-century Swedish home. They drew their inspiration from works by the painter-illustrator Carl Larsson, which feature his own home in Sundborn, Sweden. Larsson's paintings of family dwellings show how the opulent style of Swedish castles and manors during the late 1800s can be adapted to a simpler environment. Informal homes can be made comfortable and elegant with rustic chairs placed sparingly, cheery checked fabrics, and symmetrical arrangements.

When the home was finally furnished, the family christened their beloved refuge by placing the words *Völkommen till Tallbo,* meaning "Welcome to a nest in the pines," above the front door. This promises everyone a magical stay in a home that, as the owners say, "transcends time and place."

Après-Ski Retreat

While Leslye Sugar's ski home doesn't resemble European architecture, her interior is French country. "We just love the Rockies. They gripped us," said Sugar, who lives in Arrowhead, a community next door to Vail. "We never were interested in the cowboy look of antlers, Ralph Lauren plaid, and fur."

Instead, she and her husband, who have always loved France, created a fireplace that looks like French rubble or old mortar. They painted floors and hung their collection of unusual vintage ski posters. French curtains and a variety of brilliant fabrics create rich patterns in their home. A rustic chandelier with a bracelet of crystals lends a touch of "rustic refinement" to the dining room. Sugar painted all the walls brilliant colors, because color warms a house in winter, unlike cold white.

Like the Caulkinses, the Sugars built a home that wasn't too difficult to maintain. "We built our home to live in. We didn't get carried away," Sugar said. "You can put your feet up on everything." And her Maltese, Cloe, and Cloe's brother, Rocky, are allowed on the furniture if they'll sit pin-sharp-still for the photographer.

ABOVE, RIGHT An early Chamonix ski poster looks great on this brilliant magenta wall. Because winter can be so long in the Rockies, Leslye Sugar opts for cheery walls rather than plain white, which can be gloomy on short winter days.

ABOVE, FAR RIGHT A rusted chandelier with a bracelet of crystal creates a wonderful ambience of rusticity and refinement in this intimate dining room. The French poster features famous turn-of-the-century French singer Mistinguett.

BELOW, FAR RIGHT A Wilton English wool carpet, French chintz, and a duvet tied up with white ribbon create a warm bedroom in Leslye Sugar's house.

BELOW, RIGHT Leslye Sugar's Maltese, Cloe and Rocky, pose on a blue wingback chair for the photographer in a country French–style living room. The mantel resembles mortar often found in old country houses. Majolica plates and a colorful cloth over the mantel brighten this room.

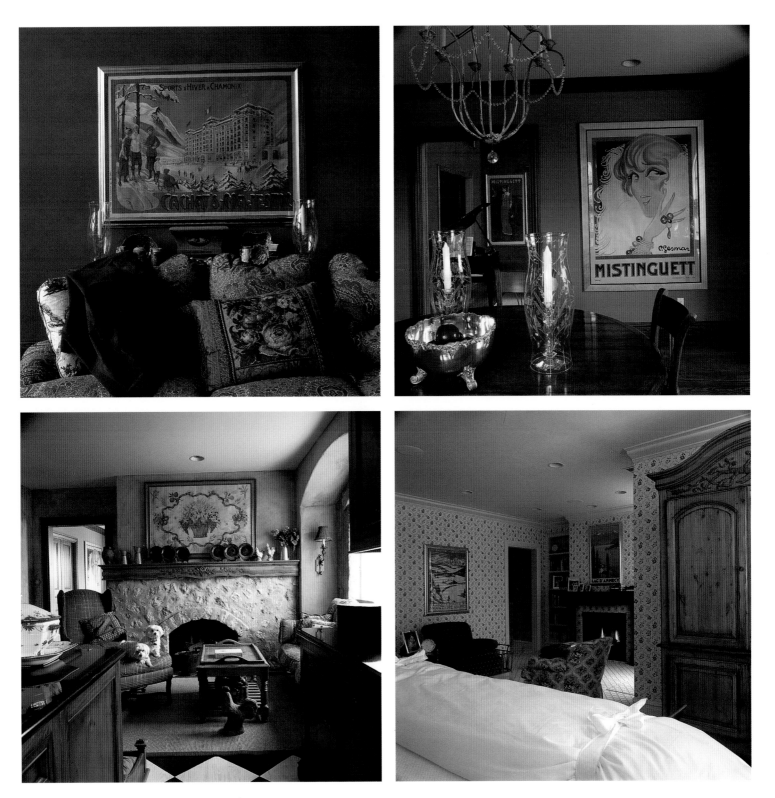

A Funky, Knockabout House

BELOW A large modern kitchen was a necessity in this mountain home, where the owners entertain their large family every winter: "We wanted an old country farm look, but the kitchen had to be able to handle three meals a day for a large crew." The dining room table was made out of old fence boards. Funky benches provide casual seating.

BELOW RIGHT An antique garden sculpture stands proudly on a card table in the living room of this Mammoth, California, cabin. The table provides extra seating during large dinner parties.

FAR RIGHT An old produce stand, once used to sort potatoes and onions, provides perfect cubbyholes for the family ski gear in this essential mud room. The front hallway leads into the living area, whose focal point is a stone fireplace. Bits and pieces of iron and horseshoes found on the property were incorporated into the hearth design. When the owners said they wanted a funky cabin, Los Angeles designers Richard Hallberg and Barbara Wiseley knew what to do.

A Funky, Knockabout House

While many of the earlier American ski homes were modest, today's ski houses are generally larger because families are using their mountain homes year round. When a Los Angeles couple started designing a ski cabin in Mammoth, California, their designers, Richard Hallberg and Barbara Wiseley, talked them out of the predictable log home kit with the tell-tale orange-varnished logs. Instead, the owners and the decorators designed a more traditional-style cabin with dark hand-hewn logs that matched some of the older homes in Mammoth. The home is a "funky, knockabout house filled with funky junk," the owners said. "Our home needed to be durable, and cozy." The couple placed the hearth at the center of the home to create old-fashioned cabin warmth. Large windows invite light inside the cabin.

Once the building was finished, they filled the home with painted pieces and country antiques found in flea markets and junk shops around the country. "You really have to have an eye. There might be just one jewel in a pile of junk," designer Hallberg said of his shopping sprees. When they needed sturdy furniture, they mixed upholstered couches, a few new chairs, and beds that looked old. Old skis and snowshoes lean against the entrance hallway to create that always-been-there look of an old ski cabin. One of the most interesting finds was a giant green produce stand that provides perfect bins for goggles, hats, and mittens.

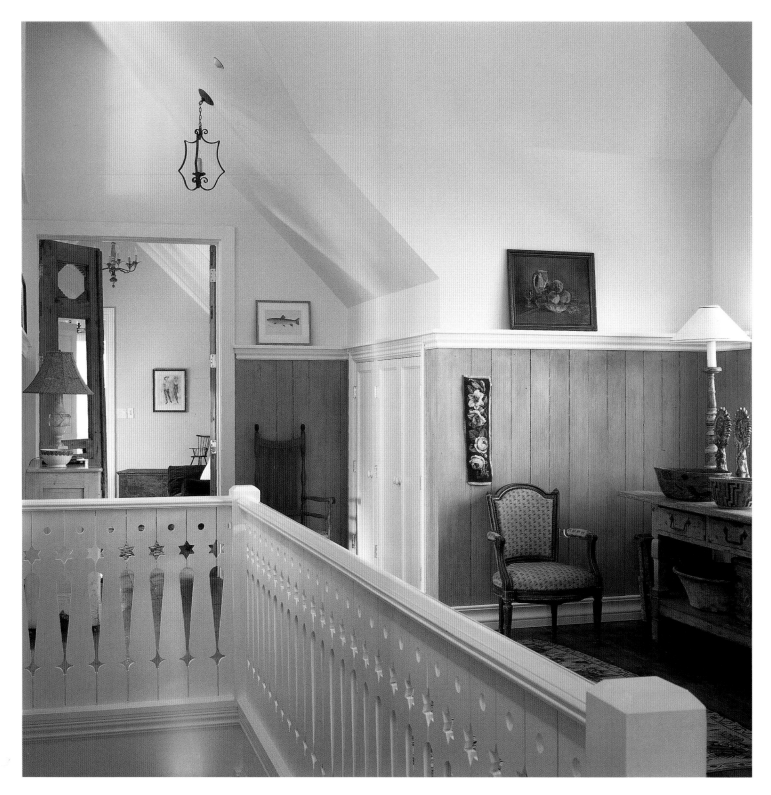

Swedish Snow Home

A storeroom-full of European antiques inspired designer Linda Bedell, a full-time Aspen resident. In her new home, which she designed, Bedell combined painted furniture from Sweden, a French ladder-back chair with a toile cushion, and an assortment of folk art in a sunny and spacious interior. "I like a lot of different things. I buy things I love," she said.

While Bedell enjoys the more rugged Western style of Navajo rugs and cowboy furnishings, she wanted her Aspen home to be a little more sophisticated and a little lighter and fresher in feeling. She is particularly drawn to old furniture and folk art. "I love to feel the person that made them, that's why I have kilim rugs, folk paintings, and painted furniture."

The simplicity and color of the Swedish style has always attracted this designer: "I wanted my home to feel like a Swedish farmhouse, I wanted it to be light and happy, and I wanted to have kids, dogs, and friends all feel comfortable. I wanted everybody to feel they could come barreling through the house, and nothing would be harmed."

One room off the kitchen, which features dark colors and sturdy leather furniture, is particularly childproof. Bedell does not worry about her children playing in this room while she prepares meals in the kitchen next door.

When drawing the floor plans and architectural elements for her house, Bedell focused on creating a home that fit into the mountain landscape. She didn't choose the barnwood exterior so much for the vintage look. "I just thought the wood would help my house blend in more. I didn't want my house to stick out," she said. Bedell also incorporated double-hung windows, very much part of the Western vernacular. She and her family enjoy the morning sun in the kitchen, a view of sunny Aspen ski slopes during the day, and sunsets from their living room.

ABOVE Bedell enjoys mixing diverse things she loves. Three Chinese sculptures pose on one of two fireplaces in her living room. The crystal candles are from Sweden; the others are English Arts & Crafts.

LEFT "I love the Swedish farmhouse," said designer Linda Bedell of Aspen. Here on Bedell's landing, the simple lines and sunny colors of Swedish style create a warm and inviting environment.

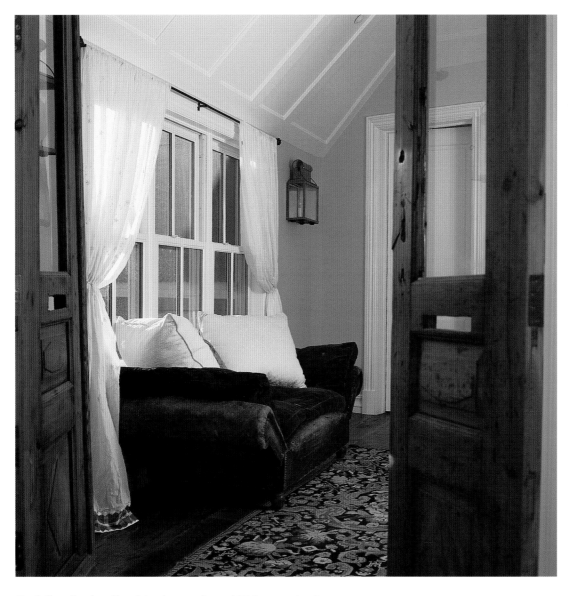

LEFT A French daybed and blustery cotton curtains in an upstairs hallway invite one to spend the afternoon reading. The window faces Aspen Mountain.

ABOVE, RIGHT An Italian fresco hangs over an English leather couch and chairs in what Linda Bedell calls her children's room. While Bedell makes dinner, she encourages her children to play here rather than underfoot. "I tried to use things that the kids could not destroy," she said.

ABOVE, FAR RIGHT Swedish pine doors open into Linda Bedell's mud room, where an early Bavarian painted bench provides seating for skiers coming in off the slopes. The seats lift up, providing extra storage for ski equipment. A painted armoire stands at the front door.

BELOW, FAR RIGHT Bedell enjoys reading to her children in this living room window seat, where she can view Owl Creek.

BELOW, RIGHT Bedell's living room looks out over Aspen Mountain. A round table, covered with a needlepoint throw, sits at the center of this room, decorated with folk art sculptures from Java, a French ladder-back chair with a toile cushion, a Spanish colonial mirror, and an impressionistic painting by Montanard. The wide floorboards and the beams came from an old Pennsylvania building.

Bedell, who has lived in Aspen since 1979, stays in the mountains because of the outdoor beauty and the informal lifestyle. She enjoys working in Aspen, because if she needs to, she simply puts on her hiking shoes and heads out on a trail for a break. Because of all the outdoor activities and the small-town atmosphere, Bedell also finds Aspen an easy place to raise children.

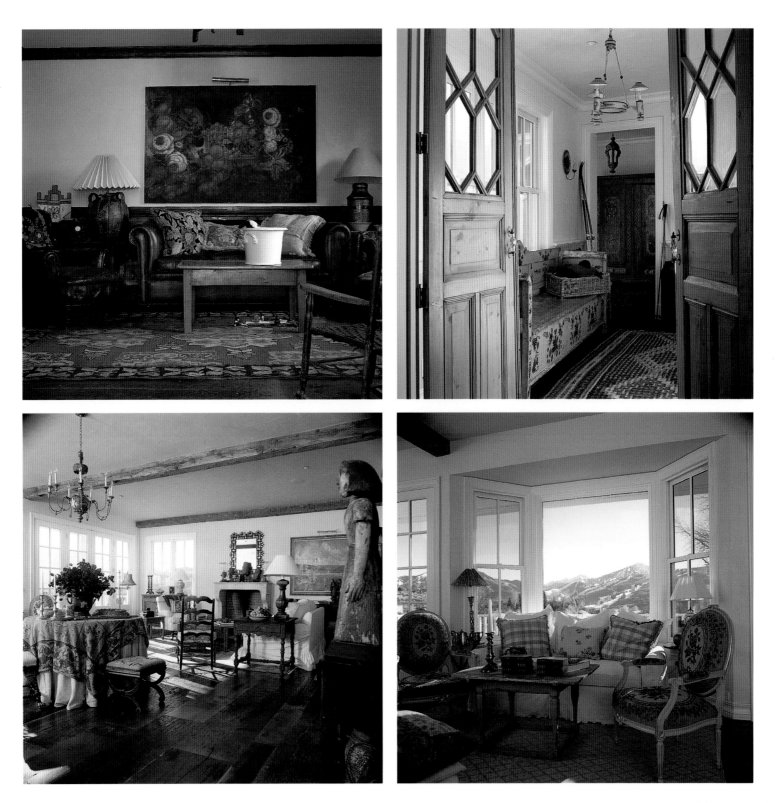

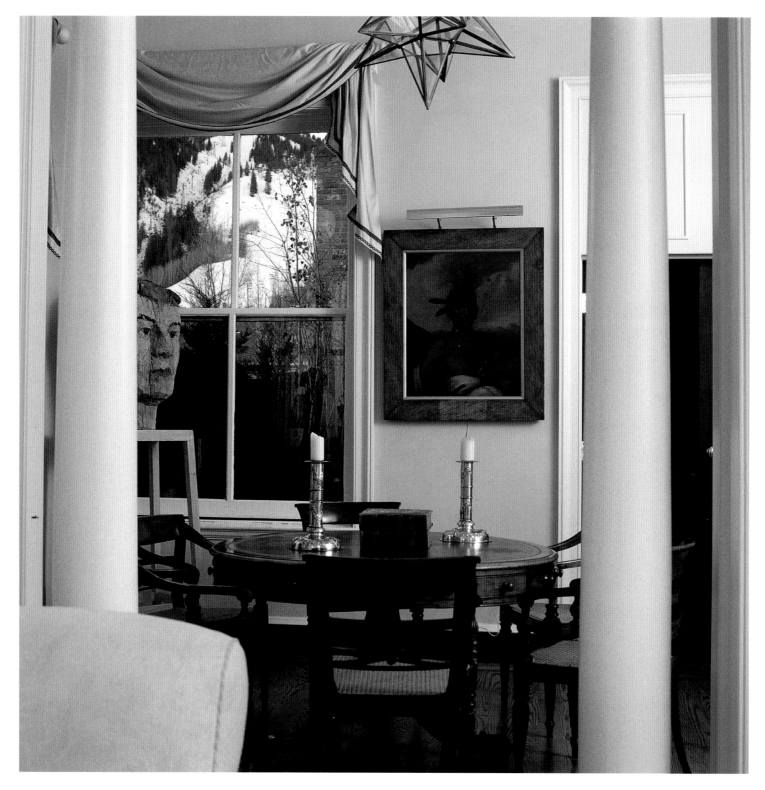

Harley Baldwin's downtown apartment in Aspen could be in New York City. Rauschenberg and Picasso paintings hang on the walls, and the dining room looks like a Palm Beach loggia. Designed by Peter Hans Kunz, the place is grand and urban, and like most ski homes,

Picasso and Wide-Open Spaces

the place has a stunning view of the local slopes.

"When you are sitting down in this apartment it's like you are in the Wild West. All you see are mountains and big Western sky," said Baldwin, a year-round resident, skier, and owner of the Caribou Club and a local contemporary art gallery. For Baldwin, who arrived in Aspen years ago and sold fifty-cent crepes on the sidewalk, his contemporary apartment was something to which he aspired.

"It's thrilling to collect art within one's own lifetime and to be part of the process," said Baldwin, placing an Andrew Lord urn on a nineteenth-century English library table. "There's never been an important period of art when there weren't collectors to appreciate the work."

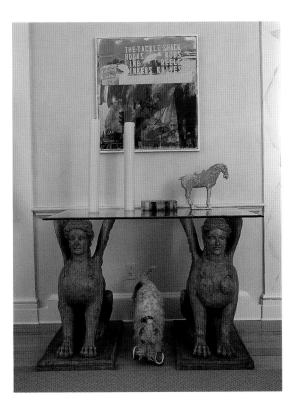

LEFT Izzy snatches a rubber bone under an untitled Robert Rauschenberg painting. A T'ang dynasty horse sits on the mantel. Two terra-cotta sphinx garden statues hold up the table.

FAR LEFT An 1820 portrait of Monahanga, the chief of an Iowa tribe, by Henry Innman after Charles Bird King hangs above a nineteenth-century English library table in Harley Baldwin's downtown Aspen apartment. The wooden bust is by contemporary artist Stephan Balkenhol. A view of Aspen Mountain is framed by the window.

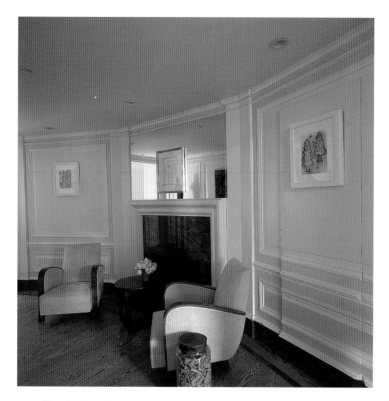

ABOVE Two Stephen Conroy drawings and a Picasso hang in this hallway, furnished with 1930s French chairs. The dog biscuits were a gift from Wal-Mart to Baldwin's three dogs.

RIGHT Harley Baldwin caters to an exclusive Aspen crowd at his Caribou Club in downtown Aspen. Guests rent out this wine cellar, called Oliver's Room, at the club when they want to have an extra-special evening.

BELOW A pair of eighteenth-century Mogul doors from New Delhi make up the dining room table. The two Spanish sculptures came from Santa Fe. The chairs are Edwardian reproductions of director's chairs. Laughing, the designer Peter Hans Kunz admits the place looks like a Palm Beach loggia.

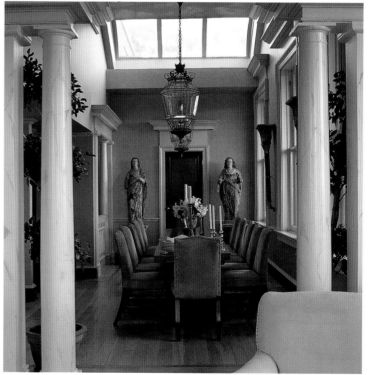

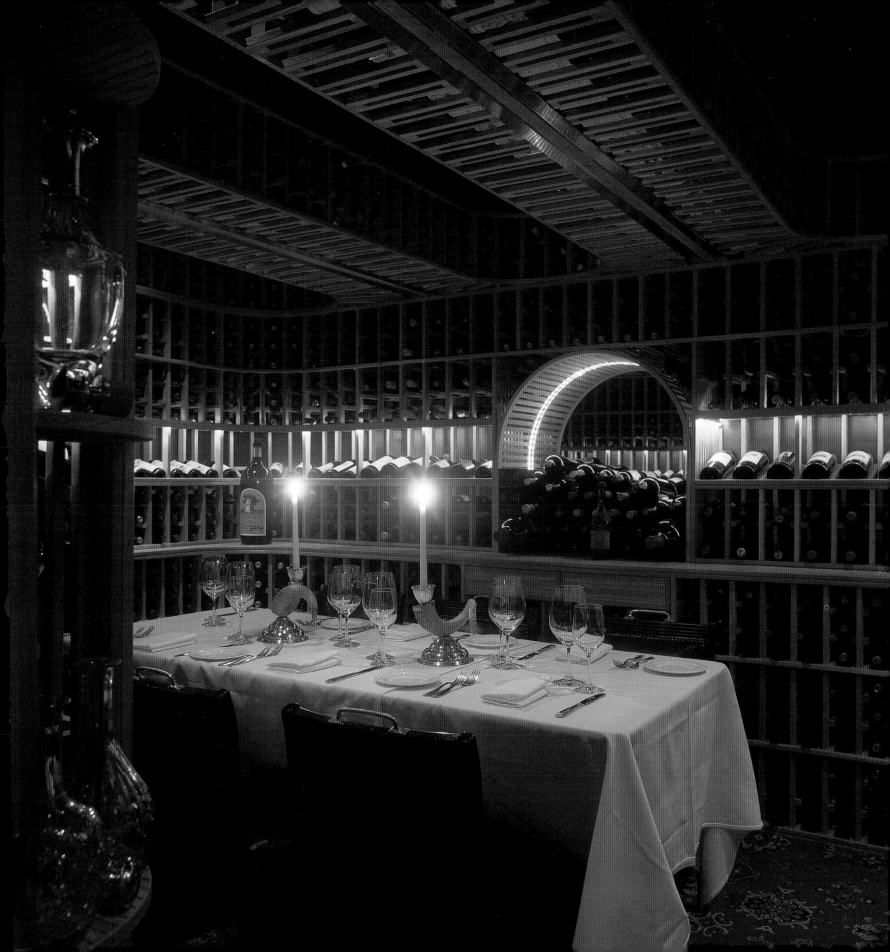

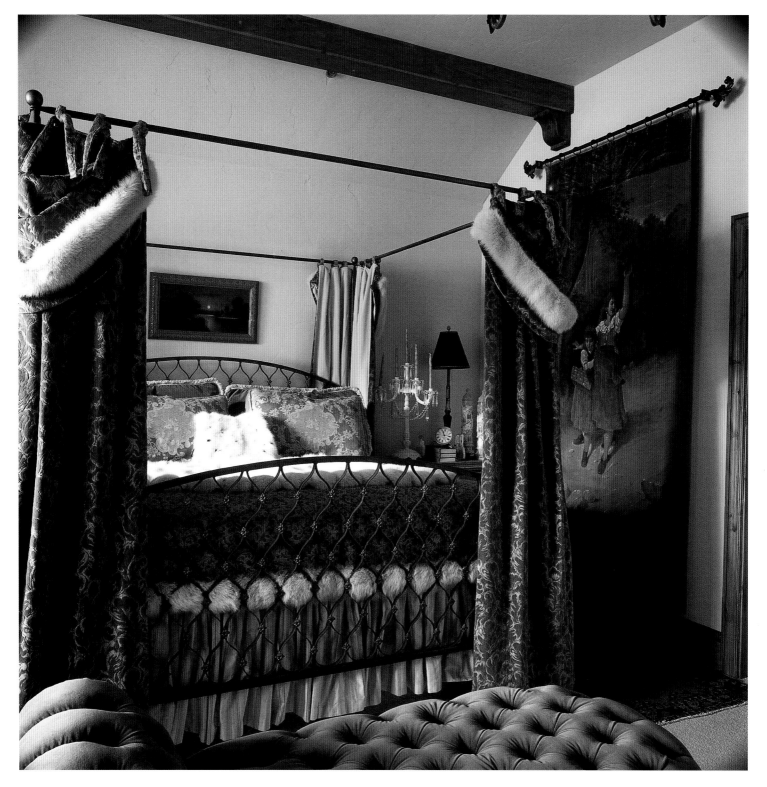

Snow Queen

Ten years ago, the Haddocks of Fort Worth, Texas, purchased a condominium at the center of Colorado's Beaver Creek Resort. The condominium overlooks a small skating rink, surrounded by shops and restaurants, as well as the main lift, Centennial. "The ambience reminded us of Rockefeller Center in New York City," Gerald Haddock said. "We loved the vibrant high-density neighborhood and the easy access to the main lift."

History and the development of Western civilization inspires Gerald Haddock, so when it came to decorating past homes he studied Minoan and French Empire styles. In keeping with this historical theme, Haddock created a Bavarian-style ski house. "The design was not inspired by Colorado lifestyle, but it fits our life," Haddock said.

With the help of Pamela K. Flowers, Inc., in Fort Worth, Texas, the Haddocks created a rich, winter retreat with antique tapestries, deep-colored fabrics, and antiques. A Bavarian drop-leaf desk turned into a wet bar, an antique windmill from Holland, and an early sleigh used as a love seat add to the ambience.

When the condominium was finished, Haddock named all the rooms. There is a room called the "Honeymooners" and one called "Best Friends." Haddock titled the master bedroom in honor of his wife, "Snow Queen Forever More." To create a comfortable and romantic room, Flowers and her assistant, Christina Hill, draped a custom-made iron bed with cut velvet and fur curtains. The curtain fabric was inspired by traditional hand muffs. In the summer, the curtains change to a satin-and-silk combination.

LEFT An element of the outrageous exists in modern ski house design. In a condominium in Beaver Creek, Colorado, a lavish four-poster bed decorated with fur drapes and pillows is the centerpiece of the master bedroom. The door to the room reads "Snow Queen Forever More."

PAGE 104 Two giant tapestries create a Bavarian mood in this condominium. Rich fabrics and dark ceiling beams help create an opulent atmosphere. An antique Bavarian drop-leaf desk made a perfect wet bar. Shelves display old steins, and cocktail napkins and stirrers fill the desk's mail slots. Carved by a local artisan, the deer head is one of the few items from Colorado.

PAGE 105 Painted bunk beds provide ample sleeping space for guests. Fabric used on the pillows resembles lederhosen.

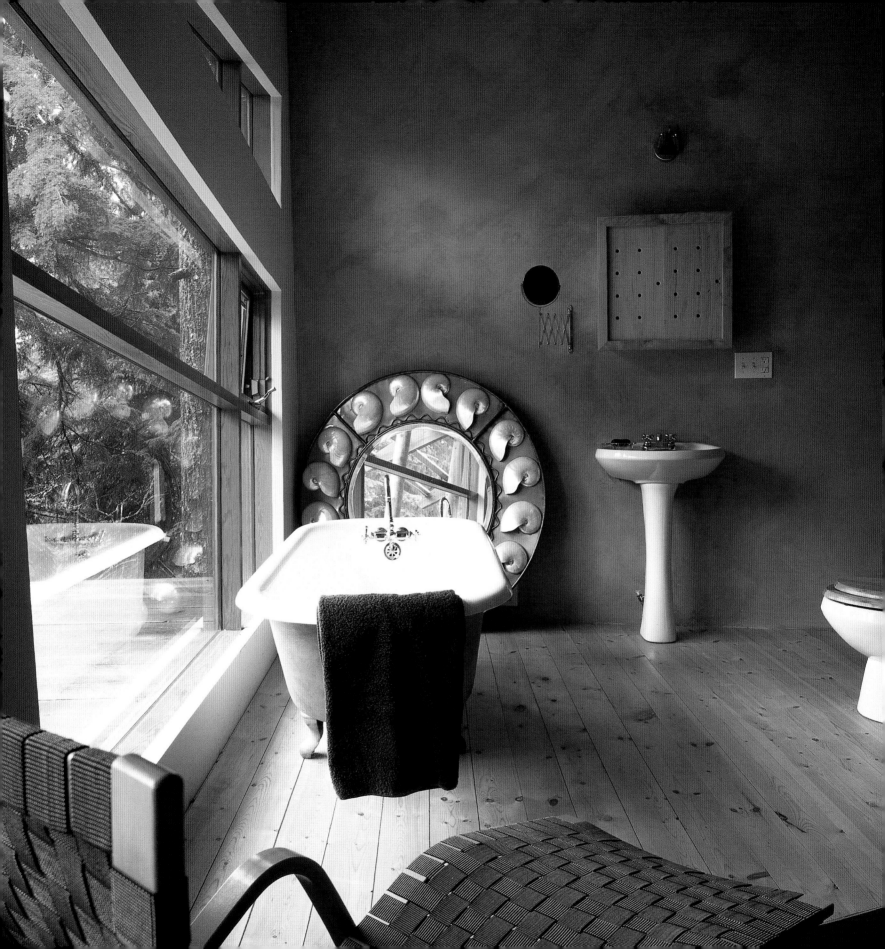

An Organic Journey

Architect David Lombardi of Whistler, British Columbia, Canada, loved contemporary styles as a young man living in Whistler, skiing and waiting tables. But he found few who shared his aesthetic. One evening when he discovered that his co-worker thought Andy Warhol was the coach of a local ski team, Lombardi left town and moved to Japan, where he taught English and studied architecture.

A fan of Frank Gehry's work, Lombardi soon tired of designing the boxy houses he had been taught to build. He challenged himself to build more organic spaces and experimented with leaning walls and curved interiors. He took this important advice from one of his Japanese instructors: "You can't build anything you can't draw."

Much of Lombardi's work reflects his appreciation for Japanese architecture. "Space and how easy we are able to flow in, around, and from it are key points in Japanese design. Space is limited, so it becomes one of the most important variables in a Japanese home," he said. When Lombardi finally moved back to Whistler, he applied Japanese building philosophies to his home. In a time when people are conscious of building environmentally friendly homes, Japanese ideas about conserving space are valuable.

LEFT To conserve space, David Lombardi created a master bedroom and bath all in one room. At night, he pulls out a Murphy bed from the wall. During the day, the bed flips back into the wall, leaving an enormous bathroom with a toilet in the middle of the room.

RIGHT David Lombardi likes fragmented spaces, because they inspire a journey to different levels. A dugout canoe and a wooden horse from Indonesia work in this colorful but spare setting. Inspired by Antonio Gaudí, Lombardi used broken tile on his kitchen counter.

ABOVE, RIGHT Lombardi likes curved lines in his interiors. His design for the dining room table, using plywood with plugged knots, was inspired by Frank Gehry. To turn the curvy fireplace on, Lombardi just flips a switch and a flame burns.

FAR RIGHT Few people were interested in this building site because of the giant boulder occupying most of the lot. David Lombardi chose to work with the rock, instead of blasting it away. He built his home out of Douglas fir, rock, flint stone, cedar shingle, barn shales, copper, galvanized steel, cedar board, and batten siding.

Instead of building the typical gigantic log home so popular in Whistler these days—what Lombardi calls the "Brady bunch variety"—he chose to hunker his building over a giant rock, an undesirable building site for many.

Inside, as in a Japanese home, the place unravels like a journey, with the master bedroom downstairs and the living quarters upstairs. There are few straight lines, and the spaces flow together. The tile countertop was inspired by Spanish architect Antonio Gaudí. The downstairs master bedroom and bath are particularly unusual. To conserve space, Lombardi and his wife sleep on a Murphy bed that disappears into the wall during the daytime, leaving a gigantic, spare bathroom, with a toilet in the middle of the room.

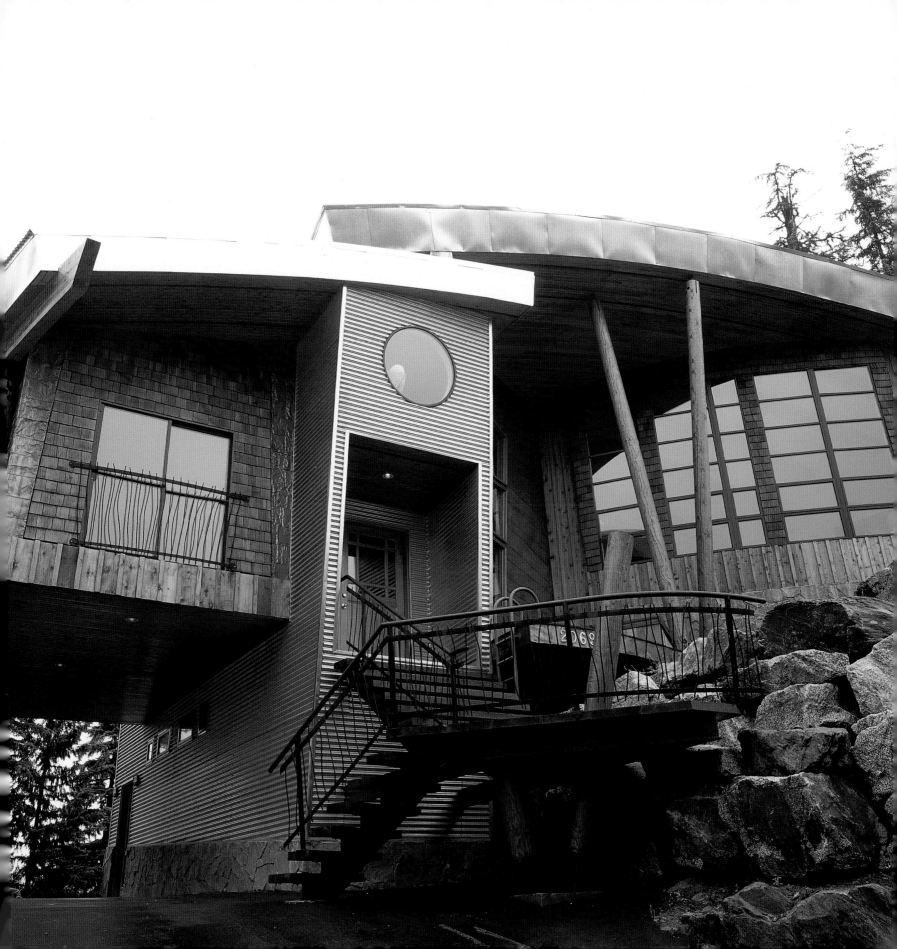

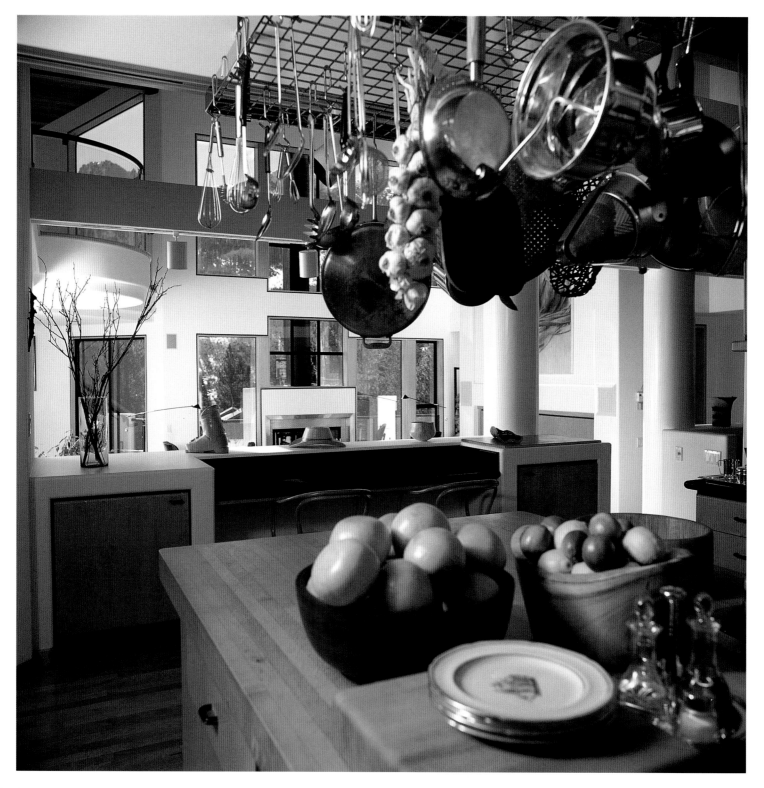

Minimal Mammoth

Artist Kharlene Boxembaum and her husband, Chuck, also appreciate the minimal look of a contemporary style. Rather than compete with Mammoth's beautiful mountainous landscape, they chose to build a simple modern home, furnished in Bauhaus style with Eames furniture and giant picture windows. Although Kharlene appreciates the more traditional mountain style of "kilims and animal pelts," the style is not for her. "It makes me itchy; I prefer the uncluttered look," she said. "People should live in what makes them comfortable and what makes them happy. What makes us feel comfortable is no clutter."

When the Boxembaums decided to build their mountain home, they sought to make it luxurious. The kitchen features modern appliances and bird's-eye maple cabinets. They treasure their furniture and collection of modern art. And the simplicity of the interior allows the Boxembaums to entertain a large crowd without too much trouble. What Chuck Boxembaum most appreciates about his house is his bedroom window, where he can look out every morning on snowy Mammoth Mountain and see what the ski conditions are for the day.

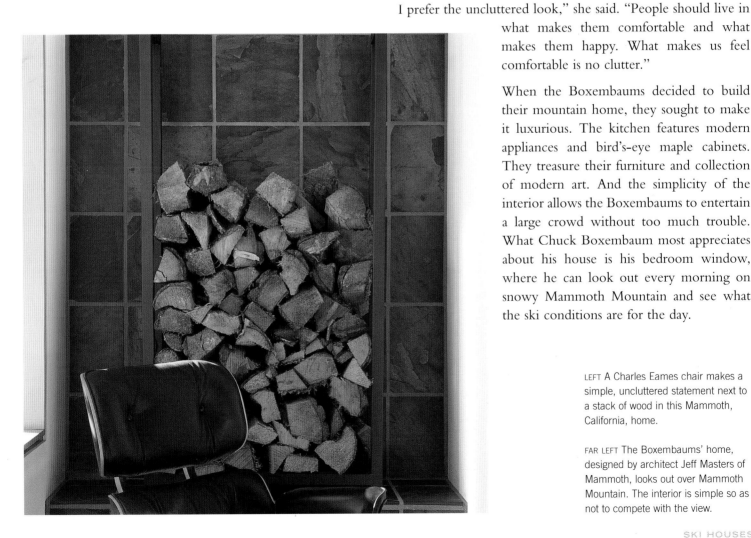

LEFT A Charles Eames chair makes a simple, uncluttered statement next to a stack of wood in this Mammoth, California, home.

FAR LEFT The Boxembaums' home, designed by architect Jeff Masters of Mammoth, looks out over Mammoth Mountain. The interior is simple so as not to compete with the view.

LEFT Kharlene Boxembaum, a former shoe designer, was delighted to meet Manolo Blahnik at Neiman Marcus. As a memento of their conversation, he drew her a shoe, which she displays on her bedroom desk.

RIGHT An Alaskan totem, with African accents, was a gift from a friend. The totem greets visitors as they approach the Boxembaums' home.

BELOW A stenciled powder room features an African-style necklace from Bergdorf Goodman.

Lake Tahoe Formal

When Bill and Michelle Green purchased a lot on Lake Tahoe for their second home, they told their architect, Kirk Hillman of Sausalito, they wanted a house that looked like "old Tahoe." They weren't interested in the early rustic retreats. The historic Viking house, a 1920s mansion designed in a Scandinavian style, was more to their taste.

The end result of their home is a spacious building constructed with cedar and pine. The Greens have a great room that includes the living area, dining room, and kitchen. "No one ever wants a separate dining room. People never go in them," Hillman said. The home also includes three guest rooms and several family bedrooms.

The Greens are happy with their Lake Tahoe home, which they admit is more formal than their primary residence. They love to share the place with family and friends and find themselves entertaining often. Winter is especially beautiful and quiet on the lake. Ski trails start right from their home. "I think as a nonresident it is easy to love winter," said Michelle, who has taken up cross-country skiing.

LEFT Designed by Kirk Hillman and built by Bruce Olson of Olson Construction, this home features mostly Western red cedar. Cedar darkens with age and evokes a lovely warmth in the spacious home.

RIGHT An upstairs balcony, furnished with a daybed, provides a private retreat as well as a lookout to see what is happening downstairs.

Whistler Wild Card

When Sharon and David Demers moved to Whistler to ski and raise a family, they weren't interested in the traditional log homes that had been multiplying in this town. The couple decided against log for the structure, because logs require so much upkeep every year. "This is not your typical ski house. We wanted something different," David said.

David designed the home incorporating old beams in the interior, modern-style windows, and an open floor plan. He sited the home so the couple could enjoy a number of views of Whistler Mountain.

Sharon took charge of decorating the home with family pieces and treasures from their constant travels. A carved stone fireplace from Mexico dominates the living area. Two modern seats that look like bread buns provide fireside seating. "I wanted people to be able to sit close to the fire and feel the heat," Sharon said. A rustic chair David traded for in a nearby ranching town decorates a living room wall. "I didn't want the house to look like it had been built in 1910 or 1990," Sharon noted. "It was important to me to create an Old World flavor, a timelessness. I didn't want my house to be stuck in time. So many houses you can drive by and tell when they were built."

The beauty and practicality of the open floor plan was a surprise. Every year the Demerses host "an orphan party" for about thirty residents in town who are living far from their families. "Whistler has a very transient community," Sharon said. While half the people sit at their simple pine dining room table, the others gather around card tables in the hallway. "That big space at the entrance has a wonderful feel."

Shadow relaxes between the living room and the dining room of the Demerses' Whistler home. The portrait of a Hawaiian princess came from Sharon Demers's grandmother's collection. The chandelier over the simple pine table was made by John Lawlor.

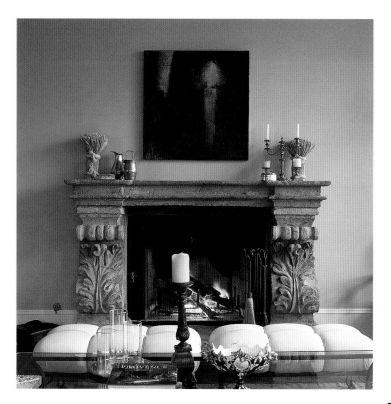

ABOVE An oil painting of a candle hangs above this prominent Mexican fireplace, an oddity in a mountain community where everyone gathers around river rock fireplaces. Two modern stools make comfortable places to sit in front of the fire.

RIGHT The master bedroom, furnished with a sleigh bed made of petrified wood, looks out on a wooded area and on Whistler Mountain.

BELOW Sharon Demers selects her household decorations carefully. She doesn't want her home to feel trendy. Sheaves of barley sit on the mantel of the Mexican fireplace next to her grandmother's candlesticks.

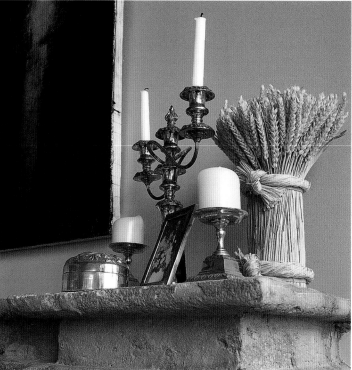

A Snow Fantasy

Propelled by an offbeat sense of style, Nancy Williams of California envisioned a large ski house for her growing family. Park City architect Kevin Price was thrilled to get the job. "I don't pay attention to any rules," said Price. "Whatever it is I'm against it and if someone says you can't do it, that's a reason to make it work."

Happily for Price, Williams wanted her home to resemble a 100-year-old barn with African influences. She had fallen in love with Park City and with her building site, because the snowy setting reminded her of one of her favorite Bev Doolittle paintings. She imagined a house on a grand scale.

"I felt like what Julia Morgan must have felt when Hearst came to her and asked her to do his house," Price said. "And I thought, I'm going to have some fun with this."

From the start, Williams and Price connected and the project quickly unfolded. They installed a Jacuzzi with a waterfall in the entrance and a 5,000-square-foot great room that included a sitting area, dining room, pool room, saloon, and library. A suspended staircase winds upstairs to the bedrooms. Giant fans blow an exotic breeze through the home. One of Williams's favorite spots on a snowy day is the cozy library just below the Jacuzzi and waterfall. Because of the sound of water, she can't hear anything else going on in the house.

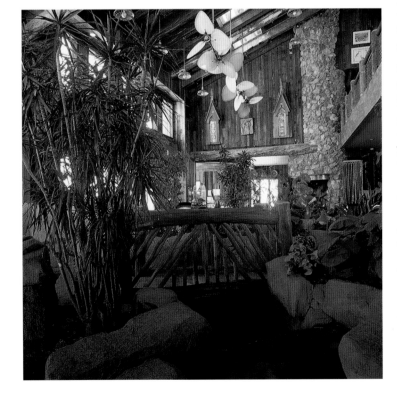

LEFT A 5,000-square-foot great room includes a dining area, seating area, Jacuzzi, pool table, library, and saloon. Italian church steeples decorate the back wall, and the sound of the indoor waterfall is hypnotic.

FAR LEFT A Jacuzzi with a waterfall sits at the entrance of Nancy Williams's Park City home, designed by architect Kevin Price. An unusual suspended staircase winds upstairs to the bedrooms.

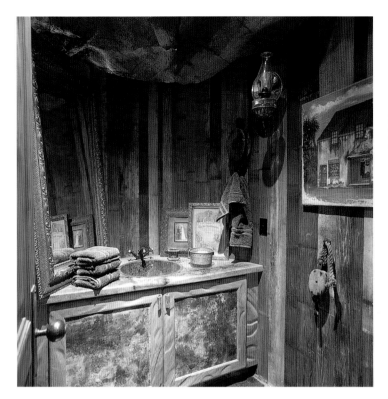

LEFT This is called the mine-shaft powder room, because it is built into a wall of stone.

RIGHT From their sunny porch, the owners can watch moose pass through their property.

BELOW Nancy Williams indulges herself with her fantasies. A Moroccan bed, designed in Mexico, draped with saris creates an exotic place to sleep during a snowstorm.

Throughout the home, Price and Williams used cedar, cyprus, and redwood from old pickle barrels. They also used woods from Hawaii, including monkey pod, mango wood, and ohia. "My house reminds me of a giant calico cat because of the different shades of wood colors," Williams said. The furnishings come from all over. Williams sleeps in a Moroccan-style bed, church steeples from France hang from one wall in the great room, and mining memorabilia decorates the stone fireplace. "When I see something I love, I just buy it," Williams said. "There are so many different things I like that I want to see all of them. I don't want to walk through my house and see the same thing, like all country French or all Italian Renaissance."

Even though Williams doesn't spend the entire year in her ski house, she wants her home to accommodate her large family and look funky. "Life's too short not to have things the way you like them," she said.

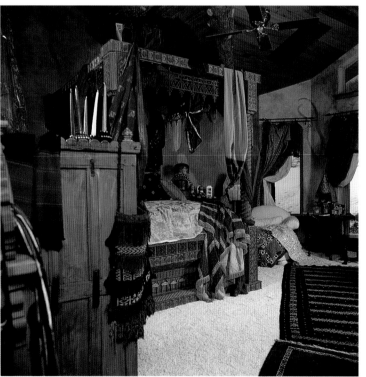

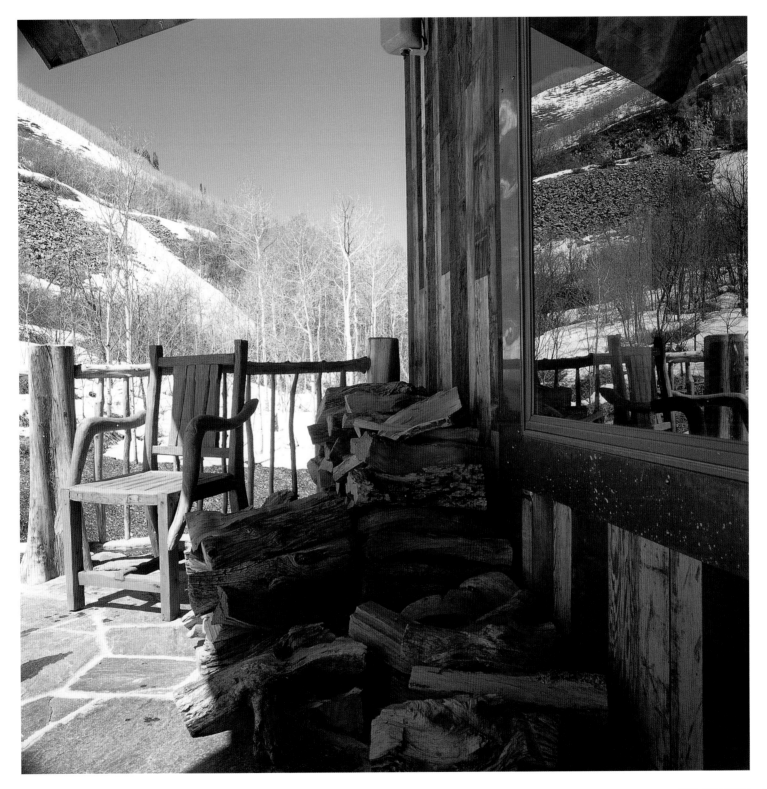

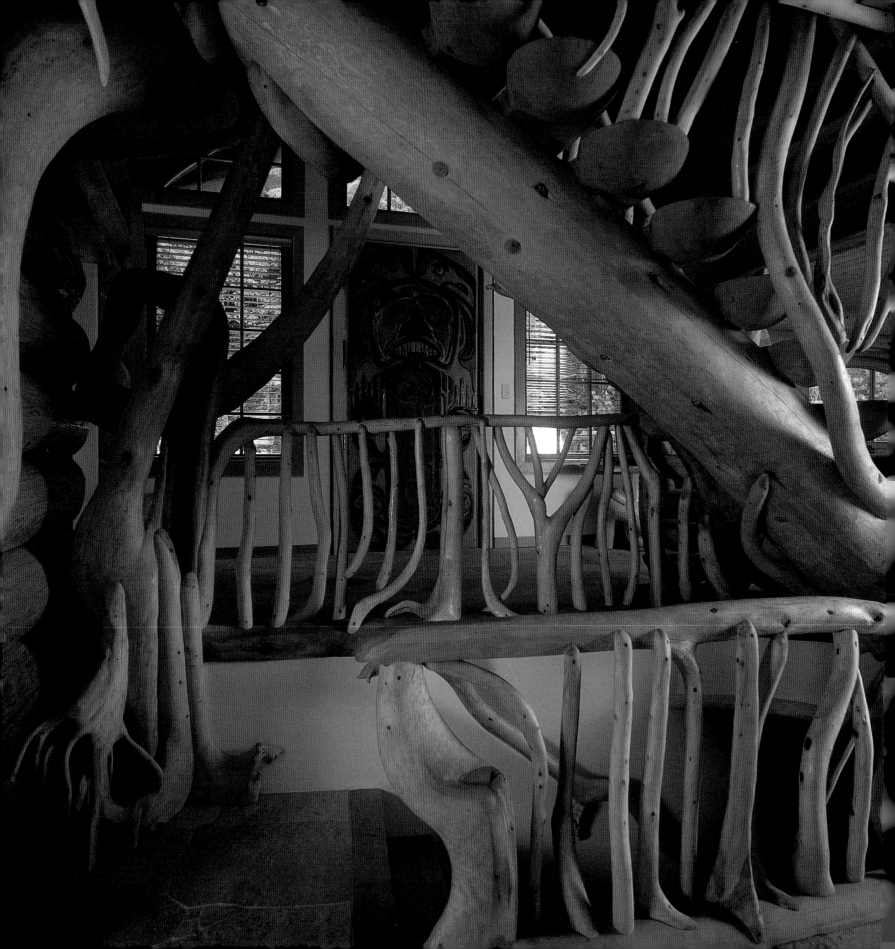

THE NEW WEST

A wealthy New Yorker once admitted sheepishly to his interior designer that he wanted to be a cowboy. This man grew up watching television stars Roy Rogers and Gene Autry gallop across the sagebrush and hoped that some day he would do the same. Years later, he purchased a Wyoming ranch. With help from his designer, he selected rustic beds, primitive tables, an old wood-burning stove, quilts, enamel coffeepots, spittoons, cowhide rugs, Indian beadwork, and cowboy club chairs with Navajo cushions. He also purchased horses and all the necessary tack, and corralled two buffalo in his front yard.

In the New West, a term used to identify recent population and development in the West, this desire to be a cowboy or cowgirl is as prevalent as cracked windshields from driving on dirt roads. Of course, these new "Westerners" don't live in homes that resemble an old waddy's line cabin. Because we have electricity and plumbing, and the means to build houses that exceed a twelve-by-twelve interior, we live more comfortably than our old-time heroes. In most contemporary Western interiors, a self-conscious attempt to connect to Western tradition pervades the ambience. Owners blend a traditional country style with Western elements such as cowboy memorabilia, local hand-crafted furniture, and Indian arts. Wit, informality, and the importance of the outdoors defines style in the New West.

For many, the Western home is a log house, with oversized lodgepole furniture mixed with primitive country pieces such as a pie safe for dishes or a simple plank-board table for dining. Designers generally incorporate primary colors into their work, and organic details such as a gnarled banister enrich the interior. Portraits of Dale Evans, tattered Stetsons on a hall tree, and antique lanterns steep the home in cowboy nostalgia. Some mountain dwellers who chose the Western style are distinctly inventive with recycling old things. Zoe Murphy Compton turns burlap feed sacks into dust ruffles. Rebecca Callender plundered a local rummage sale, uncovering vintage lace curtains. And Sandra Wolcott Willingham walked right up to an

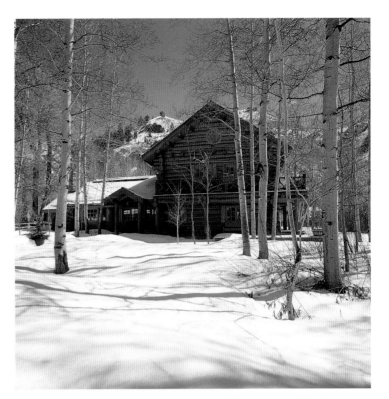

ABOVE A log house, built by Janet Jarvis of Sun Valley, hides behind Aspen trees. The home is Swedish-coped. To take advantage of mountain views, the main living quarters are on the second floor.

LEFT One of the most important rooms in a mountain home is the mud room, a place to dress and undress for outdoor activities. Old signs decorate this functional entrance in June Lake, near Mammoth, California.

PAGE 124 Artist Eric Scraggs used crooked pieces of fir to make an unusual banister in this home in Whistler, Canada. The steps are cedar. The door, featuring an Indian spirit, was crafted by a Native American.

Idaho hamburger stand, her heart beating rapidly, and asked to buy the claw-foot tub weathering in the yard. A mere fifty dollars sealed the deal.

Even those who prefer to furnish their Western homes with family antiques or non-Western-style furniture wish to connect to the Old West and the environment. They may not want to play cowboy, but they are intrigued with the beauty and remoteness of the mountains. To connect to this history, they may choose a historic building or enjoy a few Western accents like a stone fireplace, wood floors, or a picture window framing a magnificent view.

The trend in the West has been to build large log houses. Some of them get out of hand. An especially gargantuan log house perched on a cliff in Whistler, British Columbia, Canada, causes gawking motorists to crash their cars. People want to live in a log cabin, but the place must accommodate their modern desires: a great room, guest rooms, a media room, an exercise room, and children's rooms. "People are breaking the back of the log cabin," said Jackson Hole architect Stephen Dynia. Mountain community locals call these new gigantic homes "log cabins on steroids," or "starter castles."

Rather than doubling and tripling the dimensions of a cabin, successful architects and builders create well-proportioned houses by combining rustic elements in an original, sometimes even contemporary design. Some of the best projects are those homes that look like they have always been there, but incorporate modern building styles. Recycling old building materials is all the rage. Instead of building an authentic log house, many people are choosing to live in a frame home with log accents. For the most part, owners desire custom designs, from unique floor plans to hand-crafted fire screens to toilet paper holders made from branches. Because few building traditions exist, architects are challenged to develop a Western style. In most cases, fantasy, whether it is the dream of being a cowboy

ABOVE, RIGHT A bed tucked into the wall makes a creative Western hideaway for a child.

ABOVE, FAR RIGHT Pioneers built furnishings from what was available. Today, modern settlers carry on this tradition. In this Mammoth cabin, an old wagon makes an unusual double bed.

BELOW, FAR RIGHT Tahoe builder Bruce Olson built these bunks for his twins. Western bunks provide sturdy sleeping areas that require little upkeep.

BELOW, RIGHT A whimsical mural by local artist Roy Kerswill decorates the Mangy Moose saloon, a popular skier's hideout, in Jackson Hole, Wyoming.

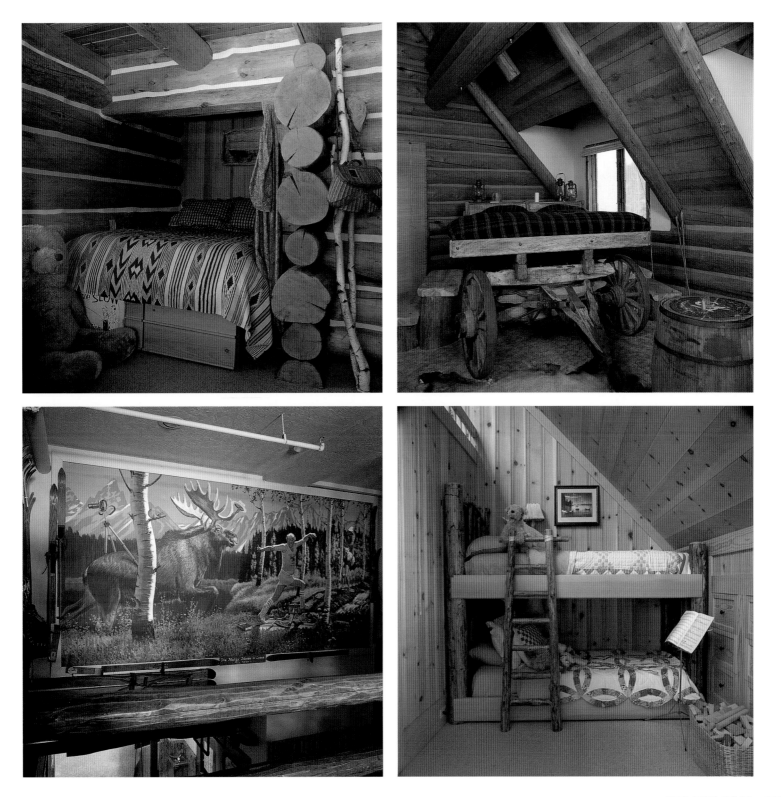

or just the dream of living in a remote place, drives the design. The few designers who are forging new ground are trying to create homes that blend traditional and contemporary styles that are in keeping with the environment.

As cities become congested, more people are moving to the mountains to live full-time. The beauty of the snow-capped peaks, the refreshing open space, and the small communities lure city slickers who want to know their postmaster, drive on two-lane roads, and enjoy a simpler life. Computers, fax machines, and the Internet have made working in remote places possible. Now people can envision a career in the mountains with lunch breaks on the ski slopes. Mountain homes have become valuable sanctuaries in this increasingly populated world.

Despite development in the New West, a rugged element of the Old West still remains. Wild animals still roam large tracts of land, and extreme weather conditions, especially in winter, challenge every settler. For anyone who decides to live in the mountains year round, adjusting to long winter months in snow country requires commitment.

"I don't know how I ended up here," said artist Greta Gretzinger of the Rocky Mountains. "When I bought a sleeping bag in California the man in the shop said it wouldn't work for temperatures lower than ten degrees. I remember thinking I'm not going anywhere colder than that." But nineteen years later, Gretzinger is still living in the mountains, where winter temperatures can drop to forty below. "The first couple years I thought how am I going to stand this? But then you get to know people and you get bonded to a place."

Like Gretzinger, others have discovered a healthful lifestyle, good friends, and the tonics of open space. Their families live elsewhere, but they have chosen to put roots down in the West.

ABOVE Cowboy lawyer Gerry Spence of Jackson Hole, Wyoming, complains every morning that he doesn't have a body like Arnold Schwarzenegger. His wife, Imaging, commissioned Jackson Hole artist, Greta Gretzinger to paint his dream figure on his bathroom wall.

ABOVE, RIGHT A window seat at the entrance of the master bedroom invites Ann Frame of Jackson Hole and her guests to cozy up on a winter day and read a book. "I wanted the feel of an old English house with deep-set window sills," she said. In the heart of winter, icicles glisten in this window.

BELOW, RIGHT A window seat in the middle of a stairway provides a quiet place to rest on a snowy day.

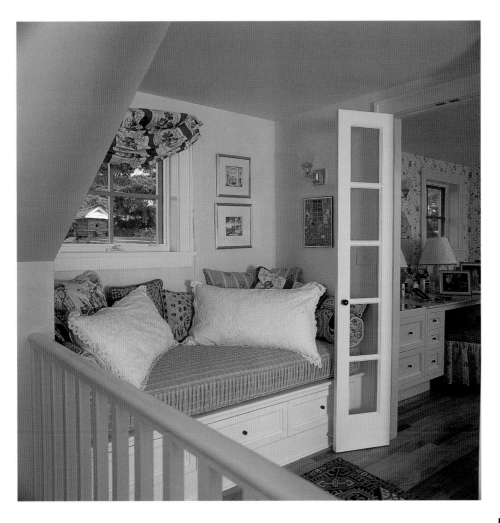

PAGE 132 Because Western mountain history is so recent, mountain dwellers have a keen sense of their past. Many enjoy collecting items like this assortment of mining memorabilia mixed with a cherished wedding photograph.

PAGE 133 Hidden under a nondescript mat in the owner's den, this wine cellar surprised us. The casual mountain style of this house did not suggest that the owner would have a first-class cellar full of fine vintages of Château Petrus, Château Margaux, and Mouton Rothschild, some exquisite ports, and a sampling of other fine wines from all over the world.

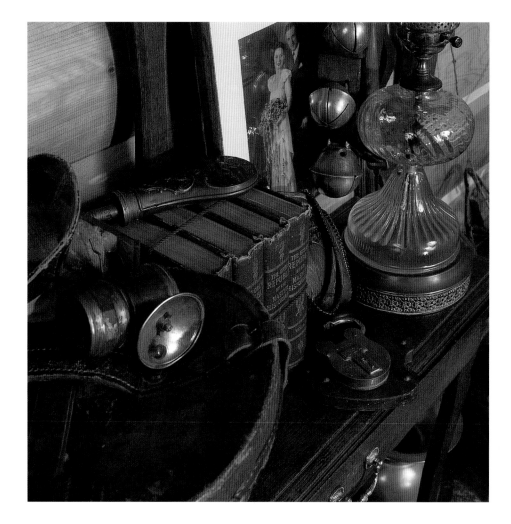

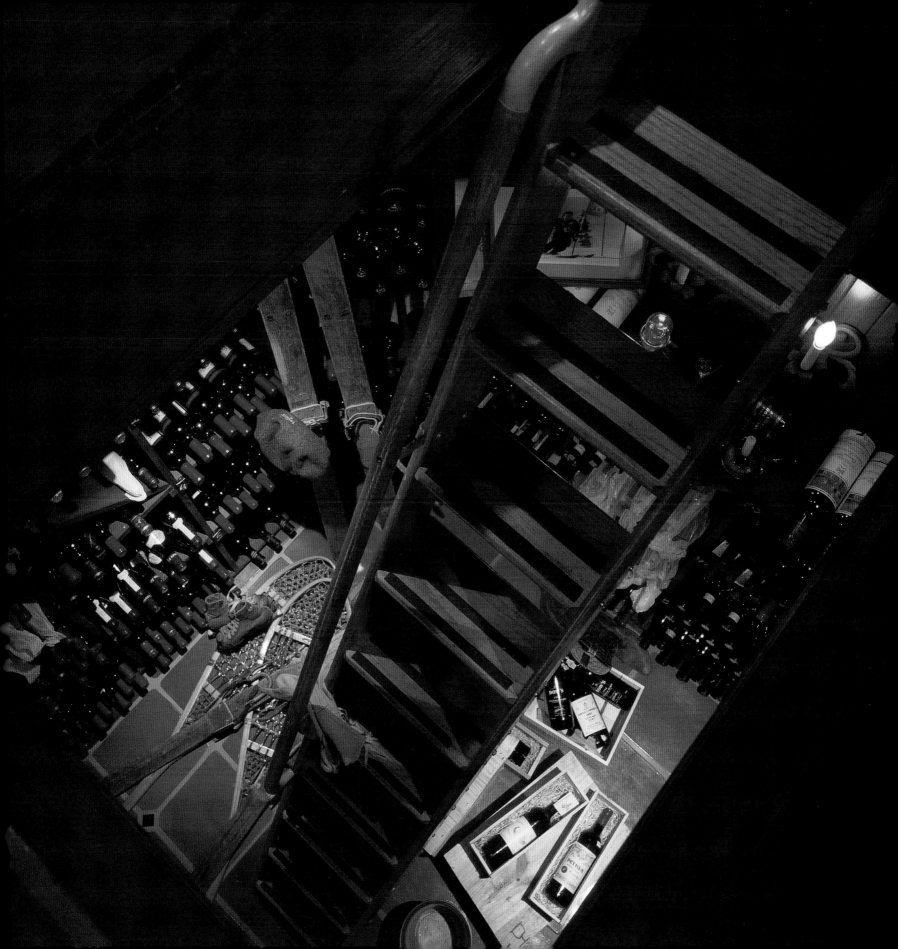

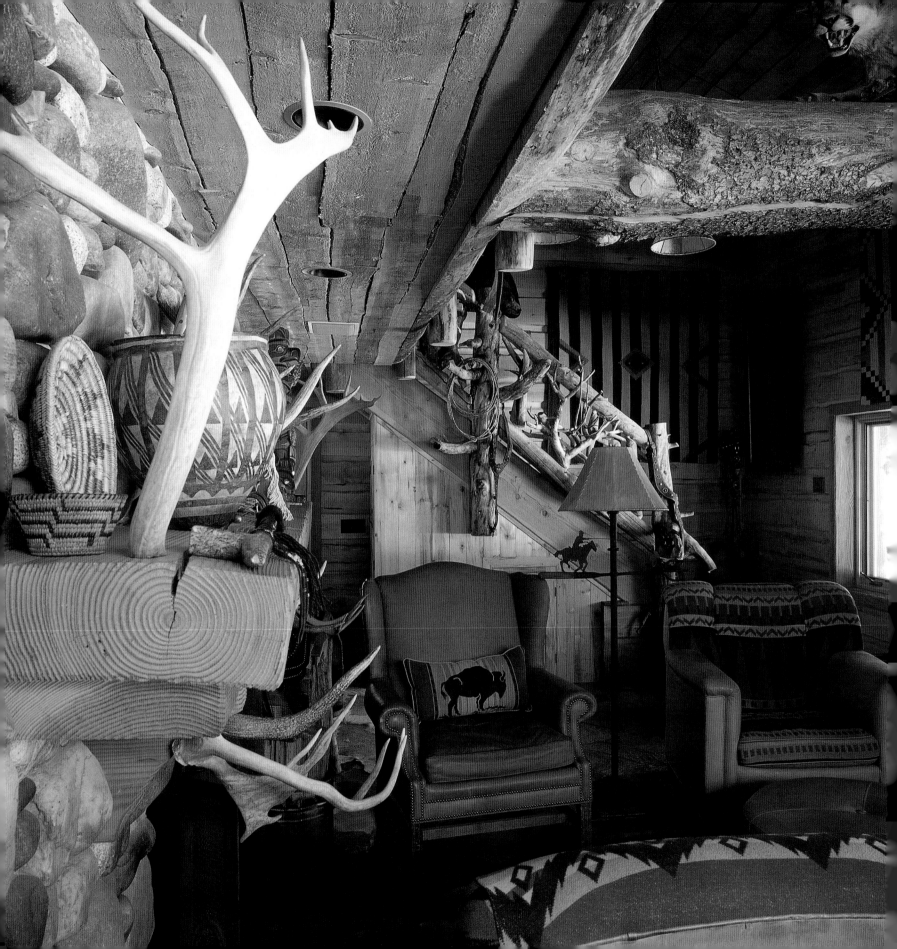

A Cowboy Dream

Craig Tillotson purchased a log cabin on a ranch near Park City, Utah, so he and his family would have a place to ride horses in the summer and snowmobile and ski in the winter. He relished collecting Western items such as Navajo rugs, Indian baskets, comfortable chairs covered in Pendleton blankets, antlers, vintage saddles, and beds fashioned from curved and twisted pieces of wood. He bathes in a stone shower, under a waterfall, and enjoys pleasant evenings with his family around a river rock fireplace. "I used to watch a lot of cowboy movies, and this house just takes me back into that time frame. It's kind of a fun era to fantasize about, the Wild West, cowboys and Indians," he said.

Tillotson hired Park City designer David Krajeski to help him create a Western interior. Krajeski works with many people who want to live out their fantasies about the Old West. "The Old West is part of our American history. It is unique only to our country," Krajeski said. "The style has become a very distinct look, something that people can reproduce."

LEFT An intimate sitting room features telltale elements of the cowboy style: Pendleton blankets, antlers, Indian baskets, a chief's blanket, and a mountain lion trophy.

RIGHT After snowmobiling and skiing in the back country, Craig Tillotson slips into this exquisitely private hot tub on a second-floor balcony off his bedroom. From the tub, he overlooks a wintry Weaver Canyon.

Krajeski describes the Western style as "rugged elegance." He believes local materials make a home inviting. When designing Tillotson's home, Krajeski gathered inspiration and materials from the surrounding area. He selected local river rock for the fireplace and used local pine for the hand railings, some of the furniture, and the floors. "I think all this goes back to the Adirondacks, where caretakers had months and months in the winter to make furniture," he said of the rustic style. Suddenly a twist of wood in the forest looks like the arm of a chair, or a banister. "All these elements start coming together. They have a real organic feel that when all is assembled, the place has almost a fairy-tale feel to it."

Krajeski also creates an outdoor ambience with his trademark waterfall shower. "It's part of that indoor-outdoor feel," he said. "You feel like you are really out in the wild."

The Western style is more about luxury and fantasy than about the simplicity of a rustic style. "The homes go beyond the rustic cabin, but they still have the capacity to be warm and cozy and intimate," Krajeski said.

LEFT A waterfall shower creates the illusion that one is outside bathing under some private cliff. "You feel like you are really out in the wild," owner Craig Tillotson said.

RIGHT The Western style embraces the craft of local woodworkers. Because of the enormous amount of building and interest in creating Western interiors, local craftsmen enjoy a booming business and the opportunity to create outlandish furnishings. A rustic bed built by a craftsman in Oregon makes a dramatic statement in this Utah ranch bedroom.

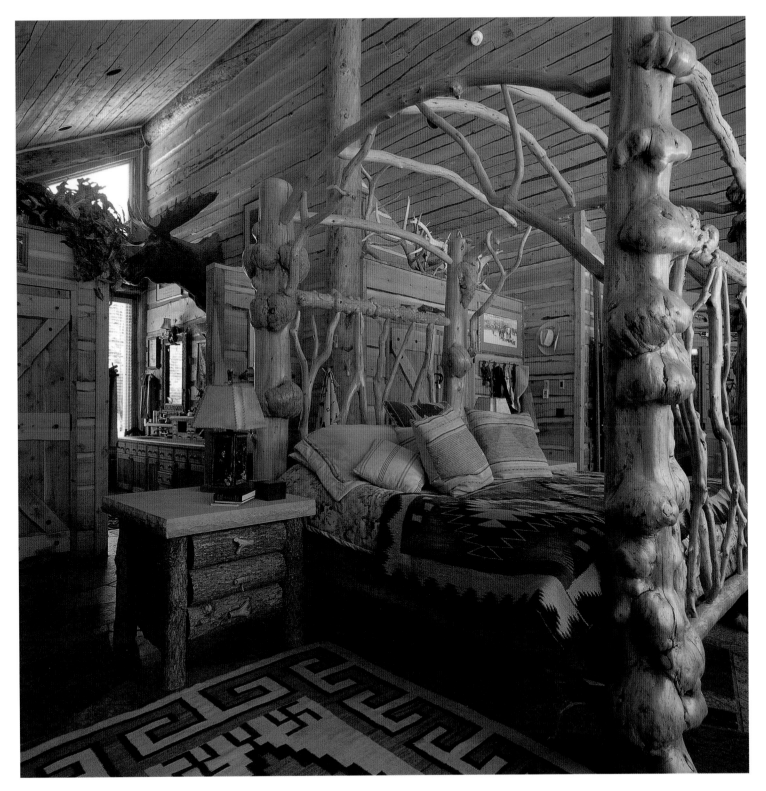

Cowboy High Style

RIGHT An old Santa Fe desk and an early cowhide chair, surrounded by a library of books on archaeology, Native American art, and twentieth-century art, provide a comfortable place for pop artist Bill Schenck to research.

BELOW An early Thomas Molesworth chair, circa 1933–34, and lamp on an old dude ranch table from the historic Bar BC dude ranch suit their adobe surroundings.

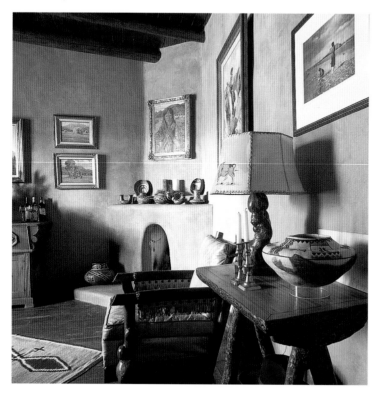

The Western style is about handcrafted local furnishings. Like the early craftsmen in the Adirondacks, cowboys made some of the first furniture out West. In the winter, they nailed together crude chairs and beds from the wood they found at their doorsteps. Inspired by rustic lodges in the Adirondacks, as well as pioneer shacks and the famous lodges out West, such as Yellowstone's Old Faithful and Yosemite's Ahwahnee, modern-day Westerners strive for an old-fashioned ambience.

Influenced by these early traditions, pop artist Bill Schenck collects and furnishes his Santa Fe adobe with Western furniture and Indian art. Schenck collects early dude ranch pieces as well as work by Thomas Molesworth, a popular Cody, Wyoming, artist from the 1930s through the 1950s. Molesworth was one of the first Western craftsmen to popularize a Western style. Almost as well known today as Gustav Stickley, Molesworth created roomscapes with handmade lodgepole club chairs, burled lamps, and carved cowboy scenes on couch and chair panels. He upholstered with Navajo weavings, covered the floors in Navajo rugs, and incorporated iron fire screens. He also understood the importance of humor. One afternoon a client caught him giggling as he tied two bullets onto a lamp in lieu of a simple on/off chain.

Although Molesworth furniture was designed for northern Rocky Mountain interiors, Schenck believes the style suits his Santa Fe home. "No one has really made the statement of Molesworth and adobe," he said. When asked why he likes this combination, he answered, "I think the question is why not? What I have achieved here is the feeling of an old lodge that could have been built by the National Park Service."

LEFT Western memorabilia is an important element of the Western style. A steer head from Texas and a pair of turn-of-the-century cowboy chaps catch people's attention at the Pioneer Saloon in Sun Valley, Idaho.

BELOW Skiers gather around the Pioneer Saloon's wood-burning stove after a long day on the slopes. An elk head and hunting photographs decorate the Pioneer Saloon in honor of the area's rich hunting tradition. The saloon was remodeled in the early seventies. The place captures the rugged cowboy and skiing history of the valley. An old Winchester bullet board hangs on the wall.

A Western Watering Hole

Western collectibles are an important part of a contemporary Western style. Cowboy equipment, such as chaps and guns, add an interesting element to the wall. Duffy Witmer of Ketchum, Idaho, enhanced the historical charm of the Pioneer Saloon, a Sun Valley bar since 1945, by hanging a collection of old things. The walls feature Boone and Crockett trophies, cowboy chaps, vintage ski photographs, and a collection of unusual Winchester boards featuring different styles of bullets. "I always wanted the bar to feel like a part of Idaho and a part of the West," Witmer said. After fifty years of business, the Pioneer Saloon retains its genuine ambience, where cowboys and movie stars mix in an environment rich with history.

BELOW The Pioneer Saloon, once called the Commercial Club, was built in 1945 and originally operated as a gambling casino by Otis Hobbs. A few years later the casino was closed for serving minors. The bar and restaurant has always attracted a lively après-ski crowd. Photographs, circa 1940, of past Sun Valley visitors hang on the wall.

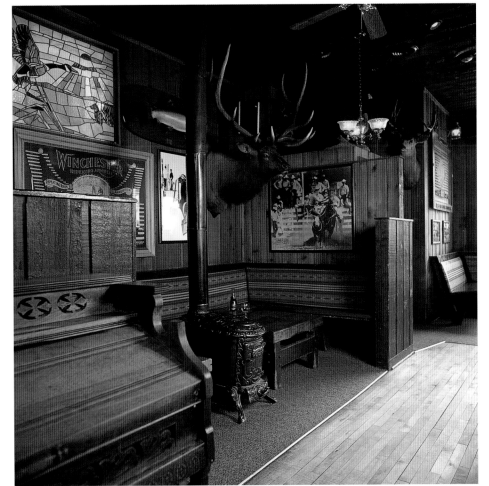

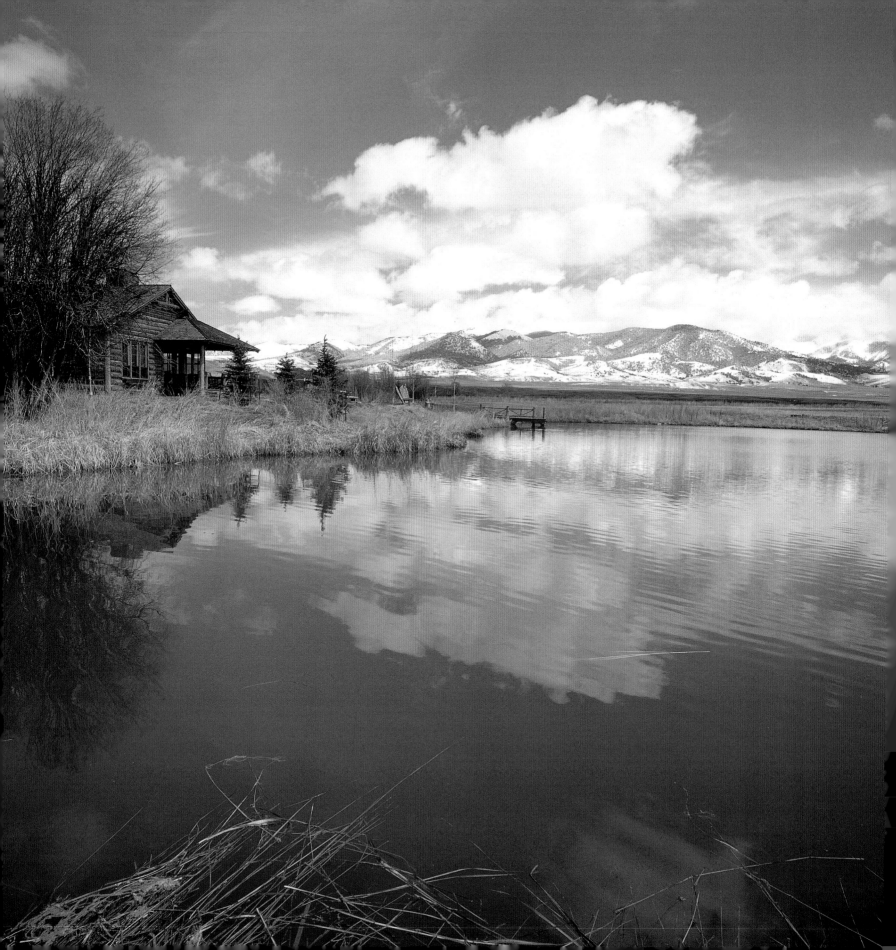

Designer Western

ABOVE The Western style has always incorporated a bit of whimsy. Here, designers Charles Gandy and Bill Peace turned a rusted galvanized bucket into a sink.

LEFT This cattle ranch, situated by an unnamed man-made lake, looks out over the Ruby Mountains, the Tobacco Mountains, and the Snow Crest range in southern Montana.

A family from Texas hired Atlanta designers Charles Gandy and Bill Peace of Gandy/Peace, Inc., and a local Montana team to create a Western home on their Montana ranch property. "We wanted to make the place quiet and understated," said Gandy. "We didn't want to be copycats or create cowboy kitsch. We wanted something comfortable but not too flashy."

The rest of the team understood the importance of understatement. "My concern is the relationship of the building to the landscape," said architect Candace Tillotson-Miller of Livingston, Montana. Tillotson-Miller believes homes shouldn't intrude, and all ranch buildings should relate to one another in a pleasing scale. She insisted on a meandering driveway relating to the swells and dips of the terrain.

Of utmost importance throughout the project, both inside and out, was the palette of materials. Yellowstone Traditions provided logs from the area that were used to accent this frame home. Bits and pieces of old wood from a woodpile made pleasing doors, trim, handles, and even thresholds. Twisted driftwood provided unusual screen door handles, towel racks, and shelves. Gandy and Peace loved these unusual Western accents and chose to carry this borrowed-from-the-environment theme throughout the interior design.

In addition to chenille sofas, rustic antiques, and English leather club chairs, innovative, whimsical surprises abound. Gandy and Peace turned a rusted galvanized bucket into a powder room sink, which shocked the cleaning woman.

The designers didn't stop there. They incorporated vintage fishing rods for towel holders and placed a long, skinny wooden bowl with pebbles from the stream on the robust oval dining room table. In all of the bathrooms, Gandy and Peace turned flattened corrugated roofing material from old barns into walls to create a real bunkhouse appeal. Farm implements from the ranch provided hooks for towels and clothes and unusual

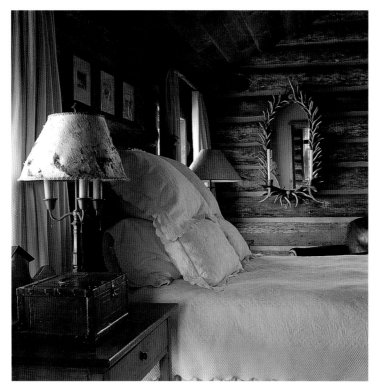

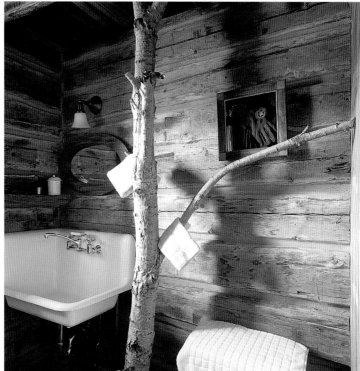

ABOVE, LEFT A bed made with white linens and earth-tone drapes softens this masculine ranch room. The mirror is horn. A 1930s leather chair provides a comfortable place to look out at the mountains.

ABOVE, RIGHT Everyone involved in this project strove to connect the house to the land. A branch makes a natural, whimsical towel rack in a guest bathroom.

PAGE 144 "The palette was drawn from a walk through the ranch, where we collected samples of sage, willows, stones, and bark," said Charles Gandy, who even went so far as to have rocks from the ranch shipped to his firm's Atlanta office. Branches and grasses and earth-toned Navajo rugs help bring the outside colors indoors.

PAGE 145 People who move out West must always be prepared to entertain guests. Tree-trunk bunk beds sleep six in this bunkhouse.

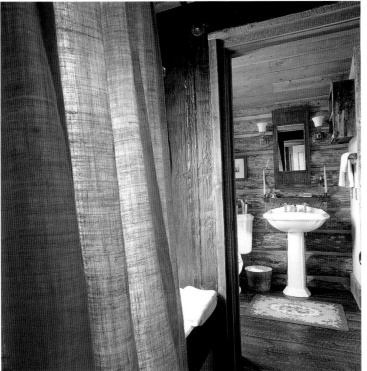

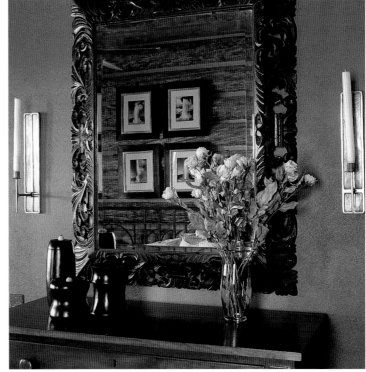

ABOVE, LEFT Crude materials from the outdoors help create a unique and weathered appeal indoors. Atlanta designers Charles Gandy and Bill Peace used corrugated metal to line the walls of this shower.

ABOVE, RIGHT Vintage Yellowstone photographs hung over a ranch gate headboard make a stunning local statement.

accents. One carpenter created a sconce from an old plowing disc and a tobacco can. Another understood the importance of age. When new fans arrived, he dismantled them, strapped the blades on his feet, and stomped around the grounds doing his work, buffing the blades with an old-time patina.

"Part of what we like to do is take the ordinary and make it extraordinary," Peace said. "I think we did that with the bucket and the tin and the cowboy hats hung in a straight line across a rustic wall in the living room."

PAGE 148 Although the designers Charles Gandy and Bill Peace tried to avoid kitschy items in this ranch home, they succumbed to a few such accessories because humor has its place in Western design. A papier-mâché moose tells time in this children's loft.

PAGE 149 Porches make wonderful living spaces in the summer, and during a chinook (a warm spell) in the winter.

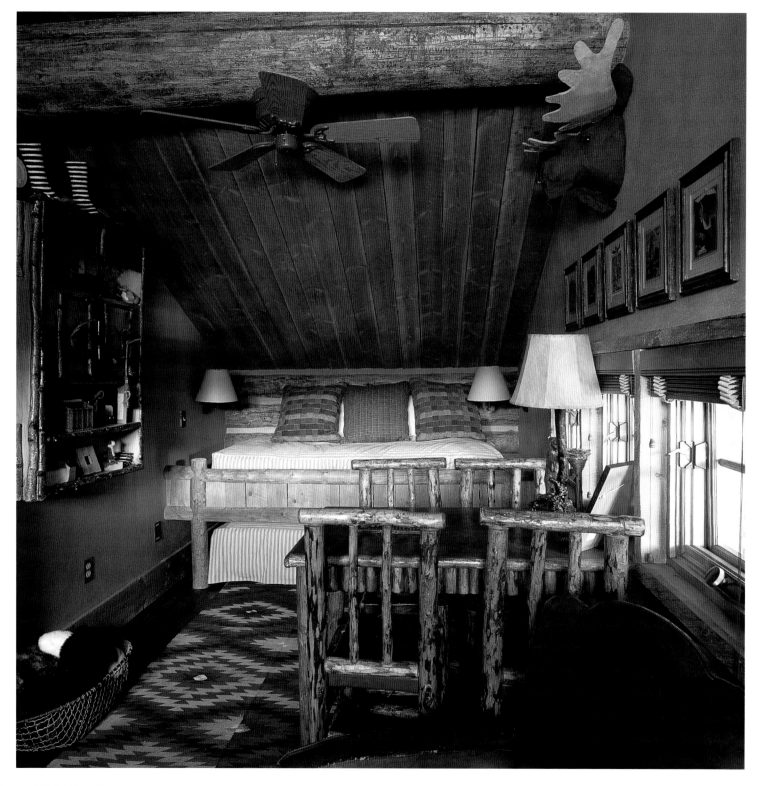

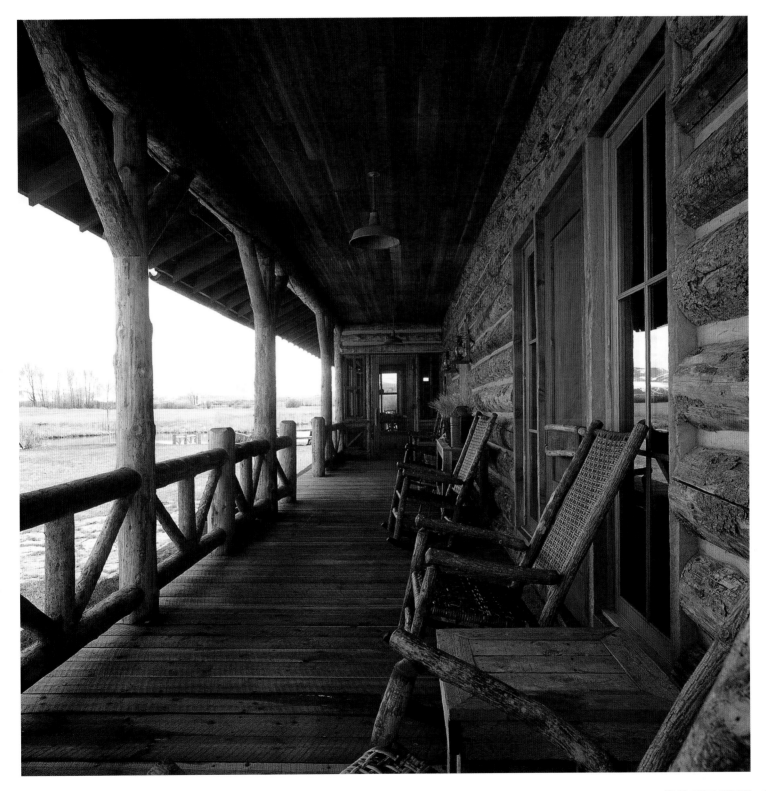

The integrity of Western style suffers from clichéd designs. This is particularly so in the Southwest, where prints of howling coyotes, turquoise walls, and Ponderosa pine furniture dominate design stores and even Wal-Mart's decorating department.

Heart of Santa Fe

"The Santa Fe style is very contrived," said Theo Raven, a native of New Mexico. "That's my feeling about Santa Fe style and that of a lot of us who live here. We always put a quote around it."

Despite her aversion for the "Santa Fe style," Raven wanted to create an interior that was in keeping with Tesuque, New Mexico, a small town a few miles outside Santa Fe central. The primary objective of Raven and her husband, Peter, was to invite sunlight into their home, so they designed walls of windows in the living room. After placing geraniums in the windows, Raven set about furnishing the rest of the room with her varied folk art collections.

Raven's heart collection inspires her interior design. In her living room, a French cabinet with a punched tin door and heart cutouts decorates one wall. A glass shadow-box coffee table holds a number of heart trinkets and antiques such as a turquoise heart, a seashell in the shape of a heart, *milagros*, and a Yakima Indian bag featuring hearts.

Other folk art pieces including a ceramic dog, several religious pieces on the fireplace, and a simple table transported to Santa Fe on a covered wagon add to the eclectic ambience. Simple shabby chic–style couches add to the home's charm without competing.

ABOVE An eccentric collection of items decorates a shelf in Theo Raven's kitchen: a collection of old wooden spoons, a wooden bust from Austria, a four-dollar oil painting of a pigeon, a German beer bottle, and a papier-mâché mouse made by her husband.

LEFT Theo Raven of Santa Fe, New Mexico, and her husband, Peter, designed a New Mexican territorial-style home that traditionally featured a pitched roof, ample windows, and exposed beams in the interior. Compared with the pueblo-style homes, the territorial houses are much more open. Raven created an inviting living room with comfortable couches and a variety of folk art pieces. In the forefront of the living room a small table, transported to Santa Fe on a covered wagon, is a charming addition. Raven loves her geraniums: "I feed them. I water them. And I'm always telling them how gorgeous they are."

Nathalie Kent, formerly a French editor, is drawn to the romantic symbolism of the West, in both the cowboy and Indian elements. Kent moved to Santa Fe because she has always had a fascination with the American West. In Paris she wore broom skirts, Navajo belts, and cowboy boots to Chanel shows, and on the weekends she gathered with a club of people who loved tipis and Indian traditions. "I love traditional things. I love to put together things that are traditional. It doesn't matter where they come from," she said.

Old Glory

Kent's home in Santa Fe mixes cowboy collectibles with Indian items and Moroccan antiques. Her greatest love, however, is for America's cowboy history. "I think it's the deepest root America has," she said. Woven American flag blankets, miniature Indian-made American flag dolls, and real flags attest to her enthusiasm for the West's past.

Kent also enjoys Indian arts. She designed the navy blue wool blanket over her bed to look like the blanket Dustin Hoffman wore in *Little Big Man*. From friends she learned to do the beadwork, which she sewed onto brain-tanned deerskin from Germany. The blanket also incorporates horsehair designs, a traditional Indian craft.

ABOVE An evening flurry sticks to Nathalie Kent's Santa Fe balcony.

RIGHT "I'm an American flag nut," said Nathalie Kent, who decorates her bed with one. She made the blanket above the bed, which is a replica of the Indian blanket Dustin Hoffman wore in *Little Big Man*. Friends taught her to do the beading over brain-tanned deerskin. The blanket also features dyed horsehair. The sculpture is called *Sacred Arrow*, by Santa Fe artist Lincoln Fox. A Moroccan lamp sits on a Moroccan table, inlaid with ivory and ebony and featuring marquetry.

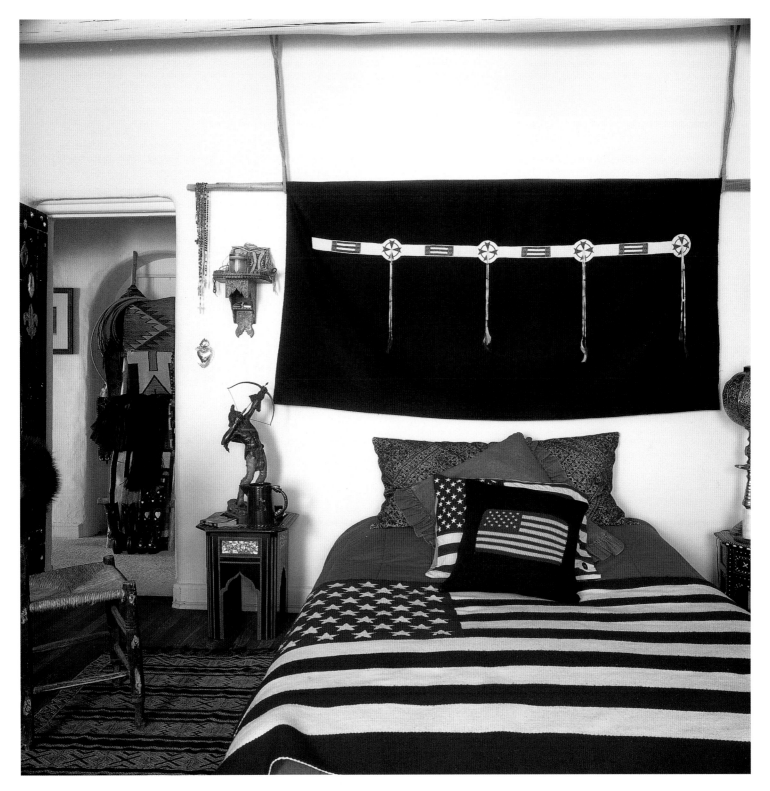

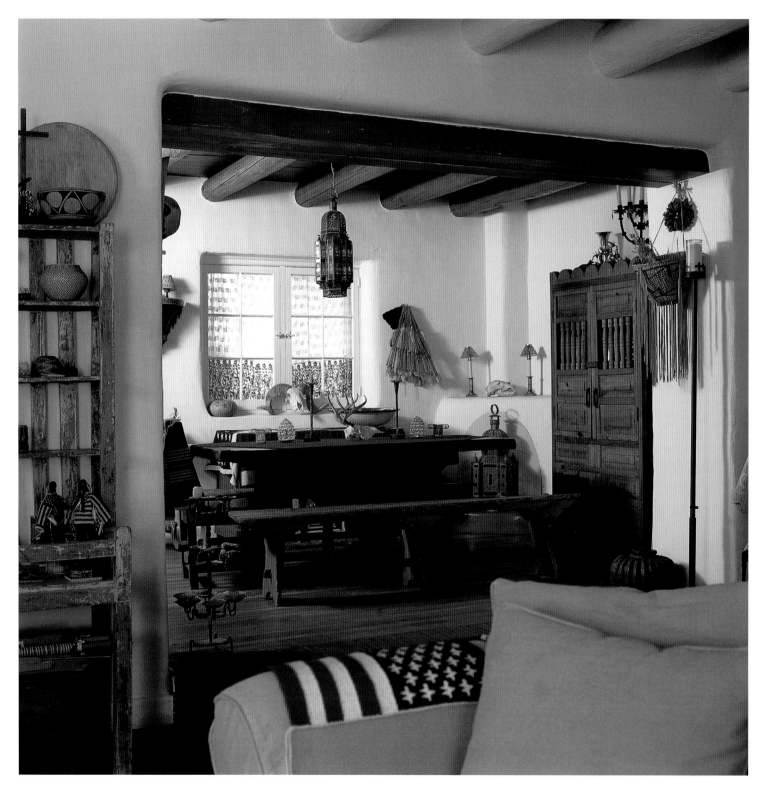

ABOVE Garlic and a wooden spoon made from a gourd hang in the kitchen. A few arrows and a photograph of Canyon de Chelly complete the design. "I love traditional things put together. It doesn't matter where they come from," Kent said.

LEFT An old turquoise Mexican cabinet holds Kent's collection of old and new pots, beaded moccasins, and handmade American flag dolls by artist Rita Iringan. Nathalie Kent uses a farm table made by a friend in her dining room and two benches from a French flea market. The trustero, a traditional Spanish cabinet, from the fifties is filled with all of her Mexican dishes and her tools for sewing and punching tin. A Brazilian headdress hangs on the back wall. The antique chandelier is Mexican.

RIGHT Nathalie Kent's Syrian desk features inlay of ebony and ivory and marquetry and an old-fashioned bell once used to call servants. The mirror is from Tangiers. A Carl Moon picture hangs on the wall.

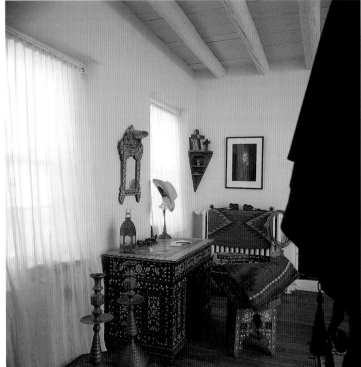

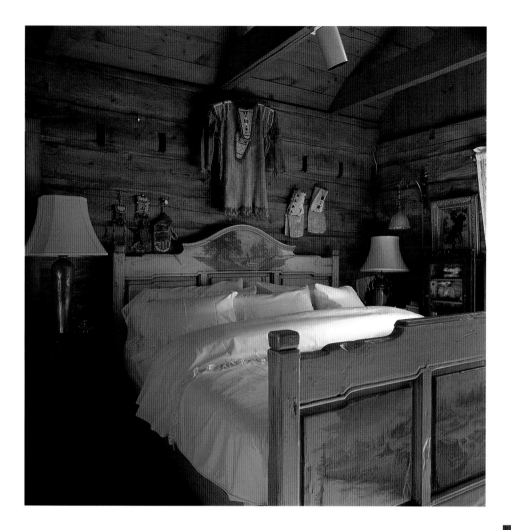

LEFT Compton commissioned an artist to paint bluebonnets and scenes of Texas on her pine bed so she wouldn't get too homesick for her home state. An Indian war shirt hangs above the bed.

BELOW "I like to mix things up, stir it up a little," said interior designer Zoe Murphy Compton about her 1877 country house in Emma, Colorado. In her dining room, an English table, English ladder-back chairs, and a collection of horns mix beautifully with an early cowboy oil painting from a Fort Worth Woolworth's.

Crystal 'n Cowboys

Funky old items mark the Western style. The glorious patina of weathered folk art pieces, the simple shapes of a farm chair, and even a five-dollar tablecloth express such charm, and invariably they reveal a great story. For many, the sentimental value of an object far exceeds the original cost. "Nothing is just here to look pretty; each piece tells a story about my life, about where I've traveled," said interior designer Zoe Murphy Compton of her farmhouse in Emma, Colorado, a town near Aspen too small for a post office.

Because Compton is from Texas, she commissioned an artist to paint bluebonnets on an old pine bed; an Indian collection reflects years of flea market shopping, and a collection of cowboy boots and vintage linens divulges a delightful passion for old Western clothing.

For Compton, who wears her pearls when she cuts calves, the Western style is about juxtaposing unlike treasures. "I love the textures of the country style, but I've never been able to do without the silver or crystal vases. I love that mix. I think it is timeless," she said. "I don't like my house to look all the same. I like to stir it up." When Compton entertains on her English country table made of barn wood, she loves to set it with her family silver and her fine crystal. "Because you have silver on the table doesn't mean you have to come to dinner in your tux," she said. Compton isn't afraid to hang an ornate turn-of-the-century glass chandelier in a room with horns on the wall and an oil painting of cowboys that once hung in the old soda fountain in a Woolworth's in Fort Worth, Texas.

Compton refuses to use mundane stainless steel sinks in her home. "They aren't much fun and they don't make me smile," she said. So she designed this hammered copper sink for her kitchen. A splendid collection of antique crystal sparkles on the back wall.

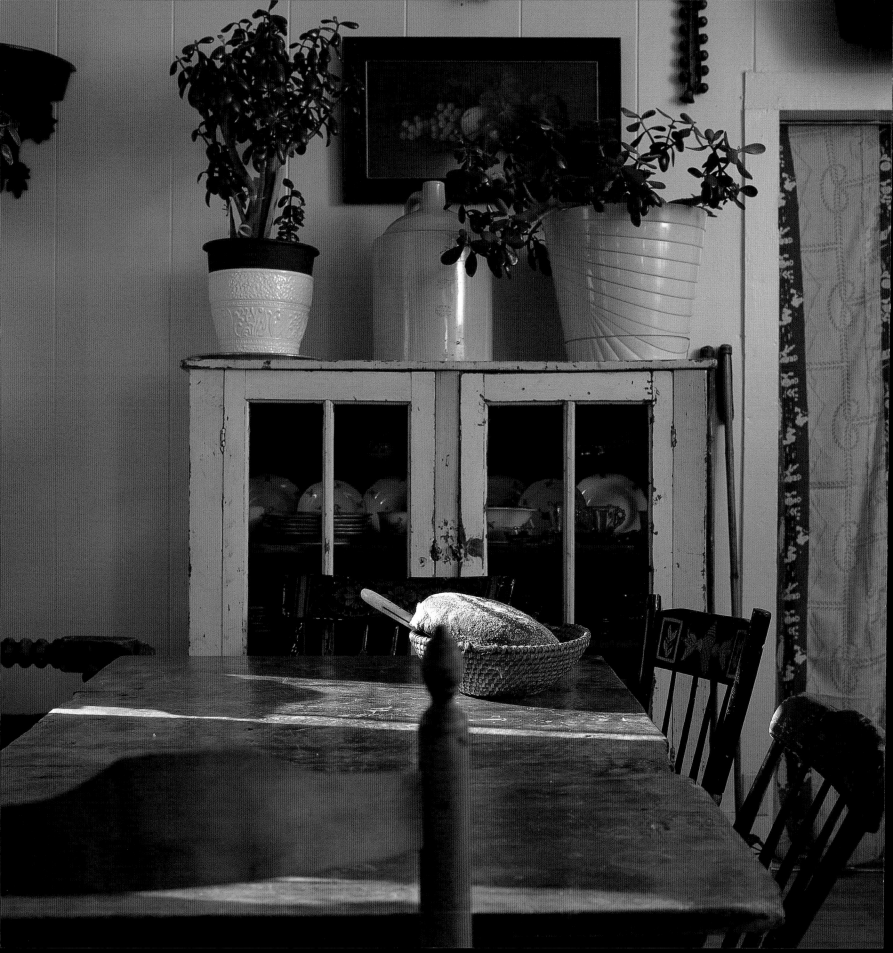

A Colorado Collection

Rebecca Callender, who has an antique shop in Minturn, Colorado, also collects old Western things. Her home, furnished with early Colorado furniture, reflects her respect for Colorado history. Callender fell in love with a plank-board table because a horse had taken a bite out of the tabletop. Worn cowboy spurs, woolly chaps, and oil paintings steep her home in Western nostalgia.

Several years ago, Callender desired an old Western house, so she called up a real-estate agent in Minturn, who said Old Man Bocco's house was for sale. Bocco had been a railroad worker and a founder of Minturn in the 1870s.

"Put it under contract," Callender said

"Don't you want to look at it?" the agent asked.

"I don't need to look at it. All those old places look the same. They're all kind of slanted and I must say all the settling the house is going to do, it's done."

To buy the house, Callender sold "everything I'd ever stashed away," and started to decorate from scratch "piece by piece." She purchased old ranch furniture, collected a pie safe, and got a Victorian bedroom set from a neighbor. Old cowboy boots, Indian baskets, rusted signs, vintage lamps, and a lovely vintage lace curtain all have added to the charm of her home at one time or another. "I'm always changing things in my house and that's what keeps it fun," she said. "I call it upgrading."

LEFT Eighteen-sixties chairs pull up to a single plank-board table from Colorado in Rebecca Callender's home in Minturn, Colorado. An early pie safe holds the owner's china.

RIGHT An early oil painting from Colorado hangs in Rebecca Callender's modest sitting area. A lariat, once used on the range, now makes an interesting wall hanging.

LEFT Old lace curtains from a Minturn rummage sale create a romantic simplicity in this 1870 miner's cabin. A red chopping block came off a Colorado ranch in Salida.

RIGHT "Collecting antiques is a treasure hunt. Once in a while you hit and you feel really good," Rebecca Callender said. Callender acquired this Victorian set when her neighbor called her on a rainy day in April. Because the dresser had a bonnet box, Callender knew the set was late 1800s.

BELOW Decorating with cowboy collectibles is popular out West. Old gear such as chaps and spurs and saddles, which can be purchased in Rebecca's Antique Accents, create a meaningful Old West ambience.

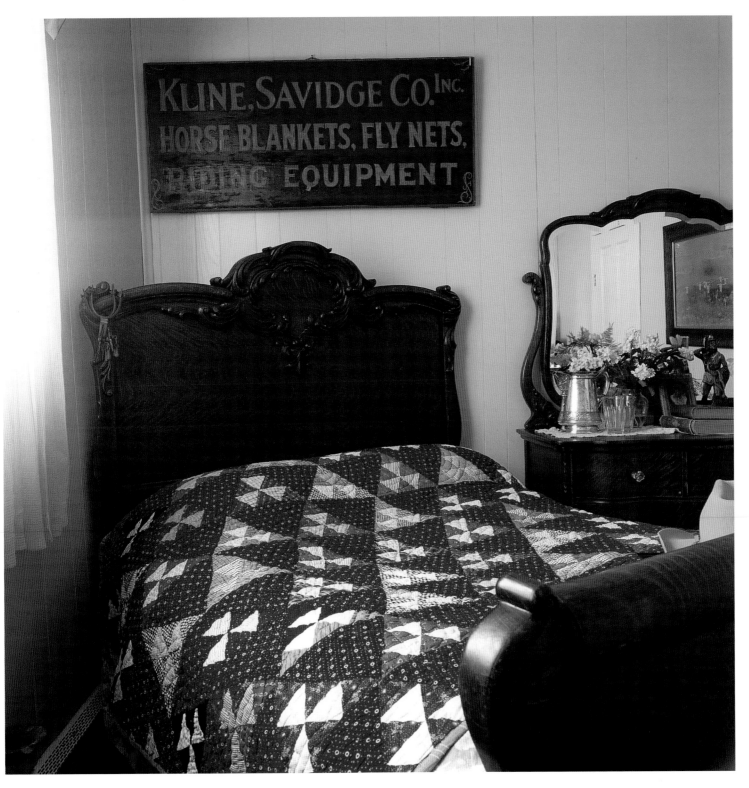

A Western home doesn't have to be an old cabin or building to be in keeping with Western traditions. More and more people are mixing rustic elements with more contemporary designs to create a Western home.

Sun Valley Sentimentals

After their children were grown, Frank and Suz Cameron of California decided to move to the mountains to work and enjoy a more outdoor-oriented lifestyle. Because they had owned the Pioneer Saloon in Ketchum when they were in their twenties, they returned to Sun Valley in the Sawtooth Mountains. They also chose the area because years before, they had fallen in love with a contemporary Western home. They were convinced they could live in Sun Valley if they lived in a house like that.

When Suz first saw the house, with windows on all sides and a mixture of adobe and log, she cried: "I burst into tears. It was the house I'd been drawing since I was little and here someone had built it." Trees surround this organic home, featuring earth-tone walls and log beams that celebrate both Native American and pioneer culture. A stream runs underneath the home and pools in a private garden. The house also has 360-degree views of the mountains.

The Camerons pursued the owners for years with offers. Finally, when they had already made up their mind to move to Sun Valley, the owners called to sell them the house. The Camerons purchased the home, and they moved in thirty days later.

The Cameron house has proved to be the sanctuary they had hoped for. And the mountain lifestyle suits this couple. "The people are welcoming," Suz said. And she finds she can organize her day to fit in both work and outdoor activities. "It's a lot easier to do things here. We're not fighting crowds all the time."

Years later, this couple enjoys the light and the open floor plan of the home. "For me light was critical," Suz said. "And being able to go outside from every room."

LEFT A Sun Valley home, designed by architects Jim Ruscitto and Thad Blanton and the previous home-owners, Bill McDorman and Barbie Reed, combines the design elements from the northern and southern Rockies by mixing lodgepole and adobe. The organic shape of the home and the numerous windows make living inside an outdoor experience. A simple selection of furnishings works well with the contemporary structure.

PAGE 164 The organic curves inside the building mimic the natural surroundings outside. What makes this home so unusual is the number of windows and doors to the outside. The winter views are especially beautiful. "The creek and the pond cover over in sculptural forms, and because the willows and aspens have lost their leaves, we can see mountains all around us," owner Suz Cameron said.

PAGE 165 Five chairs designed by Ron Mann of San Francisco surround this glass table with a log base. Recently a dinner was interrupted as guests watched the full moon travel around the house.

The Hubbards imagined a Western home, but not the "standard log cowboy kind." By combining antique timber ceiling beams and floors into a modern structure, Jackson Hole architect Mark Brown helped his clients achieve a unique Western style. "Simplicity was one thing we were really interested in," Penny said. "And we wanted to bring the outside in."

Room with a View

The master bedroom, which faces the Snake River, has windows on three sides; old beams highlight the ceiling, and white walls create a minimalist ambience. A few Western antiques decorate the room, such as fishing creels and an Arts & Crafts table and chairs by Charles P. Limbert. The chairs came out of Yellowstone's Canyon Lodge. On cold winter mornings, from their pencil poster bed, the Hubbards watch steam rise from the river and moose tromp through frosty bushes. "It looks like an icy fantasy world," Penny said.

The Hubbards wanted to create the feeling of a barn, but not exactly. As in their bedroom, old beams hold up the ceiling in their great room. Brown likes working with the old materials not only because of their rugged patina, but because of the old-growth timber's strength. "It's also easier to work with because it has already shrunk," he said. The contrast of rustic elements and modern design inspired Brown: "By not copying old buildings, I feel much freer. There is an opportunity to create. Copying has never made much sense to me."

FAR RIGHT The owners of this Jackson Hole home kept their bedroom simple. The view of their backyard, a quiet forest and the Snake River, make this room a romantic spot. "Every bit of changing weather shows up on the river," Penny Hubbard said. Hubbard Cabinet Makers of Butler, Maryland, inspired by an eighteenth-century design, built the pencil poster bed out of curly maple. An Arts & Crafts table and chairs built by Limbert decorate the left side of the room. A black-and-white photograph by S. N. Leek of elk in Jackson Hole hangs on the wall.

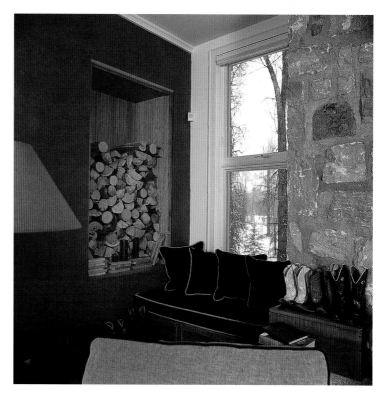

RIGHT A collection of children's boots, a stack of wood, and snow outside are all elements of the Western style. This window seat is one of two that surround the Hubbards' fireplace in Jackson Hole, Wyoming.

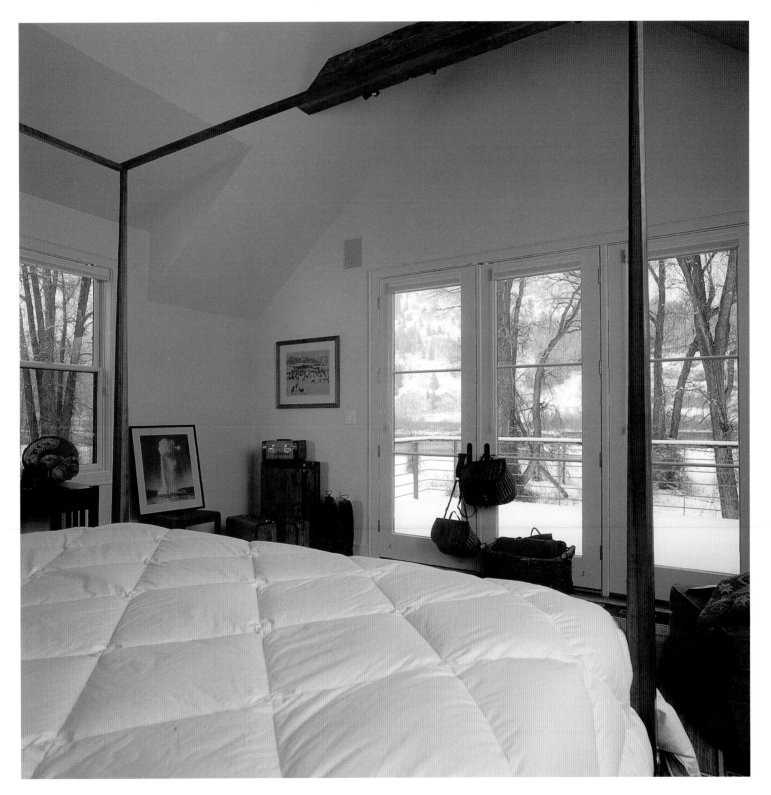

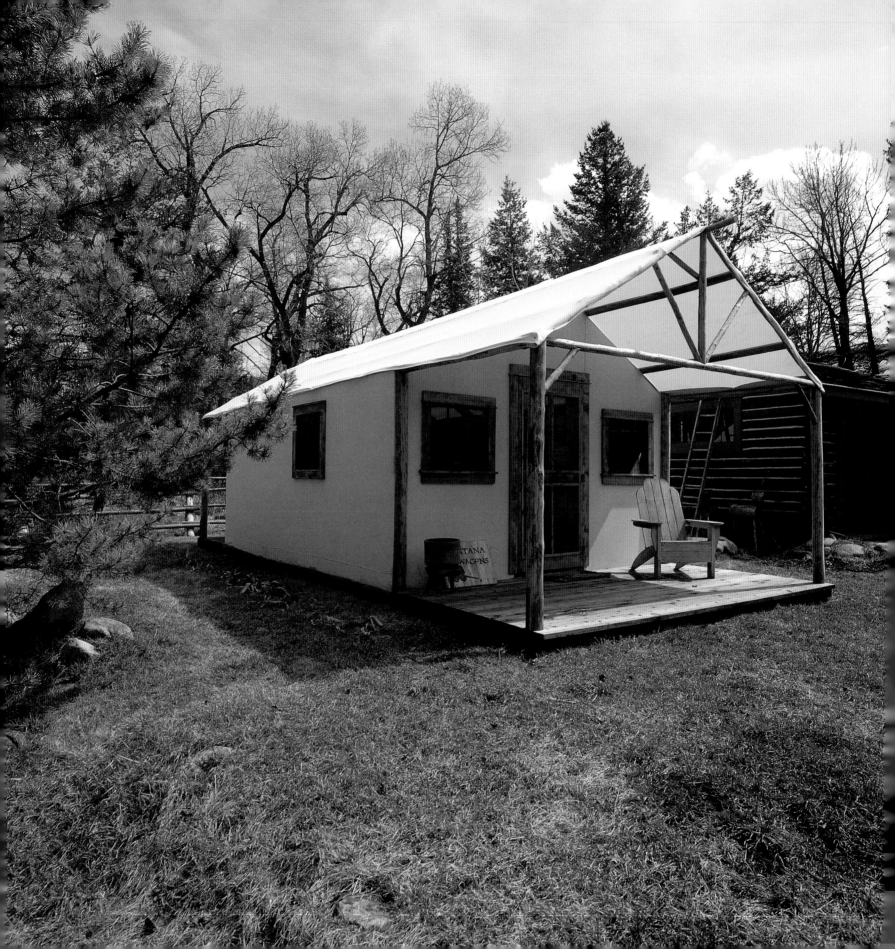

"Roughing It" in the Wild

For the person truly committed to living like a pioneer, log cabin builder Terry Baird of Big Timber, Montana, and designer Hilary Heminway of Connecticut and Montana design sheep wagons and wall tents. Both these primitive spaces are furnished with a few luxuries: a comfortable bed, old-time quilts, a wood-burning stove, kitchen utensils, and a few shelves for storage.

Baird says he could survive in one of his tents all winter if he lived by a stream and knew about edible plants. He says the secret would be to have two wood-burning stoves. He'd light one before he went to sleep, then in the morning he'd jump out of bed and light the other prepared fire. "Then I'd run back to bed and wait ten to fifteen minutes for my tent to heat up again," he added. For those whose fantasy involves a closeness to nature, sleeping in moonlight, and a simple life, the tent provides this, if only for a few nights.

"When you live in a tent you can hear the birds, the wind, the elk bugle," Baird said. "The tent encourages one to be more in tune with nature. Granted, a bear scratching at your tent is more terrifying than one scratching at your cabin door."

What makes Western shelters so unusual is the juxtaposition of a comfortable, cozy interior with wide-open spaces. A comfortable living room with a roaring fire or a warm tent interior is particularly inviting and romantic when a snowstorm rages outside.

LEFT A tent provides a romantic shelter in a backyard or in the back country. This Western-style outfitter's tent, designed by Terry Baird and Hilary Heminway for a client, can provide extra space for guests or a honeymoon suite for two.

PAGE 170 Furnished with a floor and a rustic bed, this tent makes living outdoors easy for anyone. A small stove keeps the interior warm on a frosty night.

PAGE 171 Builder Terry Baird and designer Hilary Heminway enjoy making their tents unusual retreats. Both like combing antique stores for unusual furnishings and accessories. This tent features old cowboy books, a weathered bench, an old oil painting, and early cowboy photographs.

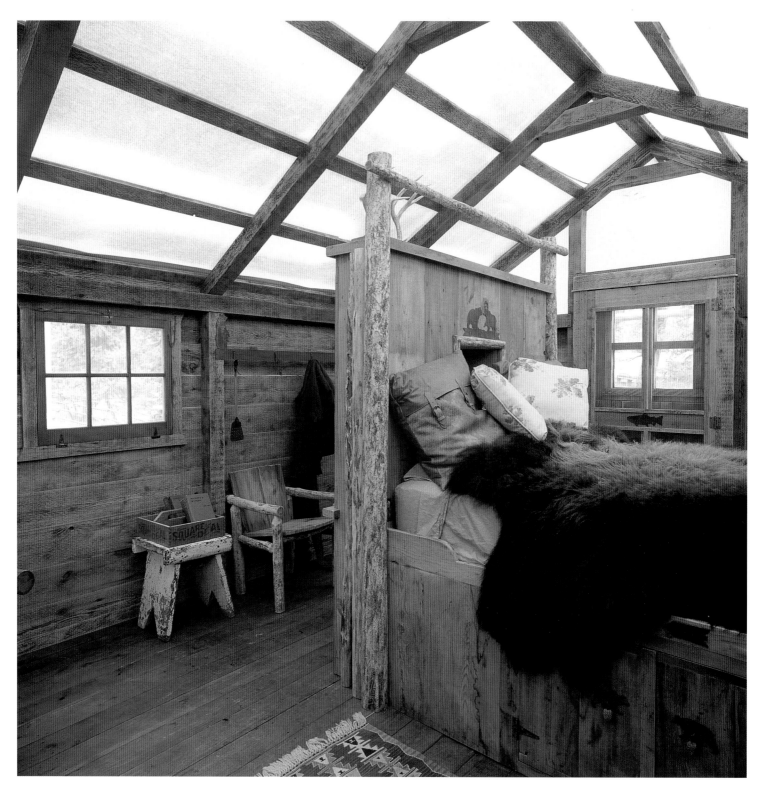

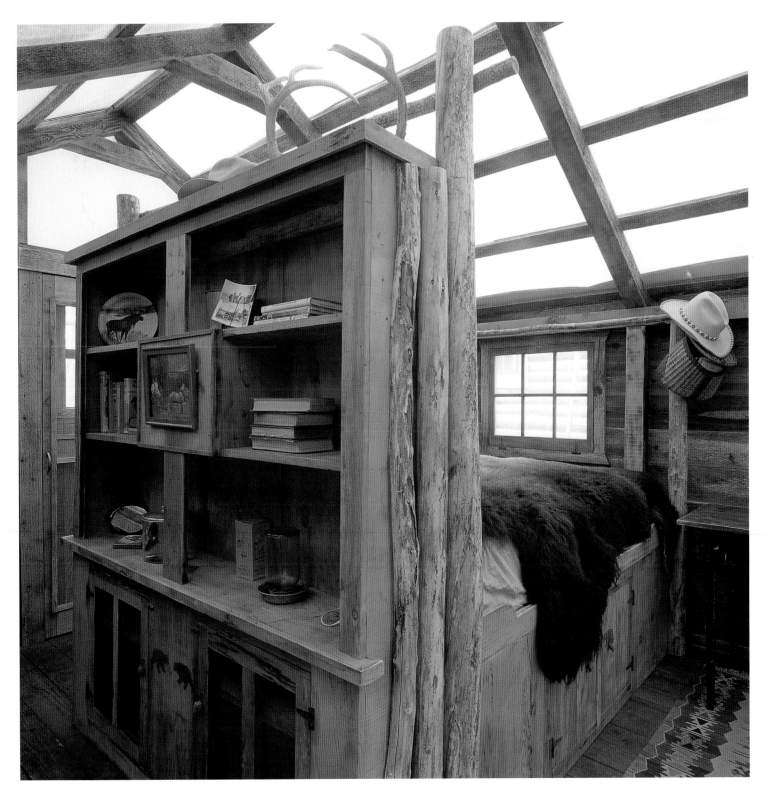

A Taos Hideout

David Smith, originally from the New York area, has lived in the West for years. Recently he purchased an old estate in Taos, New Mexico, which had never been on the market in the twentieth century. Smith's 100-year-old adobe, surrounded by sagebrush, sits at the end of a dusty dirt road. The smell of sage and piñon mixes with the fresh mountain air. The single-story adobe seems to have grown out of the soil. A low wooden front door, framed by two turquoise Moorish-style lamps, provides an unusual entrance to what was once the home of Scottish artist John Young-Hunter.

In the early 1900s, Young-Hunter, who painted portraits of the likes of the Andrew Carnegie family and Winston Churchill, discovered this adobe a mile out of Taos, adjacent to the Indian reservation. "It consisted of a two-room adobe house, one room of which was a stable, a little land, and a few apple trees," he wrote. From the home, he could see the jagged Sangre de Cristo Mountains. Closer to home, piñon, cedar, and spruce spread over rolling hills. Charmed by the place, Young-Hunter paid 200 dollars for it. For the first twenty-five years, he split his time between the Taos artist colony and New York, but in 1947, he moved to Taos permanently.

David Smith has a similar passion for the simple, magical beauty of the Southwest and this property. He respects the history the home holds and the privacy it offers. To complement the historic interior of carved Greek-style columns and Spanish portals, Smith placed a few pieces of good furniture. He dines on a table made of 200-year-old cherry. In what was once the stable, Smith sits at his desk in a family chair that is older than this country. His home also includes an extensive library and African art, gathered from travels abroad.

After a quick ski at the resort only half an hour away, Smith likes to return to his home and enjoy the sunshine in his backyard. "I like to lean against a warm adobe wall and listen to the Indians drumming next door, something they've been doing for hundreds of years," he said.

David Smith's dining room features a hand-painted door with the crest of the former owner, John Young-Hunter. Old Spanish mission chairs surround the dining room table made of 200-year-old cherry boards.

Elk horns from the area provide unusual decoration in this ancient adobe. The mirror is a family heirloom from David Smith's grandmother's house.

ABOVE The breakfast room features an early Hollywood film poster. The artist used house paint on a canvas of wheat bags. Skis lean up against the back entrance of the house, where the owner can make a quick getaway for the slopes.

RIGHT Smith enjoys this office, which once was the stable. The mask over the fireplace is from the Bobo tribe. The original fireplace came from Scotland. The gilded gold Corinthian columns were hand-carved by John Young-Hunter, as was the door on the left. And the chair at the desk, which has been in Smith's family for years, is older than this country.

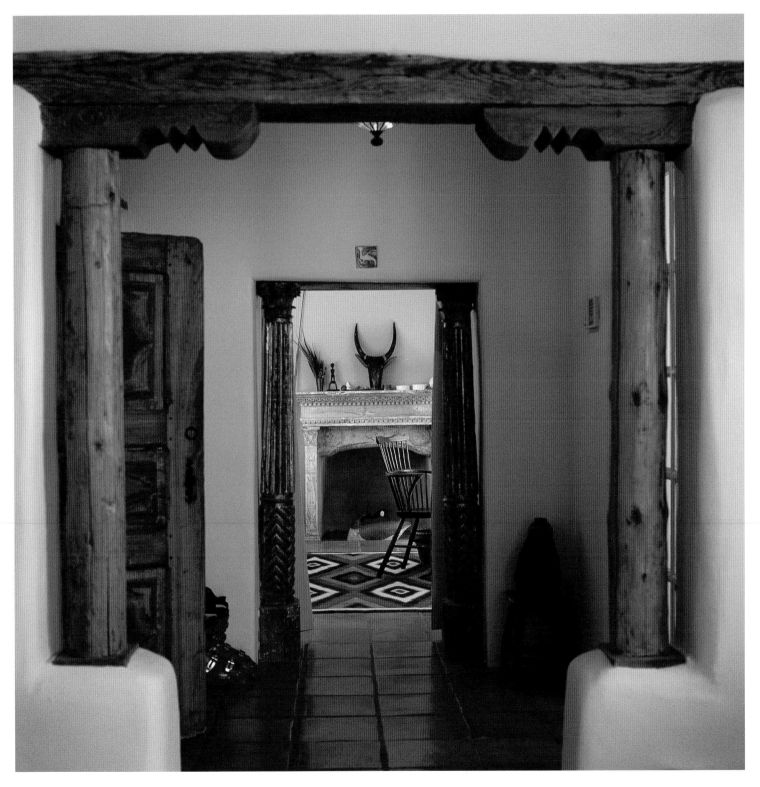

Judy Espinar and her husband Tom Dillenberg, longtime New York residents, decided to sell their fashionable city apartment and move to Santa Fe. After visiting the area on a Whitney Museum trip, they fell in love with the casual atmosphere and the rich folk art tradition. Judy dreamed of opening a pottery store, and both she and Tom wanted to live outdoors more. "My husband's family had a ranch in Montana and we were just dying to get out in the open space," Judy said.

City Slickers Move West

After moving, they searched for the perfect home. The Dillenbergs imagined something old, so when an adobe with a seventeenth-century room and eighteenth-century beams from the nearby Nambe church came up for sale on the popular Canyon Road, they purchased it. The couple decided against the typical Santa Fe style. They wanted to incorporate some of their fine European pieces from their previous home, but they weren't sure how. So to help them integrate their antiques with the Southwestern-style building, the Dillenbergs hired friend and New York designer Robert Turner.

Instead of transforming the home into the traditional Santa Fe dwelling with white adobe walls, Navajo rugs, and primitive furnishings, they chose to create a more Mediterranean or North African feel. And they decided to keep all of their New York furniture. The living room, although more casual than the New York version, features a Russian Empire table, a Biedermeier chair covered in leopard skin, and two Russian Empire chairs. Velvet paisley covers a long sofa set under the window, and a Venetian mirror hangs on the wall. A collection of contemporary pottery, including pieces by George Ohr and Beatrice Wood, is also on display.

LEFT A Biedermeier chair shares quarters with a Moroccan table and an early John Singer Sargent painting. The painting is Sargent's copy of a Rembrandt.

BELOW In the front hallway of the Dillenbergs' home in Santa Fe, candles sit on an old trestle table from Mexico. The candlestick is from Morocco and the sconce is Art Nouveau. When they entertain, candles flicker in every room.

"We respected the architectural elements, but we just did things that are not typical of the region," Turner said. When people step off of Canyon Road, "the most typical Santa Fe street," into the Dillenbergs' home, their first reaction is usually one of shock.

"I think it is better that they didn't copy others," Turner said. "I think one's home should reflect the personalities of the people who live there."

The one concession the Dillenbergs made to living in the West was to make the home more casual and durable than their New York apartment. "The colors and fabrics we chose are rich, but they are by no means precious. It is a livable house," Turner said. "We thought the colors were also an exceptional background for the Dillenbergs' pottery and folk-art collection. Everything took on a new life."

The vibrant walls also made the house feel cheery in winter. The choice of colors like pumpkin and tomato red impart a warm and informal ambience to this dark home. The paints were all mixed repeatedly to achieve the exact colors desired, which were then covered in a glaze. "In winter there is so much snow that after a month of heavy snows, the traditional white walls get to be numbing," Judy said. When the Dillenbergs come from the snowy outdoors into their home full of Mediterranean colors, they feel uplifted.

ABOVE The beams and corbels in this old Santa Fe adobe came from a 1729 church in Nambe, a nearby village. An early Santa Fe painter built this home, adding on to an existing seventeenth-century room. When the Dillenbergs moved to Santa Fe, they searched for an old home. New York designer Robert Turner helped them create a sophisticated ambience inside this historic structure.

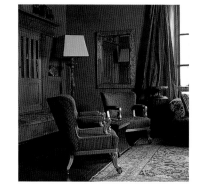

RIGHT The Dillenbergs enjoy relaxing in this room featuring their collection of modern pottery from all over the world. The walls were painted red to accentuate the colors in the pottery. The sofa is covered in French damask.

LEFT A Venetian mirror and a pediment from the Nambe church create an unusual, but interesting, contrast. The Dillenbergs' collection of George Ohr pottery sits on top of the cabinet. The metallic fish is by Beatrice Wood.

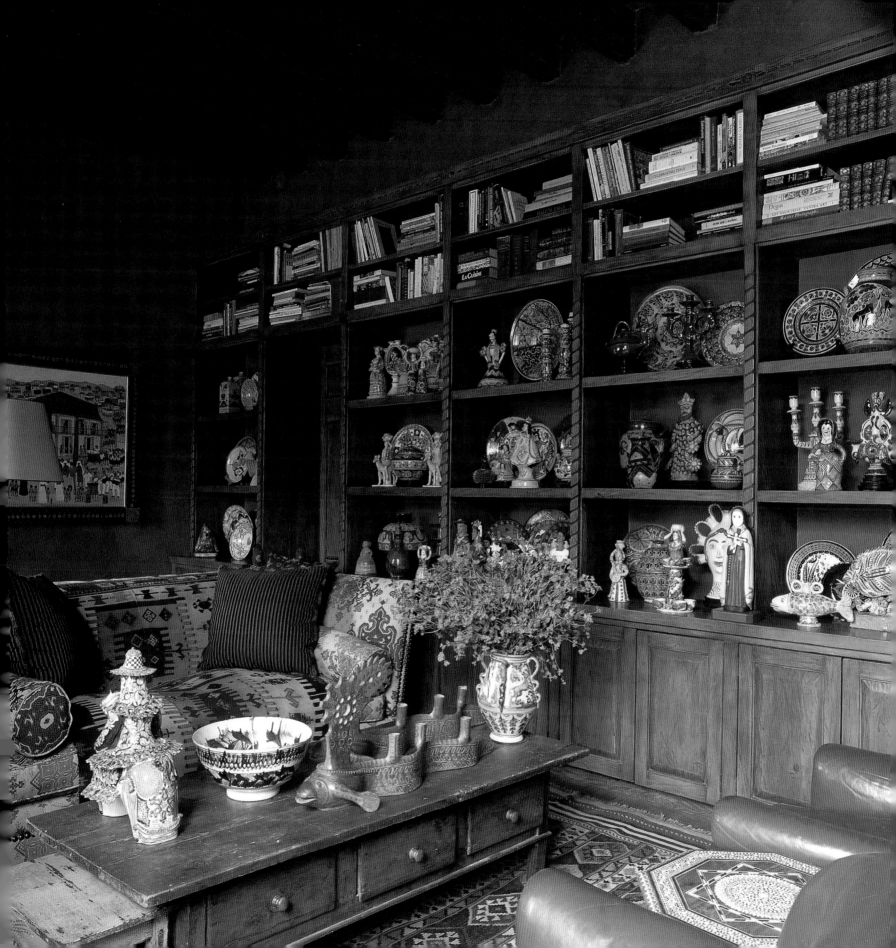

Color was also important to artist Greta Gretzinger, whose personal style resembles nobody else's. When she moved out of her 300-square-foot log-cabin trailer into a new, much larger trailer, her first priority was to paint. "My first goal was to cover the seventies brown paneling," she said. First, Gretzinger painted the walls with pink, lavender, and purple; then she painted gold swirls. "I didn't want white walls because there is enough white outside in winter. We see white all day long," she said.

Rocky Mountain Trailer Style

Gretzinger lives in a trailer because the trailer is what she can afford. But she also likes the aesthetic. "I like the seventies trailer style," she said. Soon after moving in, Gretzinger started the decorating process. "I think every house suggests to you what it wants to be," she said. "This place wanted lots of color and didn't want to be taken very seriously." Gretzinger never dreamed of hiring a decorator. "It's so impersonal," she said. "I would feel like just another knickknack in my house, if someone else designed my home." When Gretzinger decorates, her things gather haphazardly: "I don't really think about it. It's just a matter of trying things."

Shopping for household decorations is an art. "I never go around looking for a certain item. I just look for stuff. It's all part of that hunting and gathering thing," Gretzinger said. "I call it magpie shopping. I snatch up anything that looks bright and shiny and looks real glittery."

ABOVE, FAR LEFT Inside Greta Gretzinger's trailer, a glorious clutter of objects crowds every available space. "I'm all for personal expression," she said. "I think that's what people should do. It's the difference between creating your own fantasy and going to Disneyland and having them provide it for you."

ABOVE, LEFT Gretzinger wouldn't dream of hiring an interior decorator. She loves to add to her collection gradually as she finds things. Many of the objects are gifts: "Every once in a while there is some strange thing, some gag gift, that gets passed around, then gets to my house and doesn't get given away."

BELOW, LEFT A reminder to feed her neighbor's cat, Domino, assumes unusual importance tacked onto the wall. Looking around her interior, Gretzinger laughed, "I'm sure this shows that I am very ill."

BELOW, FAR LEFT A view through plastic window covering, devised to keep her home warm, is of a ski jump Gretzinger built in her backyard. An eccentric clutter of objects occupies the kitchen table.

Southern Belle in Big Sky Country

Embracing a personal style makes all the difference in a home. One of the most unusual homes we came across was a Southern mansion, built in the sixties, in Paradise Valley, Montana, where log cabins, Victorians, and ramshackle shanties have been the style for one hundred years.

Rancher Warren DePuy grew up in the state. His parents homesteaded in 1905. Late in life, DePuy built his Southern mansion from a calendar photo of the Orton Plantation in South Carolina. His wife, Eva, disapproved. "That was Warren's idea, not mine!" she said. "He always admired the architecture of the South. And it's fine if they'd just keep it in the South. But it don't belong here."

But Warren DePuy didn't care what other people thought. Although he was wealthy, he dressed like a sheepherder in long johns and floppy old hats. "One winter he was in Livingston in his ratty wool pants, his old coat and hat. He walked by the welfare office, and a man came running out saying, 'Gee, can we help you?' My father thought that was so funny," said his daughter, artist Cheryl DePuy Murray, who now lives and works in the mansion.

A Southern mansion built in the sixties by rancher Warren DePuy just outside Livingston, Montana, stands tall against a winter sky and the Absaroka Mountains.

RIGHT A nine-and-a-half-foot knife and a seven-foot fork with ivory handles from the 1905 World's Fair in St. Louis hang in the art studio of Cheryl DePuy Murray in Montana. Her father saw them as a child, then purchased the cutlery much later at an auction. Murray's mother, Eva Eyman, rode in the old surrey to town to exchange eggs and milk for groceries when she was young. The cottonwood ox yoke makes a stylish chandelier. The Scottish highlander bull above the knife and fork was raised on the DePuy ranch.

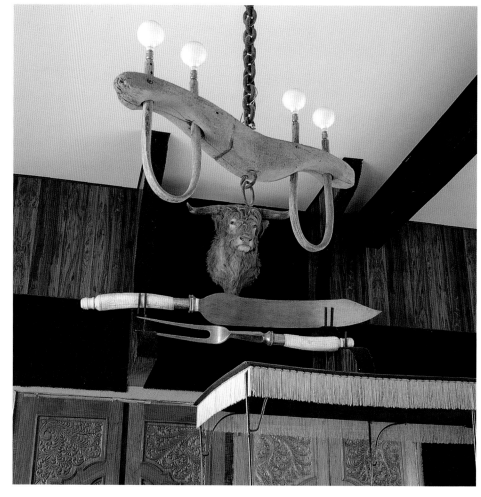

DePuy's Southern mansion took eight years to build, and as his daughter admits, it's still unfinished. DePuy had very few plans, and worked with a number of carpenters until one of them finally agreed to finish the project. Antiques, purchased from journals, decorate most of the home. One wing of the house features three museum-style dioramas: one with two Alaskan brown bears DePuy shot when he was seventy-five, a second with a Dahl sheep he shot when he was eighty, and a third that remains empty waiting for the lion he hoped to shoot in Africa. Above the dioramas is a gigantic knife and fork DePuy saw at the 1905 World's Fair in St. Louis when he was a child, and finally tracked down and purchased as an adult. This wing is now the studio for his daughter, who paints the open spaces of Montana. Her husband, Dan Murray, a graphic and website designer, works in the same room.

FAR RIGHT A life-size diorama, featuring Warren DePuy's trophies, occupies one side of his daughter's art studio in Montana. High ceilings and an open space make this old trophy room the perfect place to paint.

Antique Accents

Twenty years ago, Christine and William Pollock moved from southern California to live permanently in Sun Valley. They moved to this ski area because they wanted more of a community than the California mall strips could offer. Upon arriving, they directed their passion for gathering and selling antiques toward opening an antique business.

When the Pollocks moved into their new mountain home in an open meadow, they were adamant about incorporating European antiques into the house. Rather than filling the home with Western chairs and Navajo rugs, they used the things they had with them. They weren't interested in the fashions or trends of the area. "Both my husband and I inherited a lot of antiques in addition to being in the antique business," Christine said. "We basically took a look at the things we inherited and the things we had bought and incorporated them into a contemporary-style house."

Because this home was their primary residence, the Pollocks wanted to decorate the interior with a more sophisticated style than Western. After a hard day of work, they kick their feet up on their coffee table, an 1813 metal door from the Dartmoor prison in the south of England. They discovered this six-foot-tall door with a small round window on one of their trips to England. They acquired Napoleon prints from what Christine describes as an "aunt who just had a thing for Napoleon," adding, "I'm not obsessed with Napoleon, but I think they are interesting." An antique carousel horse from a local antique store hangs above the piano and adds to the living room's eclectic design. In the kitchen, an iron French baker's rack makes an attractive yet practical display for white ironstone dishes.

The contemporary shell worked well with their furnishings. The Pollocks enjoy the large windows and the light and space that they created inside. Building a log cabin was not an option. "Well, for one thing, it is not our taste. It never occurred to us, but it wasn't our style," Christine said.

A collection of white ironstone on an iron French baker's rack creates a feeling of a country kitchen. German botanicals adorn the wall.

RIGHT An antique carousel horse hangs over the family piano. "I inherited the piano and my mother played and I play," said Christine Pollock. A collection of Napoleon prints from her aristocratic aunt decorate the wall.

BELOW, LEFT The Pollocks' living area features treasures from all over the world. An old grandfather clock tells the time.

BELOW, RIGHT The Pollocks decorate with treasures from their travels. They set an 1813 metal prison door from the Dartmoor prison in the south of England into a steel frame to make an unusual coffee table in their modern Sun Valley home.

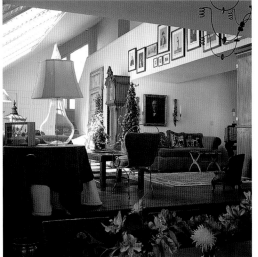

LEFT The Pollocks inherited the four-poster bed and the English desk. William Pollock's mother made the crocheted bedspread.

BELOW, LEFT One of William Pollock's ancestors was made an Earl of Salisbury. Tucked into this bookshelf are the original letters that conveyed upon him his earl status by the British parliament in 1649. A chestnut roaster, another family antique, decorates this shelf.

BELOW, RIGHT Old family photographs connect people to their past. The Pollocks' pictures sit by their bed. One photograph features the house that Christine Pollock's Swedish grandparents built when they moved to Seattle.

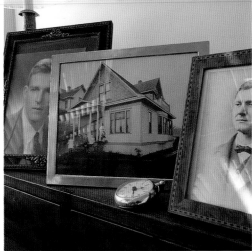

Town-and-Country Style

Making that first step to live year round in the mountains can be difficult. When Sandra Wolcott Willingham, who had previously lived in New York, London, and Los Angeles, moved into an old house in Sun Valley, Idaho, heaps of work confronted her. As she says, referring to the popular English television show *Upstairs, Downstairs*, "first I lived the upstairs, now I'm living the downstairs."

For the initial months, old buckets collected leaking roof water; rain dripped in her martini glass. Willingham has particularly bad memories about a dinner party she hosted in her unfinished dining room, when her pink insulation had an uncanny resemblance to the color of the dessert. But, with determination, vision, and help from friends, Willingham turned a relatively dumpy home into a sanctuary by opening up the place with windows, repainting rooms, and redoing the roof. Filled with family heirlooms and local flea market finds, the home imparts an ease and warmth, as well as revealing the marvelously layered character of the owner.

On Willingham's bedroom mantel, two sets of plastic wedding-cake figurines stand next to a classic black-and-white photograph of her mother. In another room, a portrait of her great-great aunt collects dust next to a shark fin from Santa Monica. An old clock and early sailor love letters composed with seashells mix with five-dollar tablecloths and an old-fashioned wood-burning stove. Sunlight streams into all the rooms. An open window allows the sound of the river to rush inside. And in the midst of this charming, rural ambience, the dogs Pinky, Chopper, The Duke of Cornwall, and Peaches cuddle on the couch, while a Labrador named Cody rests on the floor.

ABOVE A sentimental collection of wedding-cake figures and family photographs decorates Willingham's bedroom bureau.

LEFT When Sandra Wolcott Willingham of Sun Valley, Idaho, redesigned her bedroom, she made sure the wall facing the river was mostly window. "I love to wake up to the sound of water and I couldn't live in a house without light," she said.

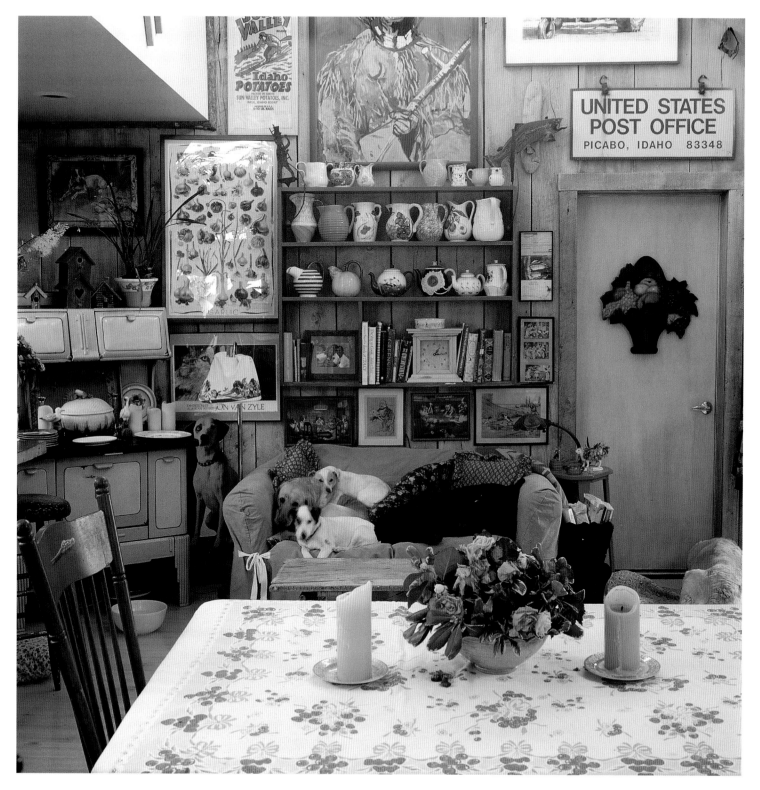

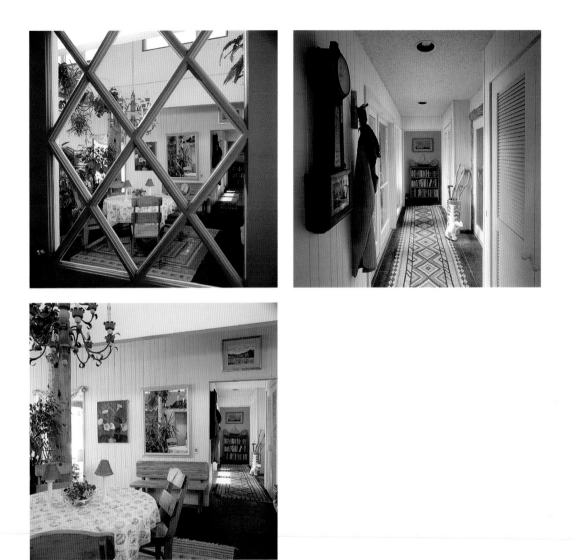

LEFT A country home must accommodate pets, handling their mud and fur. Sandra Wolcott Willingham invites her pets onto the kitchen couch. A green stove purchased nearby, a collection of old signs and memorabilia, and colorful tablecloths make this room a festive gathering place.

ABOVE, RIGHT White walls and country antiques create a cheery ambience in the dead of winter.

ABOVE, FAR RIGHT Willingham's great grandfather's clock stands proudly at the end of her Sun Valley cottage. The leather chaps were made by her husband.

RIGHT Willingham enjoys entertaining friends in her casual dining room. Her own flower arrangement provides color on a gray winter's day.

Willingham misses the city and her friends, but enjoys her rural lifestyle and running her own flower business. Family heirlooms provide a meaningful indoor environment and the outdoors gives her joy. "I'm just so used to wide-open spaces. When I wake up in the morning all I hear is the river and the birds and all I see are the mountains. I'm stimulated by the city, but as Gretel Ehrlich [a popular Western writer] once said, 'there is nothing like the wide open spaces.'"

LEFT A collection of signs, salvaged from the dump, decorate the garage.

RIGHT Vintage lace curtains provide privacy when Willingham soaks in her claw-foot tub. Warm baths can make long winters much more bearable.

BELOW A shark fin, a gift from a friend, and a wooden decoy lie next to a portrait of Sandra Wolcott Willingham's great-great aunt, once the neighbor of Abraham Lincoln.

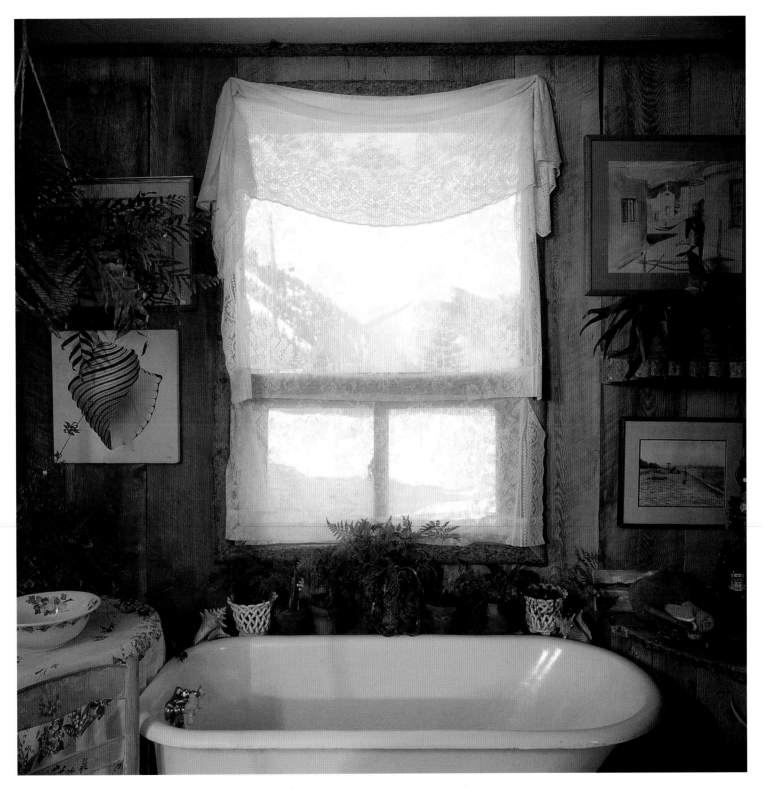

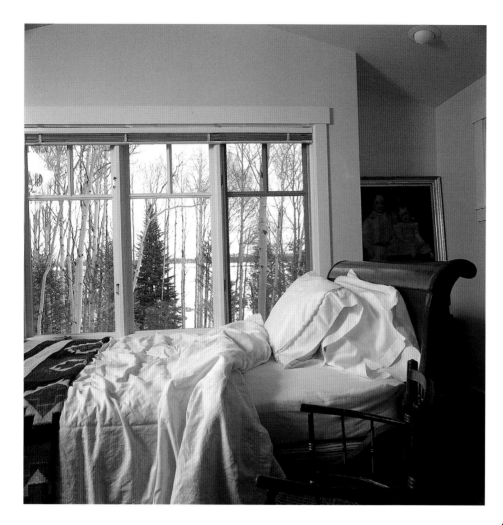

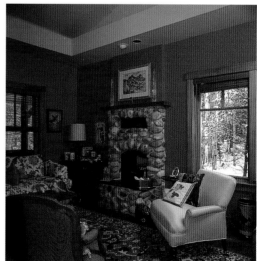

A Private Place

A jewelry designer from a well-known family lives, as she describes it, "tucked away in a village under a big tree" in Wyoming. While she could live anywhere, she chose this place because of the tranquility and beauty of the Grand Tetons and the surrounding areas. "I have the ability to experience anything somewhere else, but on a daily basis I choose to live in this quiet place," she said. A Persian rug, a sofa covered in a rich pattern from the prestigious Brunschwig and Fils fabric and furniture company, and family antiques create an atmosphere of refinement and tradition. A home that could almost be on the East Coast.

But isn't.

Upstairs in her bedroom, this woman sleeps tucked under a window on a nineteenth-century sleigh bed, once her great-great uncle's. Through the windows she looks out on a forest, with snow-capped mountains beyond. A portrait of her great grandfather and one of his sisters hangs to the side. An 1890s third-phase Navajo blanket lies at the foot of her bed.

"When I'm in bed I feel like I'm on a boat. I'm very contained, but what I look out on is incredibly expansive," she said. "The window is not a sea of glass that makes me feel exposed. There is a coziness yet an expansiveness, a sense of feeling safe."

This woman, who leads a busy life, has found peace out West. Layered with tradition and understatement, this home makes her feel comfortable. "I think my house is a reflection of who I am," she said. "As I say that, how can a house not be a reflection of who you are?"

ABOVE A collection of family photographs is a reminder of this owner's Eastern roots. Propped up in her dining room, the pictures lend an intimate ambience to the room.

ABOVE, LEFT A sleigh bed, which has been in the owner's family since her great-great uncle slept in it, sits by a cozy window overlooking a snowy forest. The Navajo textile is a third-phase transitional blanket (1895–1905).

BELOW, LEFT The owner creates a sense of Eastern refinement in her small living room with a Brunschwig and Fils sofa in a bright red library, which provides a warm place to sit in the winter and read. "I love this room," she said. "I love to lie on the floor and look at the ceiling." The owner used an Adirondack fireplace as a model, then picked out the stones from the Snake River near her home. The painting is by J. O. Nordfeldt; the rug is Persian.

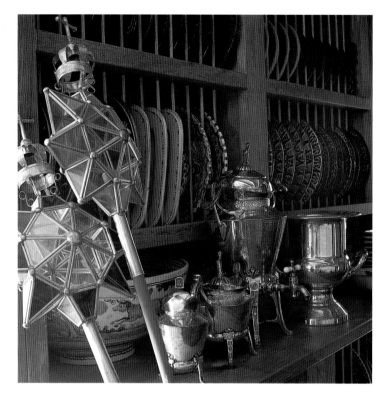

In this room, which dates back to the sixteenth century, the Dillenbergs store their silver and more of their pottery collection. The glass star torches were once used in religious ceremonies in Mexico. The Dillenbergs use them to light their garden during an evening fete.

Epilogue

The Western frontier is now a place where the Aspen elite clink their champagne glasses and the cowboy still herds his cattle. What the future holds for this diverse company is unknown.

As pioneer cabins crumble into the ground, ranches are sold to real estate developers, and cowboy and Indian memorabilia becomes scarce, residents will struggle to hold onto their past as reproductions and Disneyesque creations will continue to replace the old. How we choose to preserve our past will define our future.

Resource Guide

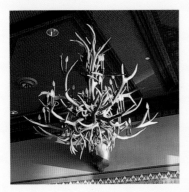

Rocky Mountains
Architects, builders, and designers

Terry Baird
P.O. Box 3
Big Timber, MT 59011
406-932-6116
A contractor who specializes in remodeling old cabins and building traditional mountain homes.

Mark Brown, Architects
4015 West Lakecreek Drive
Wilson, WY 83014
307-733-1878
Twenty years' residential practice in Jackson. Specializes in timber frame work and antique cabins.

Zoe Murphy Compton, Ltd.
321 Sopris Creek Road
Emma/Basalt, CO 81621
970-927-4201
Interior design. Specializes in blending a country and city style in the mountains.

Design Coalition
David Krajeski
P.O. Box 1180
540 Main Street
Park City, UT 84060
435-649-6006
Specializes in Western interior design and decoration.

Stephen Dynia Architects
P.O. Box 4356
Jackson, WY 83001
307-733-3766
Contemporary Western architecture. Formerly employed by Skidmore, Owings, and Merrill.

P.K. Flowers, Inc.
5316 Birchman Avenue
Fort Worth, TX 76107
817-737-2070
Interior design.

Jonathan Foote
126 E. Callender
Livingston, MT 59047
406-222-6866
Contemporary log home designs using traditional and recycled material.

Gandy/Peace, Inc.
Charles Gandy and Bill Peace
349 Peachtree Hills Avenue NE
Suite C-2
Atlanta, GA 30306
404-237-8681
fax: 404-237-6150
Interior design.

Hilary Heminway Interiors
140 Briarpath Road
Stonington, CT 06378
860-535-3110 or 406-932-4350
Interior design.

Inner Design
Linda Bedell
P.O. Box 9305
Aspen, CO 81612
970-925-4310
Interior design.

The Jarvis Group
Janet Jarvis
P.O. Box 626
Ketchum, ID 83340
208-726-4031
fax: 208-726-4097
Designs high-end Western homes.

Peter Hans Kunz Associates
205 South Galena Street
Aspen, CO 81611
970-544-9151
Interior design.

Kevin Price
Architectural Designs
P.O. 981537
Park City, UT 84098
435-658-1916
Architect specializing in resort homes.

Ruscitto, Latham, and Blanton, Architectura
P.O. Box 419
Sun Valley, Idaho 83353
208-726-5608
Specialize in resort architecture in Colorado, Idaho, Canada, and Hawaii.

Candace Tillotson-Miller
P.O. Box 467
Livingston, MT 59047
406-222-7057
Designs mountain homes. Specializes in ranch architecture.

Robert L. Turner, Inc.
136 East 57th Street
Suite 1902
New York, NY 10022
212-421-7403
Interior design and decoration.

Yellowstone Traditions
Harry Howard and Dennis Derham
P.O. Box 1933
Bozeman, MT 59771
406-587-0968
Specializes in mountain homes in keeping with traditional architectural styles.

Antiques, shops, and galleries

Antique Accents
155 Main Street
P.O. Box 125
Minturn, CO 81645
970-827-9070
Great country and Victorian antiques from Colorado, cowboy and cowgirl memorabilia.

The Back Porch
P.O. 2887
145 E. Pearl Avenue
Jackson, WY 83001
307-733-0030
Specializes in country antiques and accessories for the home.

Baldwin Gallery
209 South Galena
Aspen, CO 81611
970-920-9797
www.baldwingallery.com
Features American contemporary fine art.

Bedlam Design Group
P.O. Box 1626
Park City, UT 84060
435-647-9800
Full-service interior design and showroom.

Beyond Necessity
Antiques & Folk Arts
P.O. Box 779
335 S. Millward Street
Jackson, WY 83001
307-733-7492
Features country antique furniture, rustic furniture, and some Western memorabilia.

Cayuse Western Americana
P.O. Box 1006
Jackson, WY 83001
www.mary@cayusewa.com
307-739-1940
High-quality cowboy, Indian, and National Park antiques. Contemporary Western jewelry, buckles, and books on collecting.

The Clay Angel
125 Lincoln Avenue
Santa Fe, NM 87501
505-988-4800
An extensive selection of fine contemporary pottery from all over the world.

Crystal Farm
18 Antelope Road
Redstone, CO 81623
970-963-2350
fax: 970-963-0709
One of the finest companies selling antler furniture, chandeliers, and accessories.

Doodlets
120 Don Gaspar Avenue
Santa Fe, NM 87501
505-983-3771
An eccentric, humorous, and romantic collection of home accessories and gifts.

Flower Hardware
3445 North Pines Way #103
Wilson, WY 83014
307-733-7040
Flowers and antique containers, furniture and architectural pieces such as doors and mantels.

Fighting Bear Antiques
P.O. Box 3812
35 E. Simpson
Jackson, WY 83001
307-733-2669
One of the largest dealers of early Western furniture, including Thomas Molesworth furniture. Also sells fine Arts & Crafts.

The Gardener
Sandra Wolcott Willingham
809 Canyon Road
East Fork, ID 83333
208-788-3226
fax: 208-788-3992
Flower design.

Gorsuch Home
61 Avondale Lane
Beaver Creek, CO 81620
970-949-8092
Beautiful home furnishings, fine linen, exquisite crystal and china, unique gifts, and accessories for the home.

Greta Gretzinger
P.O. Box 802
Victor, ID 83455
208-354-3461
Muralist, sculptor, and furniture designer.

The Ernest Hemingway Collection by Thomasville
www.thomasville.com
1-800-225-0265
A collection of furniture inspired by the lifestyle and writings of the late Ernest Hemingway.

Horsefeathers
109-B Kit Carson Road
Taos, NM 87571
505-758-7457
www.cowboythings.com
Specializes in cowboy collectibles, antiques, and Western home furnishings.

Hubbard Cabinet Makers
15005 Falls Road
Butler, MD 21023
410-472-1175
www.hubbardcabinetmakers.com
Custom furniture and reproductions designed and crafted by hand. Specializes in 18th century, using exquisite woods such as bird's-eye maple, mahogany, and tiger maple.

Kemo Sabe
434 East Cooper
Aspen, CO 81611
970-925-7878
Classic Western wear, boots, hats, belts, buckles, and home furnishings.

Montana Wagons
P.O. Box 1
McLeod, MT 59052
406-932-4350 or 203-535-3110
Custom-designed sheep wagons to be used for guest houses, offices, play houses, and outhouses.

Cheryl DePuy Murray
Landscapes and Portraiture
P.O. Box 71
Livingston, MT 59047
406-222-0350
Artist who paints Montana landscapes.

Nathalie's
503 Canyon Road
Santa Fe, NM 87501
505-982-1021
Features high-end Western fashion and home accessories.

The Nemours Collection
P.O. Box 100
Teton Village, WY 83025
fax: 307-733-5403
307-733-0777
Colorful precious jewelry and estate jewelry.

Old West Antiques
1215 Sheridan Avenue
Cody, WY 82414
307-587-9014
Sells cowboy and cowgirl memorabilia.

Ranch Willow Furniture Co. and Design Studio
Lynn Arambel
501 U.S. Highway 14
Sheridan, WY 82801
307-674-1510
Specializes in handmade furniture and refurbishes old sheepwagons for guest houses.

Rustic Furniture
Diane Cole
10 Cloninger
Bozeman, MT 59718
406-586-3746
Builds beautiful rustic furniture.

Schenk Southwest and Billy Famous, Gallery and Studio
268 Los Pinos Road
Santa Fe, NM 87505
505-424-6838
Contemporary artist, furniture maker, and Navajo rug dealer.

Whitechapel Ltd.
www.whitechapel-ltd.com
P.O. Box 11719
Jackson, WY 83002
1-800-468-5534
Major U.S. supplier for thousands of unusual furniture and architectural fittings from a variety of small European and domestic manufacturers. These manufacturers are chosen for their dedication to Old World methods and materials, and many have roots dating back to the nineteenth century.

Hotels, bars, and museums

The Fechin Institute/Museum
P.O. Box 832
Taos, NM 87571
505-758-1710
Tours of artist Nicolai Fechin's home.

Hotel Jerome
330 East Main Street
Aspen, CO 81611
970-920-1000

Pioneer Saloon
308 N. Main Street
P.O. Box 986
Ketchum, ID 83340
208-726-3139
Popular Sun Valley watering hole.

Sonnenalp Hotel and Country Club
20 Vail Road
Vail, CO 81657
970-476-5658

The Sierra Nevada
Architects, builders, and designers

The Finishing Touch
Corinne Brown
P.O. Box 100
550 Old Mammoth Road
Mammoth Lakes, CA 93546
760-934-5545
Full-service interior design.

Hallberg-Wiseley Designers
Richard Hallberg and Barbara Wiseley
8748 Melrose Avenue
Los Angeles, CA 90069
310-659-3531
Interior design.

Kirk Hillman/Architect
706 Spring Street
Sausalito, CA 94965
415-332-1778
A small full-service firm that specializes in creating and producing exceptional-quality residential and low-rise commercial architecture of timeless design.

J. Masters Contruction, Inc.
P.O. Box 1174
Mammoth Lakes, CA 93546
760-934-9319
Jeff Masters builds upscale custom homes, including contemporary, log, and Adirondack style.

Neubauer-Jennison, Inc.
John Neubauer and Greg Jennison
P.O. Box 3579
Mammoth Lakes, CA 93546
760-934-2511
General contractors.
License number: 615228.

Bruce Olson
P.O. Box 1518
Tahoe City, CA 96145
530-581-9000
One of the most popular contractors in the area for high-end homes.

Rubicon Collection
Diana Cunningham
P.O. Box 6495
Tahoe City, CA 96145
530-581-5717
Interior design and showroom.

Sierra Design Studio
Robin Stater
P.O. Box 1280
550 Old Mammoth Road
Mammoth Lakes, CA 93546
760-934-4122
Unique mountain interior showroom. Complete interior design service.

Antiques, shops, and galleries

Ron Bommarito
P.O. Box 1
Genoa, NV 89411
775-782-3893
Sells Western antiques, mining memorabilia, and cowboy and cowgirl artifacts, and has an extensive collection of early photographs.

Rituals
756 N. La Cienega Boulevard
Los Angeles, CA 90069
310-854-0848
Features antique and reproduction furnishings and accessories. Styles include Adirondack, Lodge, Western Ranch, Spanish Colonial, Monterey, Arts & Crafts, and Primitive.

Whistler, British Columbia, Canada
Architects, builders, and designers

John BenBow Construction
P.O. Box 1340
Whistler, B.C. VON 1BO
604-932-8794
benbowconstruction@telus.net
Builds quality custom homes, post-and-beam and log.

Fullondesign
David Lombardi, Architect
With offices in Nagaoka, Japan; Bali, Indonesia; and Whistler, Canada, Fullondesign is reached most easily by email:
dave@fullondesign.com.

Heartland Appliances, Inc.
800-361-1517
www.heartlandapp.com
Gas, electric, and wood-burning vintage-style stoves.

Duane Jackson, Architect
6276 Piccolo Drive
Whistler, BC VON 1B6
604-938-3120
Mountain and resort architecture.

Index

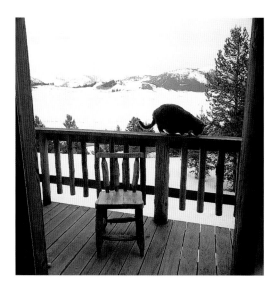

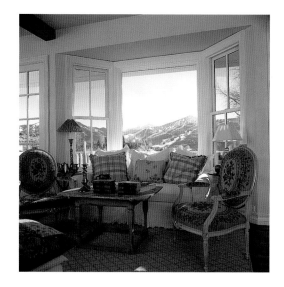

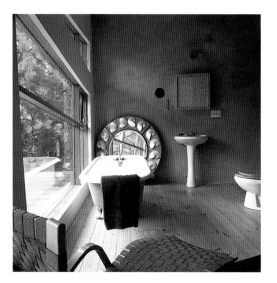

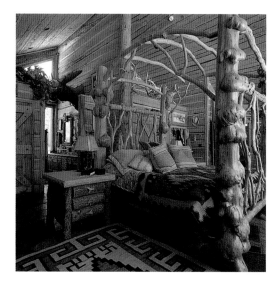